EUROPEAN CERAMICS

EUROPEAN CERAMICS

Robin Hildyard

PENN

University of Pennsylvania Press
Philadelphia

First published 1999 by V&A Publications
Copyright © 1999 Board of Trustees of the Victoria and Albert Museum

Robin Hildyard reserves his moral right to be identified as the author.

First published in the United States of America 1999 by
University of Pennsylvania Press
Philadelphia, Pennsylvania 19104-4011

Printed in Hong Kong by South Sea International

10 9 8 7 6 5 4 3 2 1

ISBN 0-8122-3503-3

A CIP catalog record for this book is available from the U.S. Library of Congress

Designed by Bernard Higton
Photography by Richard Davis

Frontispiece:
Salt-glazed stoneware jug. Made by Wally Keeler, 1992. C.104-1992.

CONTENTS

ACKNOWLEDGEMENTS

My thanks go to the V&A's Research Department and to all in the V&A's Ceramics & Glass Department for their help, understanding and encouragement: the Chief Curator Oliver Watson, Jennifer Opie, Reino Liefkes, Hilary Young, Judith Crouch, Alun Graves, Stephen Jackson, Fi Gunn, Melanie Nunzet, Jill Creak, and especially Terry Bloxham for her speedy and efficient management of the photography. The sparkling new images by the Museum's photographer Richard Davis may speak for themselves. I am most grateful to Mary Butler and Miranda Harrison of V&A Publications, and to the editor Sarah Jenkin, for their cheerful patience in a tight publication schedule, and to Kate for her constant and unwavering support.

INTRODUCTION

Small modelled figurines made by Eastern-European cave dwellers show that the knowledge that fire can transform raw plastic clay into an entirely different hard material is at least 25,000 years old. Later, when nomadic life gave way to settlement, the need for permanent buildings and vessels gave rise to bricks, tiles, and the pottery or 'ceramics' that forms the subject of this book. The constant and universal need for expendable containers has ensured that pot-making has flourished and pursued many paths of development in most parts of the world. On a basic level, beakers and bowls met the needs of a largely rural community. At the other extreme, refinement of material and form, together with various forms of decoration, enabled functional and decorative vessels to rival or surpass similar objects made of precious metal – their obvious fragility and impermanence enhancing rather than diminishing their value. So universal is the production of ceramic vessels today that it is difficult to imagine a world without their most basic manifestation – plates and mugs.

The essential element of anything 'ceramic' is that it is brittle and easily broken. Paradoxically this ephemeral quality, combined with the fact that the material is of no intrinsic value and cannot be recycled, has left an enormous legacy of almost indestructible fragments or 'sherds'. These have proved vital for archaeological dating, and, with a variety of shapes, decoration and sometimes bright enamel colours, acted as a barometer for the prosperity of the time, the state of its culture and perhaps the wealth of the individual user. The evidence of surviving whole artefacts – in many cases aristocratic, collectors' or museum objects that have always owed their preservation solely to some exceptional quality, usually decorative – is random and often highly misleading. Ultimately, however, a balanced view of the history of ceramics can be achieved through the co-ordinated study of excavated fragments from production and domestic sites, surviving objects and contemporary documentary evidence. Thus, the study of ceramics, beginning in a serious way with the opening of Enoch Wood's factory museum at Burslem around 1816, has divided into many branches – from the strictly archaeological to the modern collecting of 'antiques', a category which embraces not only utilitarian objects as recent as the 1960s but also 'designer' ceramics and craft pottery.

The changing meaning of ceramic objects forms a study in itself. Almost all ceramics (by their nature highly portable) lose all record of their origins the moment they leave the shop or place of manufacture; and, although acquired for a particular purpose, they must adapt to changing fashions and needs or suffer oblivion. When deprived of its original function, a pot's future is indeed precarious: it may be used for some lesser purpose and ultimately destroyed; it may be put away and be forgotten; or it may be rediscovered and acquire a new life as a prop for an artist's studio, a 'decorator's piece' where only its physical characteristics (colour or pattern) are thought worthy of consideration, or as a tiny but treasured link in the chain of ceramic history constantly being compiled by museums and the vast army of collectors and connoisseurs.

Some types of pottery and porcelain – notably Wedgwood, Meissen and Sèvres – have made a seamless transition from household furnishings to art objects within a generation of the date of their manufacture. Others have become the playthings of fate. The outmoded aristocratic porcelain table decoration of the mid eighteenth century becomes a cabinet curiosity for the wealthy, and perhaps socially aspiring, collector. The cheap nineteenth-century cottage chimney ornament becomes an interesting example of English folk art, now affordable only for those with disposable income. The seventeenth-century slipware dish made for a local market languishes in a farmhouse for two-and-a-half centuries, only to be hailed by the art critic Herbert Read as a great and rare English Primitive and then exported to America or Japan. The flawless blue and white Kangsi vase fought over by rich collectors in the late nineteenth century gathers dust when taste swings in the twentieth century towards early Chinese monochrome bowls from burial grounds unearthed by the laying of Chinese railways. The mid-nineteenth-century collectors' love of elaborate painted decoration and intricate pattern in the Renaissance manner – the foundations of the collections of the Museum of Ornamental Art and its successor, the South Kensington Museum – is first popularised by imitation and then glutted, to be replaced by the search for the simple and perfect match between form, material and function.

Museums can afford to take a long-term view of changing fashions. For example, the unashamedly decorative work of Bernard Palissy, always on display in museums, but in aesthetic exile for nearly a century, is now back in fashion. This introduction to European ceramics, based around the V&A Collections with all their strengths and weaknesses, cannot be free of bias in its interpretation, but its intention is to make all areas of the subject equally accessible. All ceramics, as mirrors of their makers, their users and their age, have something to offer.

FROM EARTHENWARE TO STONEWARE

By 1500, Europe was emerging with increasing speed from the period we arbitrarily call the Middle Ages. Pottery-making, which had enjoyed a brief renaissance in the twelfth and thirteenth centuries, had settled back for the next 200 years into a pattern of slow improvement. Although pottery was quick to respond to increasing wealth and expanding markets, its makers were still locked into the medieval system of village potting and farming family communities. Further, the limiting factors of soft material and comparatively dull colours (reduction-fired olive green, and drab red or yellow depending on the iron content), although partially offset by low manufacturing costs and the ready availability of materials, militated against its development in the face of competition from the perfected stonewares of Germany and the painted tin-glazed earthenwares of Italy, quite apart from the availability of more durable pewter. Simple techniques of decoration never impinged on the function, but added little in the way of sophistication. Inevitably, however, some of these potters attempted to refine and to raise the status of their products, by replacing their porringers, braziers, skillets and pipkins with a range of fine wares suitable for the dining table of the new wealthy merchant classes and the aristocracy. During the sixteenth century, while immigrant *maiolica* potters were still struggling to establish their trade in Northern Europe, earthenware and stoneware were raised to a peak of technical and artistic excellence not to be equalled again until the eighteenth and nineteenth centuries.

In France, where the authoritarian monarchy and concentration of wealth around the Court in Paris produced a great demand for luxury goods, the arts were able to flourish ahead of other parts of Europe. By 1500, production of decorated pottery was already well established in areas where suitable beds of clay, local markets and transport by water were to be found, notably at Saintonge in the South West and at Beauvais in the

North. Drawing on the skill of artisans from Italy, the Netherlands and Germany, as a result of emigration caused by its continuing bloody religious wars France also played an unintentional role as disseminator of these skills to the Protestant countries of the North.

At Saintonge, where 50 kiln sites have now been excavated, the established wine-trade with England via Port Berteau and along the Charente had already been supplemented by the export of basic buff jugs, jars and braziers decorated with brown and green bands. From this cluster of potteries at Saintes, however, emerged a multi-talented potter, Bernard Palissy (pp. 24–25), whose ten years of experimentation resulted in the new blue and yellow glazes and moulding techniques that would bring refined lead-glazed pottery and sophisticated Renaissance ornament together to form an entirely new class of pottery suitable for the tables of the wealthy (fig. 1). Palissy allied art with science and craft, astounding his patrons with a wide variety of elaborately moulded tablewares, using bas-relief moulds based on engravings, or life-casts of small creatures such as snakes, lizards and frogs painted in naturalistic coloured glazes in the popular grotesque style. When his growing fame compelled him to move to Paris in 1562, he left behind a cluster of imitators who continued his style in a cruder form at Saintes, La Chapelle des Pots and Port Berteau until well into the next century, the chief forms being moulded dishes, costrels (fig. 2) and boat-shaped vessels evidently intended for incense. In the nineteenth century, the great popularity of Palissy as Protestant martyr and ceramic innovator led to imitations which have muddied the waters of attribution ever since.

A comparatively small class of tablewares – salts, candlesticks and dishes – made of an almost white clay with contrasting brown designs impressed with metal dies (thought to be book-binders' tools) were for a long time styled 'Henri II Ware' and attributed to an obscure

1. *The innovative moulded and coloured wares of Bernard Palissy sometimes had to rely on metalwork prototypes for both overall shape and figural decoration. This particular ewer form was also copied in* majolica *in the 19th century.*

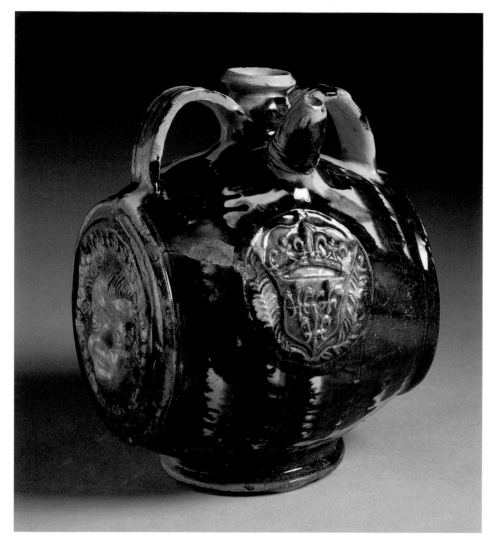

2. *The Saintonge area, which produced the great Bernard Palissy, continued to make a limited range of decorated but functional wares. In the absence of strong glass bottles, portable earthenware flasks or 'costrels' (here in the shape of a barrel) were always in demand.*

pottery at Saint-Porchaire, for no better reason than that they bore armorials of local families. These technically brilliant objects include moulded human and animal figures, some of which have been shown by recent excavations in Paris to overlap with wasters of the Palissy workshop. Indeed, it seems unlikely that such sophisticated objects would have been made in the provinces.

Elsewhere in France no-one matched the stature of Palissy. Jugs made in the Loire area of Western France reached Scotland in the sixteenth and seventeenth centuries, while in Normandy a purplish unglazed utilitarian stoneware was developed, and at Martincamps a light-buff stoneware was used for the flat long-necked bottles (originally covered in wicker, and similar to the eighteenth-century Belgian spa water bottles) intended for export. At Beauvais itself, a light-grey stoneware of

Siegburg type, sometimes with a naturally formed ash glaze, is recorded from the late fourteenth century. At the height of production around 1500, some moulded dishes were given a unique blue glaze in a second firing. Of great importance for Britain were the *sgraffito*-decorated Beauvais slipware dishes, bowls, jugs and *albarelli* (tall drug jars) which attained a high level of sophistication in the first half of the sixteenth century. The light clay body was dipped once or twice in red or white slips to provide alternative backgrounds for floral designs or inscriptions in Gothic script, the surface further embellished with brushed patches of copper-green glaze. As with the painting of tin-glazed earthenware, the unforgiving surface of slipware demanded great skill from the decorator. However, by the early seventeenth century the fashion had passed and *maiolica* had arrived. Only the elegant

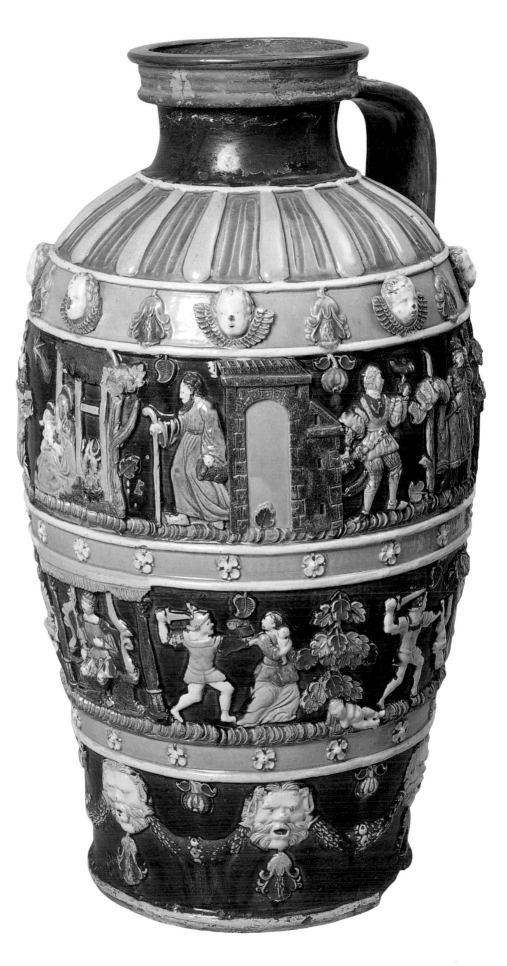

3. Stove-tile makers in Nuremberg eventually began making grand jugs for display. Although the moulded decoration was inevitably much coarser than German stonewares, the bright lead-glazes stained with oxides were very much bolder than those of contemporary maiolica*.*

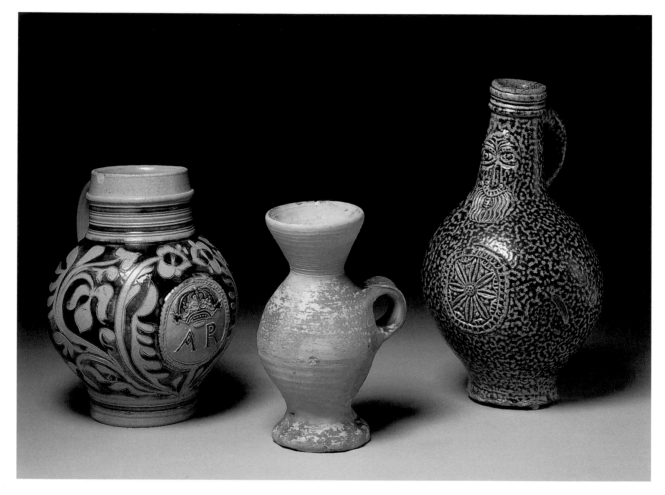

4. *Until the late 17th century, Britain relied on the Rhineland to supply salt-glazed stoneware beer mugs and storage bottles such as the above. The trade was routed through London, mainly by Dutch dealers operating from Dordrecht, Nijmegen and Rotterdam.*

brown lead-glazed wares traditionally attributed to Avignon and the elaborate wares in Renaissance style made at Le Pré d'Auge in Normandy show that the material continued to be respected.

The domination of *maiolica*, which reached France, the Netherlands and England from Spain and Italy, depended on supplies of light-coloured clay and tin. When the local clays proved unsuitable, as in the region of the River Po, at Padua, Mantua, Ferrara and Bologna, the art of making *sgraffito* slipware, borrowed from the Middle East, was developed in the sixteenth century as a serious competitor to painted *maiolica*. Fluent figure-drawing executed with a point, as well as carved bands of scrolling or geometric ornament, either left as red and cream or brushed with coloured glazes, provided a range

of highly attractive effects. On a more functional level, marbled slip jugs and costrels with lion-mask bosses were probably exported from Pisa in the first half of the seventeenth century.

In Northern Europe, the major ceramic innovations of Germany were connected to the embellishment of large ceramic stoves or to the demand for vast quantities of beer mugs for home consumption as well as for export to the Low Countries and England. The making of stoves built up from deep hollow-backed moulded and glazed tiles, mounted onto an outside wall with exterior flue and stoke-hole, had evolved at least as early as 1400 from earlier brick-built types popular in Germany, Austria and Switzerland. A palette of bright polychrome glazes·was added to these moulded tiles from about 1500. This type of decoration was soon adopted for the grand luxury jugs – the antithesis of the thin crisply moulded wares of Palissy and his followers – made at Nuremberg especially by the Preuning family (fig. 3), and later at Hesse and

Cologne. Although the thick glazes inevitably obscured moulded detail, the effect of the bold primary colours was more startling than anything offered by German stoneware or even imported *maiolica*. However, although the type continued to be made in Germany and Eastern Europe, its status declined in the seventeenth century to that of a peasant craft in the face of advances of tin-glazed earthenwares.

The most typical decorated ceramic product of Europe in the sixteenth- and seventeenth-centuries is German salt-glazed stoneware (fig. 4). Its origins lie not in a sudden breakthrough discovery, but (as with the development of porcelain in China) in steady refinement of local clays over several centuries. In the Rhineland, this resulted in vitrified stoneware and finally in the discovery of salt-glazing during the fifteenth century. Siegburg was the first centre to exploit the potential of the almost white clays that lay near the surface. Cheap drinking mugs, unglazed and plain or decorated only with small applied prunts, were exported in large numbers to the Low Countries, until the upsurge in ceramic development of the sixteenth century encouraged new forms of decoration, including carved leaf patterns, pierced double-walls, applied medallions and crisply moulded plaques covering the entire surface of the tall *Schnellen* intended as luxury beer mugs. Orange 'flame' marks and random ash-glazing give the early products the appearance of modern studio pottery; such imperfections were accepted as inseparable from a uniquely hard material which rapidly became indispensable throughout Europe.

Raeren, now just over the Belgian border, was content to supply vast numbers of frill-based salt-glazed globular mugs from the late fifteenth century until its trade was stolen by the less rustic products of Cologne and Frechen in the mid sixteenth century. At this turning point in European ceramic development, while the neighbouring potters at Langerwehe were content to carry on producing archaic pots in the early Raeren manner, several Raeren Master Potters – led by Jan Emens and his family – began to standardise the rich orange glaze and to adopt a range of new shapes suitable for the moulded bas-relief decoration which they copied from popular woodcuts by the Little Masters of Nuremburg, in particular Heinrich Aldegraver, Sebald Beham and Virgil Solis. Arcaded central friezes of the Electors, Cavaliers and the Peasant Dance ensured instant popularity for these 'panel' jugs (fig. 5), so much so that when Raeren potters migrated in the 1590s to the Westerwald, they took their moulds and

continued production using a reduced grey body embellished with cobalt blue. As Raeren hardly produced stonewares throughout the seventeenth century, the Westerwald area took over and vastly expanded its export trade. By the 1660s, a new range of shapes (including beer mugs, jugs, chamber pots and various household articles) had evolved, now decorated with moulded strip-decoration and painted blue and purple. Westerwald ale mugs with GR medallions were amongst the last German stonewares to be imported into England in the late eighteenth century.

Manufacture at Cologne started comparatively late and, having no medieval tradition, entered the sixteenth century with a small range of mass-produced simple shapes, brown-dipped and, apart from the tapering *Schnellen* and smaller *Pinte* beer mugs with their crude applied plaques, sparsely ornamented with trailing patterns of oak or rose. From the second quarter of the sixteenth century, necks were clad with the familiar *Bartmann* mask (fig. 4), mistakenly supposed to have been modelled after Cardinal Bellarmine. Moralising bands around the waist characterise the bottles made at Cologne and Frechen (where the Cologne potters migrated – or returned – after their expulsion from Cologne in 1566). A huge export trade in mugs and bottles continued until the 1660s, when a combination of factors, including the newly invented English black glass wine bottle, brought about a rapid decline. Nonetheless, the making of utilitarian stoneware at Frechen, as at Langerwehe, survived until the nineteenth century.

Far away from Rhineland and its export trade, stoneware of many different types was made for local markets in Saxony, Thuringia and Bavaria. Surviving products are mainly the large beer tankards (*Humpen*), mostly commissioned and perhaps used for ceremonial purposes or even, like the enamelled glass versions, intended for communal drinking. In Saxony, the smooth, black-slipped surface of Annaberg stoneware made a perfect background for bright enamel painting, popular from the 1630s until its decline after about 1700, a life-span shared with Altenburg where the white clay was fired to a tan colour and ornamented with applied reliefs or white slip beading resembling icing sugar. Freiberg, notable for its fine grey clay and enamelled geometric cut decoration embellished with enamels, flourished throughout the seventeenth century. The functional wares of Waldenburg, in production from as early as the fifteenth century, have reflected the changing styles of

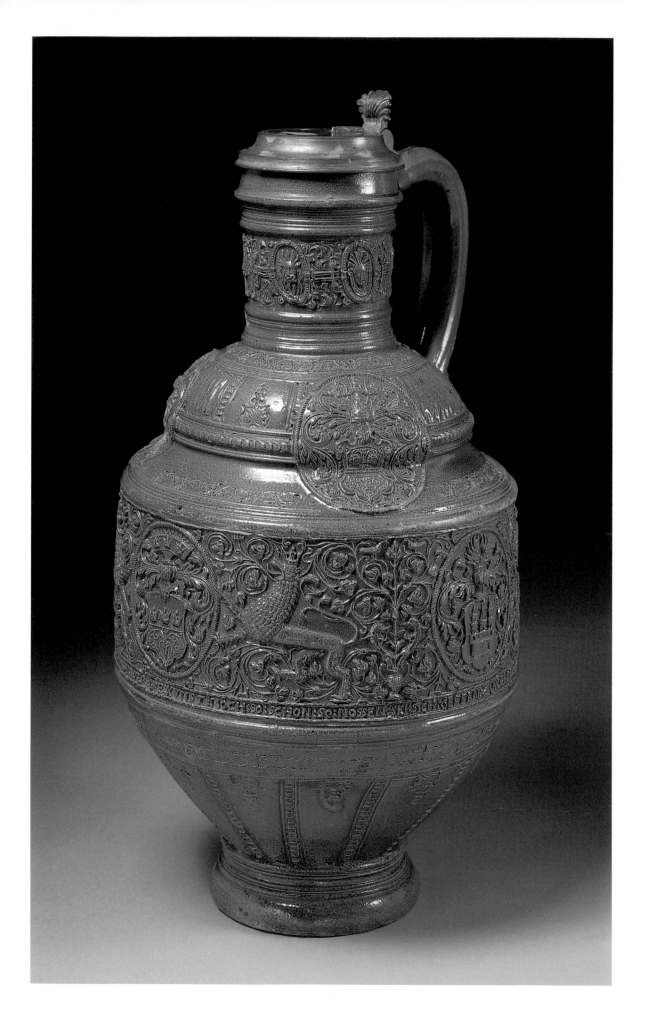

Rhineland stoneware and managed to survive until the present day. The centres at Zeitz and Bürgel in Thuringia are notable for their evenly coloured surface, either brown-slipped or a dark-blue glaze achieved by combining the salt with cobalt, not unlike the blue developed by William Littler and Aaron Wedgwood in Staffordshire in the eighteenth century. In Bavaria, the reddish *Bienenkorbhumpen* (beehive-shaped tankards) (fig. 6) made at Creussen from the early seventeenth century were often elaborately enamelled with a central frieze of the planets or the apostles or with hunting scenes. Such attractive and evocative objects, originally made for wealthy patrons and always mounted with pewter lids, were avidly collected and brought to Britain in the nineteenth century.

On a more basic level, German slip-decorated pottery exerted a considerable influence on the potters of the Low Countries and Britain, to which countries much of it was exported. Potteries along the River Werra were established in about 1500, flourishing for 150 years. They supplied fine bowls and dishes for export, using an expensive extra biscuit-firing and a highly accomplished mixed technique of trailed and *sgraffito* slip decoration, with dated examples (fig. 15) spanning the period 1568–1653. At the same time, another group of potteries on the River Weser supplied functional cooking pots and dishes with simple geometric trailed slip patterns.

In the Netherlands, through which exports from the Rhineland flowed, pottery of all kinds (and later Chinese porcelain) was easy to import. By the same token, it was easy for immigrants to move there and establish new manufacturing industries, in particular glass and pottery. There were, however, also long-established potteries which were supplying Britain with cooking pots as early as the thirteenth century, and later with candlesticks, money boxes and salts – basic forms which the unadventurous potters of England only began to copy in the sixteenth century. The heavily gouged *sgraffito* wares were probably made in the Utrecht area, while a late offshoot of the Werra potteries was working at Enkhuizen in

5 (opposite). *Towards the end of the 16th century, the potters of Raeren developed the large cylindrical 'panel jug' around which various moulded scenes could be wrapped, such as the Electors, the Peasant Dance and elaborate armorials.*

6 (right). *Elaborately decorated and pewter-mounted beer tankards were made in Saxony, particularly at Creussen where the dark reddish clay provided a perfect background for painting by local glass enamellers.*

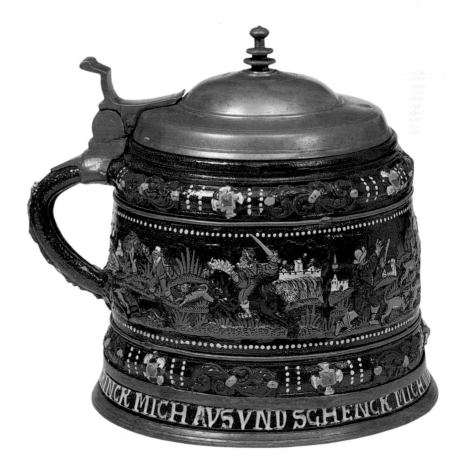

7 (above). *Imported from North Holland, slipware bowls with ear handles, suitable for both eating and drinking, were popular in early 17th-century England and inspired the use of trailed slip by native potters at Harlow, Wrotham and, later, Staffordshire.*

9 (below right). *Using available contrasting red and white clays, which under a honey-coloured lead-glaze appear treacle-brown and yellow, the farmer-potters of Wrotham in Kent produced sturdy slipwares with bold decoration throughout the 17th century.*

about 1602–10. Even by the mid sixteenth century, the fashion for *sgraffito* was beginning to fade and the trailed slipwares of North Holland (fig. 7) soon took over, superseded in turn by marbled slipware at the end of the seventeenth century.

Although 'export quality' in terms of ceramics invariably means second-best, and frequently also out-of-date, the numerous unsophisticated imports into Britain did introduce an element of colour and variety into a country whose native potters were interested mainly in function. By 1500, the main British pottery-making areas had refined their materials and forms according to regional styles. So-called 'Border Ware', a light-bodied pottery with brushed apron of copper-green lead glaze made by potteries on the Surrey-Hampshire border, replaced the wares of the previous century made at Kingston, Mill Green, Cheam and Farnham, in supplying London with a range of household articles during the sixteenth and seventeenth century (fig. 8). Significantly, these included, from the mid sixteenth century, the first English drinking mugs – often copying Rhineland stonewares – which replaced traditional turned ashwood cups. In the Midlands and North, the glossy black-glazed Cistercian Ware remained popular and virtually unchanged throughout the sixteenth and seventeenth centuries. The practical form and simple dignity of many of these unpretentious pots was rarely disturbed by decoration.

Influence from the Continent – from the imported pottery and the potters of the Netherlands, Northern France and Germany – is discernible in the first slipwares which emerged about 1600, at exactly the time when such pottery was bound to be eclipsed by the newly established delftware potteries. At Harlow in Essex, 'Metropolitan' slipware of orange-red fabric with stylised floral white slip decoration or pious inscriptions was made for the London market particularly from the 1630s to the 1670s. In the village of Wrotham in Kent (fig. 9), a cluster of potting and farming families made slipware jugs and multi-handled drinking vessels of variable quality for a local market throughout the seventeenth century, using stamped white pads sometimes moulded directly from German stonewares. Showing strong influence from Beauvais, the *sgraffito* wares made at Barnstaple and Bideford area of Devon, and at Donyatt in Somerset, from the early seventeenth century onwards found a ready export market to North America, remaining in production as country pottery until the twentieth century.

Surprisingly, in view of later developments, Staffordshire was the last potting area to respond to foreign influence. Lacking access to the sea, from the mid

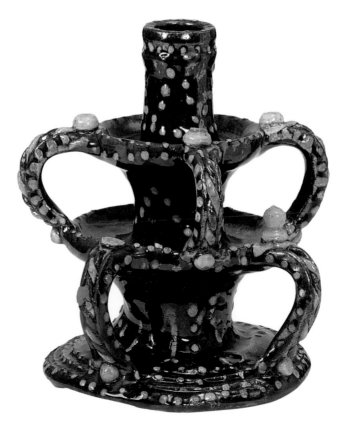

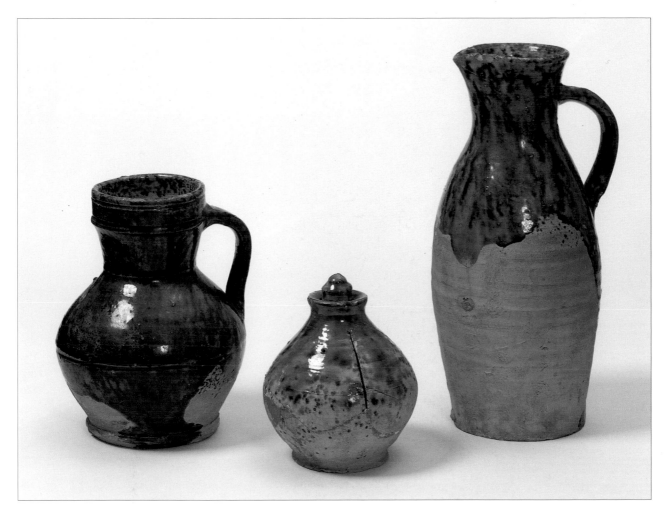

8. *Apart from imported German stoneware drinking vessels and French and German lead-glazed earthenwares, London was supplied with cheap local green-glazed pottery from the Surrey-Hampshire borders.*

seventeenth century local markets were served by a range of porringers, bowls and simple press-moulded dishes with trailed slip decoration made at Burslem (fig. 10), in parallel with the extraordinary group of huge dishes made (no doubt as a side-line) by the country potter Thomas Toft I (working about 1671–89) and his followers (fig. 11). The purpose of these dishes, which show no signs of use, remains as obscure as many of their makers, but the skill and artistry of Toft in particular is unquestionable. In the main potting centre of Burslem, slipware tygs, porringers and small mugs, often with feathered decoration, were made from the 1690s. However, the future lay with a new class of fine lathe-turned earthenware with iron-manganese glaze imitating salt-glazed stoneware.

Imported German stonewares continued to supply Britain with bottles and beer mugs throughout the sixteenth and seventeenth centuries. Various attempts to reproduce the flint-hard material in England were made by the English and Dutch merchants who controlled the stone bottle trade, from the patent applications of William Simpson at the end of the sixteenth century to Thomas Browne and his partners in 1614 and the Dutch merchants Rous and Cullen in 1626. The first certain stoneware experiments are, however, entirely undocumented and known only from the chance archaeological discovery at Woolwich Ferry of a German-type kiln of the mid seventeenth century. Here, the stoneware clay was imported, but suitable English clays must have been identified by the 1660s when the German Symon Wolltus made bottles for the entrepreneur William Killigrew at Southampton.

Despite this, in 1672, the scholar and amateur scientist

17

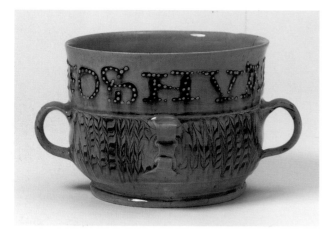

10 (left). *Wide pots with two or more handles for the communal drinking of 'posset' (spiced ale curdled with milk) were one of the standard forms of late 17th- and early 18th-century Staffordshire slipware. Like the 'Toft' class of huge dishes, these pots often bear the potter's name as part of the decoration (here 'Joshua Heath 177').*

11 (opposite). *Of necessity, the huge 'display' chargers made for a local market by Staffordshire potters in the late 17th century were fired upright in the kiln, with the risk of partial collapse (as in this case). Thomas Toft, whose slip drawing is by far the most accomplished, has given his name to the whole class of pottery.*

12 (below). *Probably the 'marbled porcellane' of John Dwight's second patent of 1684, these experimental agate wares with contrasting white sprig-moulded decoration were unlike anything made in Europe at the time.*

John Dwight (fig. 19), experimenting at the same time as George Ravenscroft with his new lead crystal glass, obtained a patent for his discovery of the materials and salt-glazing process. In the same year, he founded a pottery in Fulham and initially made an astonishing range of sophisticated wares (fig. 12), including almost white stoneware and some remarkable figures. Even the quality of his tavern wares far surpassed that of contemporary Frechen imports, and from this time imports from the Rhineland virtually ceased. Before Dwight's second patent expired in 1698, the manufacture of stoneware ale mugs had spread to the Southwark potteries, to Nottingham, and shortly thereafter to Bristol. In Staffordshire, the Wedgwood brothers, sued by Dwight in the 1690s, claimed that their mugs were earthenware imitations – doubtless the fine mottled wares mentioned above.

Dwight's patent also covered red stoneware (then known as 'Bastard China') of the type imported from Yixing, which was made commercially but secretively by two Dutch silversmiths, the Elers brothers, in the 1690s near the source of excellent iron-bearing clay at Bradwell Wood in Staffordshire. Following the departure and bankruptcy of the Elers, only their slip-cast, thinly lathe-turned and sprigged teawares remained to teach by example. Similarly, the refined, almost white, lathe-turned stonewares of John Dwight's pottery remained to tantalise Staffordshire potters after his death in 1703; but, by that time, the salt-glazing process had finally reached Staffordshire and the way was open for further development. Nonetheless, it was 40 years before all the methods of Dwight and the Elers were re-discovered and fully exploited there. The survival of Dwight's family heir-looms and recent excavations at the Fulham Pottery show that his experiments of the late seventeenth century had

brought the development of English ceramics ever closer to, and in some cases ahead of, developments on the Continent.

Although increasing wealth and changes in table manners during the sixteenth and seventeenth centuries had greatly raised the status of pottery by refining the

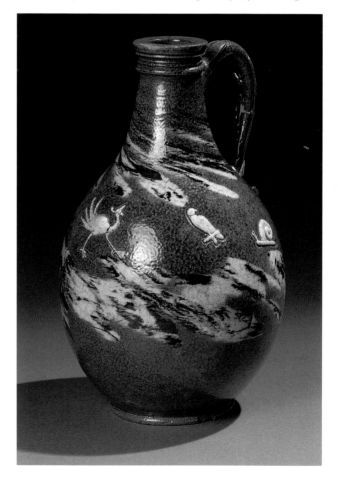

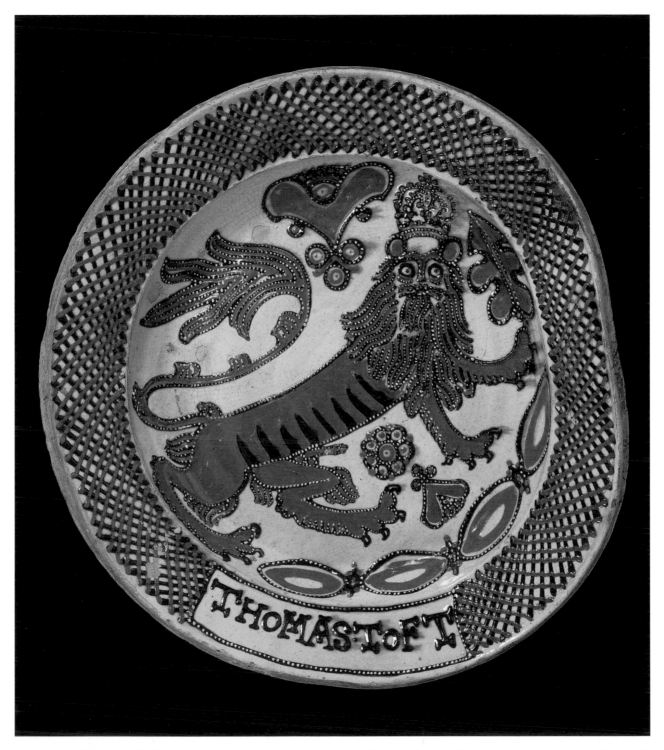

material and bringing it from the kitchen to the dining table, after about 1600 (when the impact of Chinese porcelain began to be felt in Northern Europe) its decorative limitations confined it to a more lowly position. It was the growing number of new *maiolica* potteries which proved capable of mass-producing cheap painted tin-glazed earthenware tablewares to satisfy the universal hunger for blue and white.

Sgraffito

The exact origins of the technique of scratching through one layer to expose a contrasting ground colour below are unknown, but may have developed from cameo-carving of sea shells to the cameo-glass of Roman times. When the surface of red or buff clay was enhanced by dipping or brushing with white slip, and sometimes with two contrasting layers of slip, incising with a point or gouge became a natural way to decorate the surface. Popular and highly developed on Byzantine pottery of the tenth to thirteenth centuries, and on Cypriote pottery of the fourteenth century, it reached full maturity in the fine free-drawing of animals and human figures in Bologna in the fifteenth and sixteenth centuries. Italian influence was responsible for its spread in the sixteenth century to Beauvais in France, to Werra in Germany and to the Netherlands, whence it was exported to Britain and set a fashion which took permanent root in the West Country. At Fremington and Ewenny in South Wales, the making of *sgraffito* wares survived until the twentieth century.

16. Potters in the West Country (Somerset, North Devon and even South Wales) disguised their brick-red clays with an entire coat of white slip, on which stylised floral decoration and inscriptions could be incised with a point or carved. Popular themes on the big harvest jugs were nautical compasses, hearts, tulips and birds.

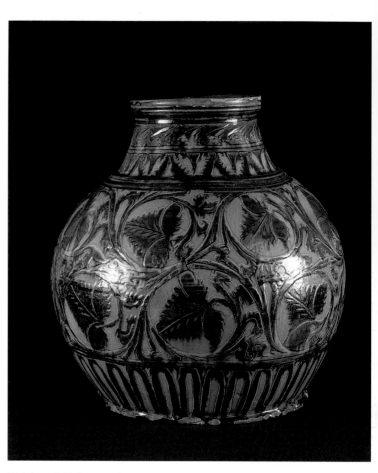

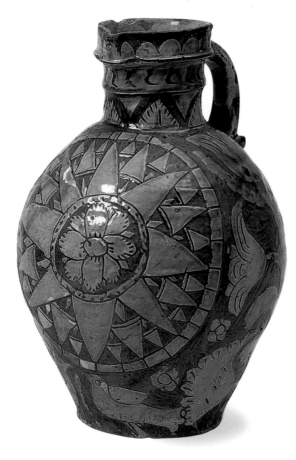

13 (above). Following the stylised *sgraffito* decoration of Middle Eastern pottery, the potters of Northern Italy used a layer of white slip on their red-bodied wares as a basis for bold carved patterns. Here the design perfectly fits the form, emphasising the base, belly and neck.

17 (right) Art potters of the second half of the 19th century, notably Doultons in London and the Della Robbia pottery at Liverpool, revived *sgraffito* decoration as a means of combining drawing with pottery. Henry Doulton, keen to raise the image of his products from basic sanitary wares to individually produced and signed collectors' items, encouraged the application of drawing to his new range of stonewares.

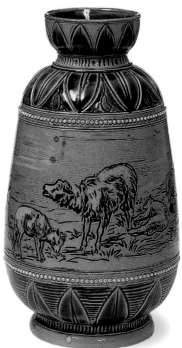

14. The lack of a buff clay suitable for making *maiolica* at Bologna led to the development of line-drawing skills in the *sgraffito* technique which show a wonderful sureness of touch, heightened by the haphazard effect of brushed colours. In addition, modelling and even modelled figures are found on these wares.

15. At the potteries along the River Werra in Germany, dishes and bowls combining the techniques of trailed and *sgraffito* decoration proved a highly popular export. With a palette of white, orange, green and brown, the decorative effect of these dishes could almost rival *maiolica*.

Salt-glazing

The process, although simple and cheap, depended on advanced kiln technology, suitable high-firing clays, and the secret of adding salt at the peak of the firing. Without scientific knowledge, the potters of the Rhineland used empirical methods to raise their kiln temperatures until vitrification (1,300–1,400 °C) of their local clays was achieved by about 1350, producing a non-porous stoneware body. Sometime during the fifteenth century it was discovered – perhaps by chance – that salt would vaporise at high temperatures, when it would release noxious hydrogen chloride gases but combine with the silica and alumina of the clay to form a tight-fitting glaze over a body which varied from buff to honey to chocolate, depending on the iron content of the clay. This closely guarded secret enabled Germany to supply the rest of Europe with durable mugs and bottles for the next three centuries, but when it was re-discovered in England in 1672, Germany lost its main customer. In the late eighteenth century, migrant German potters introduced reduction-fired blue and grey stoneware of Westerwald type to North America, where it flourished greatly.

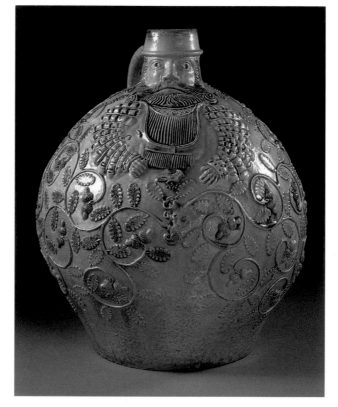

19 (below). John Dwight, scholar and scientist, patented his independent discovery of the salt-glazing process in 1672, building a pottery in Fulham with the intention of making porcelain. His innovations included refined white stoneware (including some figures and busts, professionally modelled), sprigged decoration, 'scratch-blue' and red stoneware.

18 (right). Bellied pots had, at least from Roman times, lent themselves to human caricature. In Germany, it was the Cologne potters of the mid 16th century who developed the idea until the *Bartmann* (mis-named *'Bellarmine'* in England) became the universal storage bottle throughout Europe. The Tree of Jesse motif alludes, however inappropriately, to the popular theme of the ancestry of Christ.

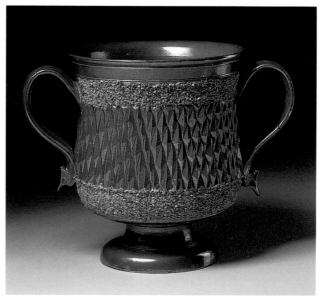

20. With a fine lustrous surface, the stoneware made at Nottingham from Derbyshire clays invited various forms of decoration. Here the German type of *Kerbschnitt* cutting has been employed, but sprigging and incising were more frequently used. Nottingham was famed for providing the Midlands with elegant thinly potted ale mugs throughout the 18th century.

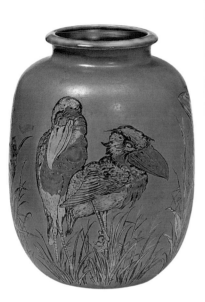

21. The eccentric Martin brothers at Southall together combined fertile imagination with great drawing and modelling skills which they applied to the making of one-off pieces of art pottery. Crisp incised drawing, applied decoration and various subtle colours gave an endless variety of effects.

22. Modern studio potters have taken up the technique either because of its suitability for domestic 'oven-to-table' wares, or because of the range of interesting random effects achievable through the use of slips and careful control of kiln and salting. Apart from Wally Keeler, notable exponents are Sarah Walton, A. & J. Young and Mick Casson.

Palissy

Perhaps the best remembered potter before Wedgwood is
Bernard Palissy, whose life and exploits qualified him for
elevation almost to sainthood in the eyes of nineteenth-century
writers on ceramics. Born in 1510 of a poor potting family,
Palissy established his pottery around 1540 at Saintes and set
about developing a range of coloured glazes, including a
yellow and blue which complemented the common brown and
green. At the same time, out of his ceaseless creativity evolved
a completely new class of ceramics – dishes relief-moulded
with scenes copied from contemporary prints, or covered with
lizards, fish and shells cast from life and naturalistically
coloured. These 'rustiques figulines' caught the eye of Anne,
Duc de Montmorency, who commissioned him to build a
grotto. In 1562, he was patronised by Catherine de Medici and
moved to Paris where he began to build a grotto in the
Tuileries. Neither project was completed, partly because his
activities as a militant Protestant in a Catholic country resulted
in the destruction of his Paris workshop and his imprisonment
in the Bastille, where he died in 1590. Today, he is judged not
only by his prolific writings and his surviving work, which is
now thought possibly to include the technically brilliant 'Saint-
Porchaire Ware', but by the fact that his style lingered on in
the work of lesser Saintonge potters for the next century, and
that he inspired the invention of Minton's *majolica* in the 1850s
as well as the mass of highly deceptive copies made for
collectors.

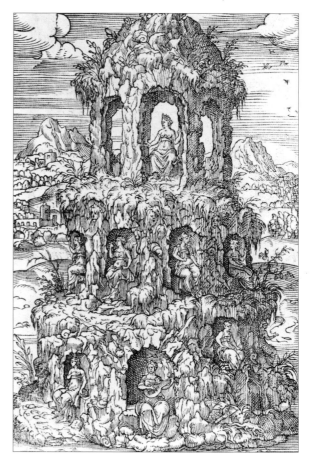

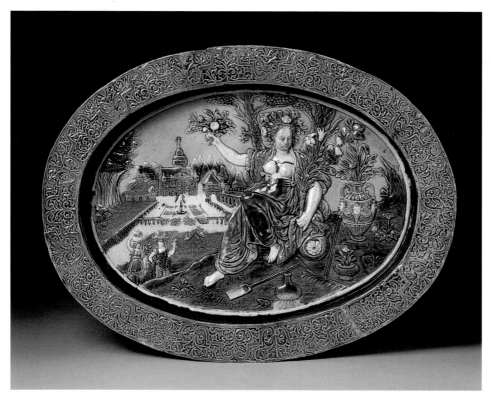

23 (above). Bernard Palissy
was sometimes described as
an 'architect' in the 16th
century. Certainly, he was an
inspired artist and designer as
well as a practical potter and
author, and this wood
engraving shows the kind of
fantasy world into which his
ceramics fitted – a dank world
of sea creatures, mythological
and emblematic figures,
grottoes and caves.

24 (left). The popular, crisply
moulded subject of Pomona
gave an excuse for including
a wonderful array of
cultivated flowers and
gardening implements, set
against the backdrop of a
magnificent 16th-century
French landscaped garden.
Made in about 1600 and
intended for display rather
than use, this dish must be
the work of one of Palissy's
successors.

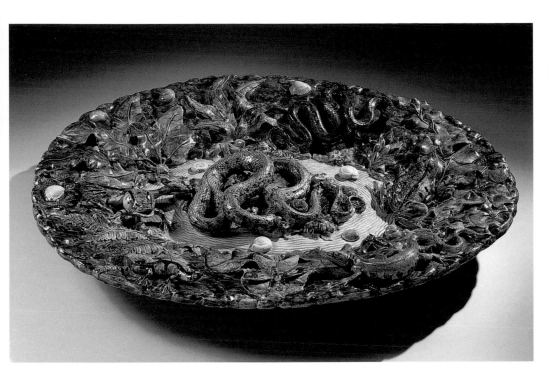

possible maker. The difficult manufacturing process was unravelled and reproduced at the Minton factory by Charles Toft in the 1870s.

25 (left). Palissy's exotic dishes covered with creatures cast from nature were much prized and imitated in France and elsewhere during the 19th century. This example, bought by the Museum from the Paris Exhibition of 1855, was made by Joseph Landais of Tours, brother-in-law of Charles Jean Avisseau who was the first to reproduce Palissy's work in the 1840s.

26 (below). The so-called 'Gondola Cup' was a favourite vehicle for Palissy's inventive humour, and it seems likely that these objects were actually used. Here Bacchus and Ceres, paired for convenience as lovers, are revealed when the contents are poured out. Similar shaped vessels, made at Saintonge after Palissy's death and thought to be incense burners, incorporate the sacred monogram, IHS.

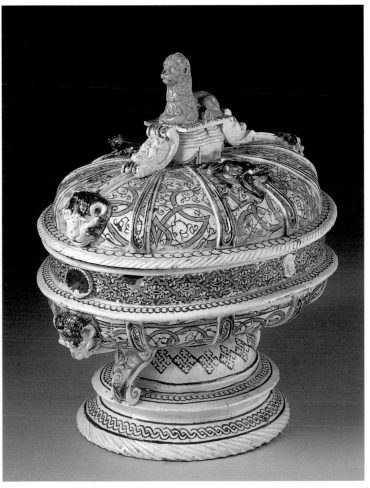

27 (left). When collectors in the 18th and 19th centuries began to find exquisite cream-coloured earthenware objects entirely ornamented with impressed designs filled with brown clay, the local armorials they bore pointed to an obscure potting village, Saint-Porchaire. Recent excavations in Paris, however, point to Palissy as the

CHAPTER TWO

TIN GLAZE

As the first truly white ceramic body capable of imitating Chinese porcelain, tin-glazed earthenware spread from Iraq, where the technique was already well developed in the ninth century, to the extreme North of Europe and acquired a number of different names. The first lustred wares imported into Italy from Spain in Majorcan galleys, acquired the name '*maiolica*'. In a similar way, the first Italian *maiolicas* imported into England and the Netherlands in Venetian galleys became known as 'gally-ware', simplified in England in the seventeenth century to just 'white'; and, after the meteoric rise of Delft as a manufacturing centre at the end of the century, to 'delft-ware' or 'delph'. In France and Germany the origin of much early *maiolica* imported from Faenza was reflected in the words '*faience*' and '*fayence*'.

Buff or even reddish biscuit-fired earthenware coated with glaze to which calcined tin-oxide had been added provided a smooth and opaque white surface eminently suitable for decoration. A limited palette of high-firing (about 1,000 °C), *grand feu* colours – usually cobalt-blue, manganese-purple, copper-green, antimony-yellow and iron-red or brown – dextrously painted onto, and combining with, the unfired powdery glaze resulted in hazy and spontaneous painting of considerable subtlety. As an added and expensive refinement, elaborate enamel overglaze *petit feu* painting (about 750–850 °C), a technique known to potters of the Islamic world, was used first to imitate Chinese *famille verte*, and then, after the mid eighteenth century, Meissen and Sèvres porcelain. Yet no matter how much the glaze and decoration were refined, it was never possible to eliminate the tendency to chip and crack.

It was through the Moorish potters of Southern Spain that the technique of tin-glazing was introduced to Europe. Grandiose lustrewares of Malaga had even reached England by 1303. As potters moved to Murcia and Valencia, a major centre at Manises (fig. 28) was established, which in 1428 exported lustrewares to Philip the Good of Burgundy and armorial services to the noble families of Italy, creating a demand there for fine table-wares that would only be satisfied by the creation of native industries. After the expulsion of the Moors to North Africa in 1610, lustre fell into sharp decline until the nineteenth century, when the technique, if not the spirit, was revived for making reproductions.

To compensate for the fading of a great Moorish craft, tiles with polychrome decoration divided into dry-framed areas (*cuerda seca*) were being made in Seville by the late fifteenth century, to be replaced in the early sixteenth century by relief-moulded tiles which retained the separate colours in hollows (*cuenca*). The opportunity to make painted tile pictures attracted potters from elsewhere, notably one Francisco Nicoluso from Pisa in about 1500 who worked until his death in 1529. Thereafter, waves of Italian and Italo-Flemish immigrant potters spread the art to Seville, Toledo and Talavera, which in 1601 benefited immensely from harsh legislation requiring table silver to be melted – a situation that would be paralleled in France 100 years later. The viscous tin-glaze and bright orange and green of Talavera wares, either with armorials (fig. 29) or the popular hunting scenes after engravings by Johannes Stradanus, epitomised Spanish pottery of the seventeenth century. While Talavera declined, at Alcora in 1727 Count Aranda imported French *faience* painters, and later artists from Moustiers and Marseilles, to establish the factory's diverse range of products, including eventually porcelain and creamware. As elsewhere in Europe, the industry had virtually ceased by about 1800; and the tin-glazed earthenware made to this day in Spain owes little to its fine ancestry.

28 (right). *Lustred Hispano-Moresque* maiolica, *often combined with cobalt-blue painting, was perhaps the most refined ceramic material of the 15th century. This vase form is known, from its appearance in contemporary paintings, to have been used for cut flowers.*

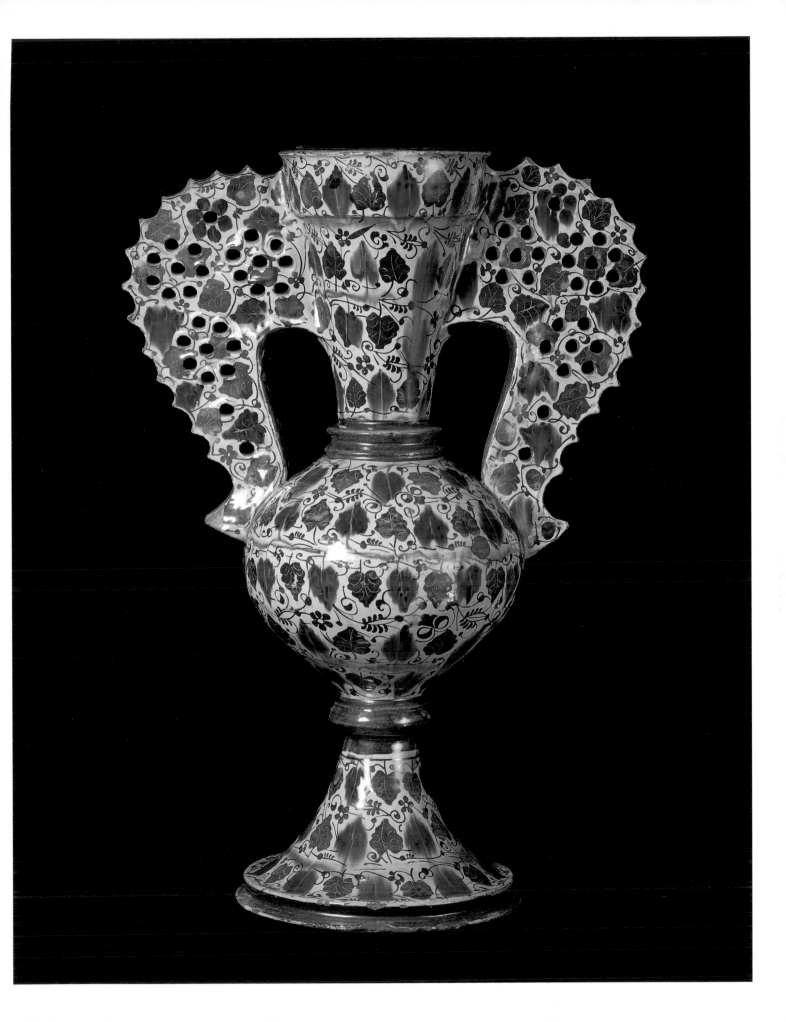

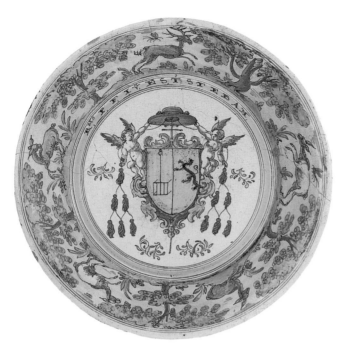

narrative painting or *istoriato* (fig. 31). From unsophisticated beginnings, such as the service made at Faenza for Matthias Corvinus, King of Hungary, in about 1476–90, this pictorial pottery soon became dominant, embracing a wide range of subjects from the Old Testament and classical mythology and attracting artists of considerable talent. Although usable, its primary purpose was for display.

By the early sixteenth century, itinerant artists from Faenza had spread the new fashion which also took root in Cafaggiolo, Urbino, Castel Durante, Pesaro,

29 (left). *After 1601, when aristocratic table silver was compulsorily melted down to pay for Spain's military campaigns, the brightly coloured tin-glazed earthenware made at Talavera was immediately adopted at every social level.*

30 (below). *As the Portuguese were major shippers of Oriental porcelain, it was natural that their native tin-glazed earthenware industry should adopt Chinese styles. They also exported so much to Germany that, until recently, it was thought these jugs with the arms of Hamburg were of local manufacture.*

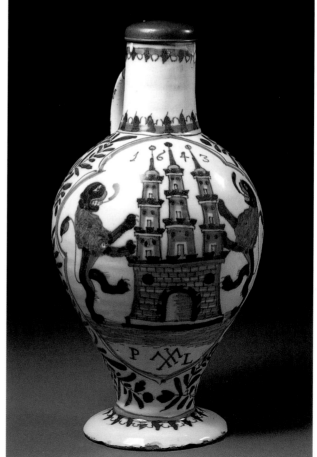

When *maiolica* manufacture began in Portugal in the late sixteenth century, it was the Chinese porcelains carried by Portuguese ships which first provided their models. Blue and white wares were exported, especially to Germany (fig. 30), and – as in Spain, with its similar climate – pictorial polychrome tiles for external cladding became an important product.

Italy is generally considered the birthplace of painted *maiolica*, although it was the import of fine fifteenth-century Spanish armorial lustrewares that had provided the original stimulus to develop the drab functional pots with simple manganese-brown and copper-green decoration. By the mid fifteenth century, thick cobalt-blue decoration was to be found on the prolific 'oak leaf' drug jars of Tuscany. Thereafter, a discerning wealthy clientele enabled several potting centres, notably Faenza, to rise to prominence. The 'Italo-Moresque' style gave way to the crisply scrolling 'Gothic Floral' and, at the end of the century, the full polychrome patterns of palmettes and peacock feathers, together with floral motifs derived from imported Ming porcelain. By the end of the fifteenth century, the letters of Pope Sixtus IV and Lorenzo de Medici refer to *maiolica*, silver and jewellery as equals.

Not content with mere pattern, and inspired by pride in their Roman past and the emergence of books illustrated with popular engravings (Ovid's *Metamorphoses* was published in Venice in 1497), *maiolica* artists developed

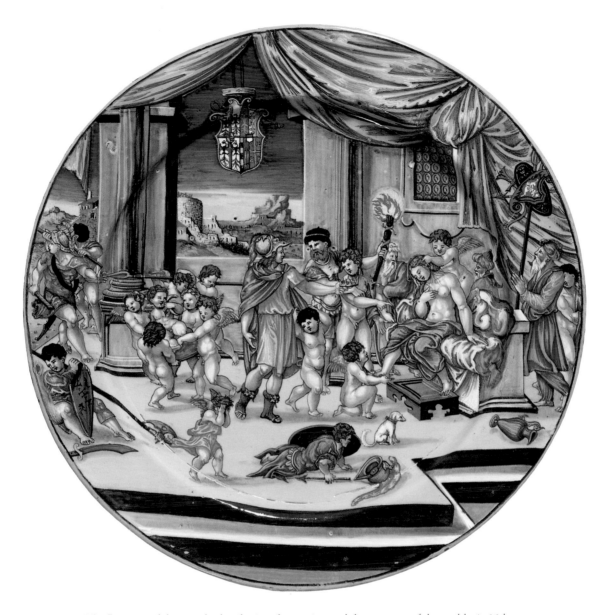

31. *The flowering of the arts, the distribution of engravings and the patronage of the wealthy in 16th-century Italy combined to produce* istoriato maiolica. *Made for display and painted by talented artists, the decoration on these dishes usually also told a story or held a moral.*

Montelupo and Venice in the North. Painted dishes of such quality were often signed, although the significance of the name is not always clear. Whereas connoisseurs of the nineteenth century imagined that Raphael was a part-time *maiolica* painter, in fact the large number of subjects after Raphael derive from the engravings of Marcantonio Raimondi, who propagated Raphael's work even before his death in 1520. A number of names stand out, particularly those at Urbino: the workshop owner Nicola da Urbino, responsible for the 'd'Este-Gonzaga Service' of

about 1519; Fra Xanto Avelli da Rovigo, a freelance artist whose dated dishes range from 1530–42 and whose compositions derived from a number of different sources; and the workshop owners Guido and Francesco Durantino, later styled Fontana, the most prolific makers of *istoriato* in the period of 1530–70, Guido being responsible for the service made for the Duc de Montmorency in about 1535.

Just as *maiolica* imported from Spain had advertised the high status of the material to Italian potters, so the

32. *The lustre technique of Spain, whereby a thin layer of metallic oxide was painted on to a finished pot and fired at low temperature, reached a height of refinement when adopted by Italian* maiolica-*makers at Deruta and Gubbio.*

important trade in Italian armorial *maiolica* made from about 1515 for the wealthy merchants of Augsburg and Nuremberg created a demand there for finely-painted wares. A direct legacy of Spanish pottery was the rediscovery and use of lustre at Deruta (fig. 32) and Gubbio shortly before 1500. The most famous practitioner was Maestro Giorgio Andreoli, whose workshops at Gubbio specialised in adding lustre to wares of other potters (dated pieces range from 1518 to 1541). As the most decorative of all *maiolica*, these lustred polychrome wares were highly prized.

When the fashion for pictorial pottery waned in about 1560, action was taken to halt the expected decline in manufacture. Painted *grottesche* on a white ground copied from Raphael's Vatican Loggias of about 1519 were adopted at Urbino by the Fontana and Patanazzi workshops; and at Faenza there appeared a new style *Compendiario*, with stronger body shapes and minimal painting, culminating in the plain *Bianci di Faenza* of the seventeenth century. Having copied many of its motifs, *maiolica* soon found itself competing directly with Chinese porcelain. It adapted to change in various ways,

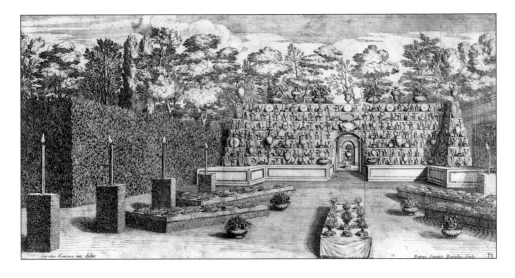

33. *Decorated Italian* maiolica *was usually intended for display, in this case to provide massed tiers of vases and dishes illuminated by candles for a grand garden party held by Cardinal Chigi in 1668.*

either as at Urbino by making elaborate baroque vases intended for display (fig. 33) or slowly degenerating into popular peasant pottery as at Deruta. The striking early seventeenth-century dishes of Montelupo with their ladies and cavaliers (fig. 34) display a determination not to fade into obscurity, and compare well with contemporary German slipwares with similar subjects. Provincial pottery centres, such as Sicily, prospered greatly, making the large quantities of drug jars still needed by Italian pharmacies. In the North, polychrome landscape painting was developed at Venice, while the Laterza potteries in Apulia specialised in magnificent landscape painting in blue. At Castelli, the Grue and Gentile families revived the spirit of *istoriato* in the early eighteenth century. In complete contrast, light and airy fantastical painting in blue, inspired by Transitional Period Chinese porcelain, typified the wares of the Savona (fig. 35) and Albisola potteries in Liguria from the late seventeenth century.

Thus, *maiolica* manufacture survived on different levels until the eighteenth century, when Count Ferniani demonstrated its further possibilities at Faenza by refining his products in order to compete with porcelain, aided by French and German artists. This last great phase of fine *maiolica*, which included factories at Milan, Doccia, Le Nove, Bologna, Savona and Naples, adopted overglaze enamel decoration from the mid eighteenth century, but did not survive the upheavals of the Napoleonic Wars. The nineteenth century saw the production of much derivative and reproduction *istoriato maiolica*, by competent painters such as Achille Farina of Faenza.

France, not yet supplied with the imaginative lead-glazed earthenwares of Bernard Palissy, but well aware of the luxury *maiolica* tablewares made by its neighbour, lost little time in allowing Italian potters to settle. As early as 1512, Italian potters are recorded as working at Lyon, but few examples of their work have been identified. A more promising start was made at Rouen, where the Frenchman Masseot Abaquesne worked from 1526, having perhaps learned the secrets of *maiolica*-making by working with Girolamo della Robbia in Madrid. Tiles for that great patron of the arts, the Duc de Montmorency, at the Chateau d'Écouen in 1542–59, and an order in 1545 for 5,000 drug jars for the apothecary Pierre Dubosc testify to the capability of his pottery, which closed after Abaquesne's death in 1564. Two other potteries in the South also flourished at this time: Antoine Syjalon worked in Nîmes about 1548 until his death in 1590, and in Montpellier a dynasty of *faience*-makers was established by Pierre Esteve in 1570. These early wares are barely distinguishable from contemporary Italian products.

From the South of France, *faience*-manufacture – essentially a provincial art which, depending on large amounts of clay and firewood, did not take root in Paris – went to Nevers, where the potter Julio Gambin from Faenza is recorded as working with the Corrado (or Conrade) brothers from Albissola in 1588, obtaining a 30-year royal privilege in 1603. Although this factory survived for 300 years, it was overshadowed by Rouen, which enjoyed access to Paris and the sea via the River Seine, and where the most important French factory, established with a royal privilege in 1644, was acquired in 1656 by Edme Poterat and his highly successful dynasty. The high status of *faience* was suggested by Louis XIV's order for the 'Trianon de Porcelaine' for his mistress Madame de

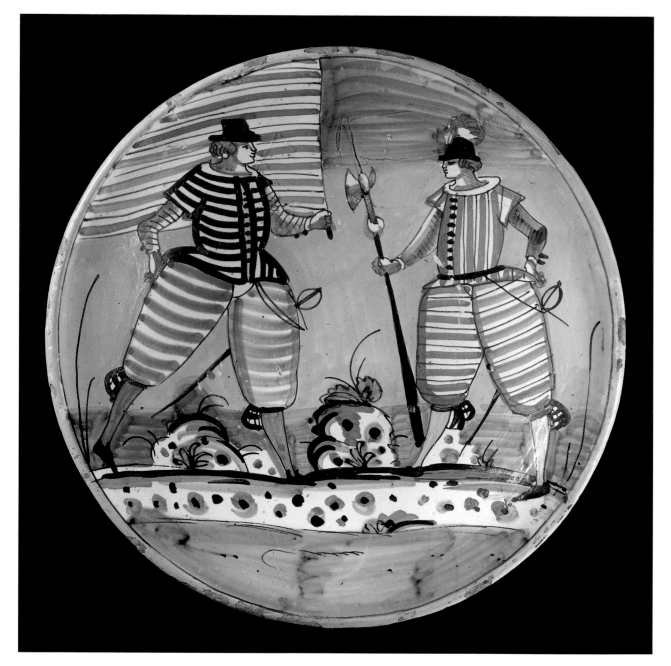

Montespan, and confirmed in 1687 by the announcement of Poterat's death as 'grand maître des faïenceries royalles de Rouen'. The absorption of decoration based on Chinese porcelain in the late seventeenth century ensured further successes, boosted greatly (as in Spain a century earlier) by the melting down of silver plate to pay for the wars of the Grand Alliance and of the Spanish Succession, culminating in a harsh edict of 1709 after which, according to Saint-Simon, 'every table in the land

34. *After the heyday of Italian* maiolica *in the 16th century, manufacture spread and declined, in some cases almost to a peasant craft. Immediate appeal characterised the stylised, exaggerated figure drawing on Montelupo dishes.*

of any importance was laid with *faience* within a week'. The adoption of a strong red colour derived from red ochre to complement the blue, improved white glazes and a new style of radiating formal decoration called *style rayonnant* (fig. 36) in the early eighteenth century suited

35. *Influence from Chinese 'Transitional' porcelain was especially strong in Northern Italy in the late 17th century. The airy effect of such hazy, whimsical painting on Savona dishes was further heightened by piercing.*

the demands of the French nobility perfectly, and the number of factories increased. Elaborate table services included salts, sugar dredgers, ice pails and great dishes which held '18–20 partridges, 12–15 chickens'. Copies of Chinese *famille verte* in the second quarter of the eighteenth century were followed by essays in the rococo and, about 1775, by a last desperate attempt to rival porcelain with the introduction of brilliant overglaze enamelling. By 1786, the Poterat factory (one of 18 factories at Rouen) was employing 1,200 workers and exporting two-thirds of its products to less discriminating markets, such as Canada.

The story of Rouen typifies the rise and fall of *faience* in France and its success in adapting to changing taste.

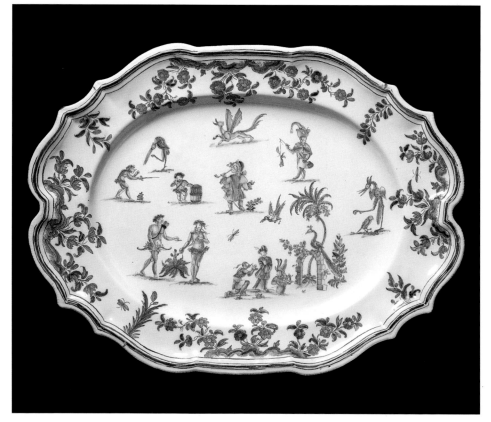

36 (above). *The Rouen faience factory benefited hugely from edicts compelling aristocratic families to melt down their silver plate. Decorated mainly in blue with ornament derived from contemporary engravings rather than Chinese porcelain, the material was fashioned into many shapes normally made in metal, such as pot-pourris for freshening grand rooms.*

37 (left). *Southern French faience was much influenced by Italy. At Moustiers, using the traditional grotesques and fantastic figures derived from engravings of Jean Bérain and Jacques Callot, an informal style of decoration evolved using a very limited palette of colours.*

38 (opposite). *When tin-glazed earthenware spread to Switzerland, it was used for cladding tiled stoves as well as for making local types of vessel, such as this water carrier. As with drug jars, it was easy to incorporate inscriptions in the painted decoration.*

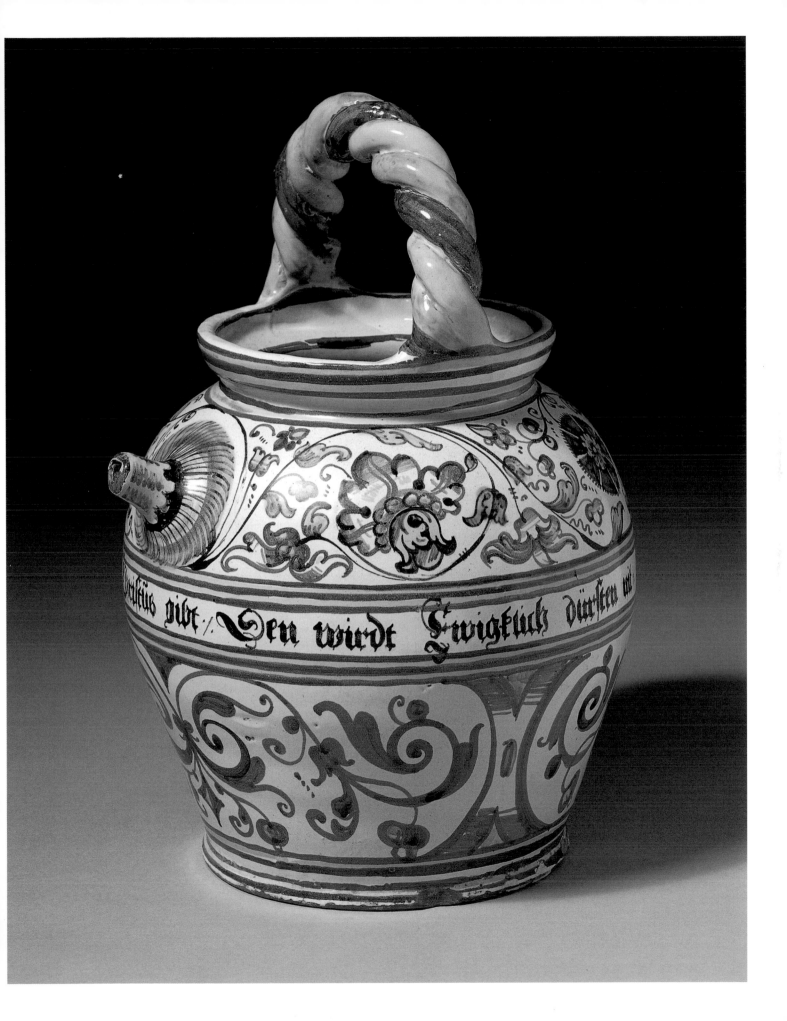

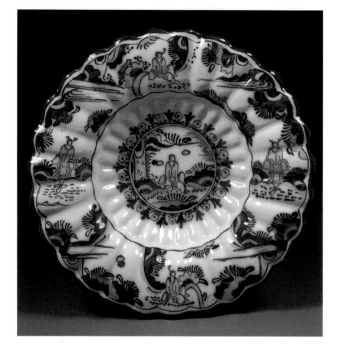

39. *By the end of the 17th century, some types of tin-glazed earthenware had become almost universal. Lobed dishes with Oriental figures on rocks and clouds, deriving from the Chinese 'Transitional' export porcelain, were made in Germany and the Netherlands.*

When Italian influence faded in the late seventeenth century, the next fashion for blue painting of Chinese and Delft types, using engraved sources, soon gave way to a native French style based on designs published by the Court designer, Jean Bérain, in 1711. Painters at Nevers, the earliest French factory, excelled at this phase during the reign of Louis XIV (1661–1715), but fell into artistic decline by the mid eighteenth century, when the 11 factories were producing rustic commemorative *faience patronymique* and eventually revolutionary wares.

Elsewhere, *faience* took different paths. In the 1670s Joseph and Pierre Clérissy (brothers of Italian origin) set up important factories at Marseilles and Moustiers, where initially grandly painted large tablewares were made in the prevailing taste. The delightful wares made by Joseph Olerys (recently returned from Alcora) and his partner J.B. Laugier at Moustiers (fig. 37), the exuberant wares of the Fauchier (Fauquez), and the Veuve Perrin and Gaspard Robert factories at Marseilles provided France, from the second quarter of the eighteenth century, with every possible shape and type of decoration for the table. Belgian influence was introduced at Lille,

where a factory was established by workers from Tournai in 1696, and at Saint-Amand-les-Eaux by the Fauquez family in 1718–93. Factories in the East at Niderviller, Lunéville and Strasbourg provided an entrée for German influence in the mid eighteenth century, in particular the introduction of *petit feu* decoration which enabled French *faience* to compete successfully with the new porcelain of Sèvres and Meissen. The factory at Strasbourg run by three generations of the Hannong family from 1721 represents a last flowering of the art. Here, in 1748, German painters arrived, including the Löwenfinck family from Meissen, bringing with them technical secrets and artistic skills in enamel decoration and gilding. Despite the up-to-date industrial organisation of the factory, which issued a comprehensive catalogue (*Prix Marchand*) in 1771, ironically it was ruined by attempts not to rival porcelain but to create it. Fragile *faience*, as white as porcelain but much cheaper, did come close to being a serious rival at Sceaux near Paris, where the legislation that prevented the factory from making porcelain compelled it to retaliate by enticing painters from Sèvres. The resulting soft earthenware copies of soft-paste porcelain must rank as the final development of the art.

With English creamwares flooding the market after a trade agreement of 1786, the inability of *faience* to adopt a neo-classical idiom, and the availability of cheap Paris porcelain, *faience* manufacture hardly outlived the eighteenth century. Some factories, with ambitions to survive rather than to compete with porcelain, changed over to making creamware or *faience fine* without major upheaval. Those that continued making *grand feu faience* into the nineteenth and twentieth centuries, such as at Quimper in Normandy, relied on making homely knick-knacks or reproductions in the eighteenth-century style. As for tablewares, to this day, the decorative charms of moulded rococo forms and bright hand-painted decoration still weigh heavily against the inherent fragility of the material.

Germany, well supplied with stoneware drinking vessels but lacking refined tablewares, was an early importer of tin-glazed earthenware. At Nuremberg, where mercantile families had imported Italian *maiolica* from the sixteenth century, locally made stove tiles were painted by Bartholomaus Dill, a pupil of Dürer, and, by the 1530s, *maiolica* drug jars and dishes were being made, together with a local speciality, owl-jugs. By the late sixteenth century, tin-glaze had been adopted by stove-makers at

Winterthur (fig. 38) in Switzerland. However, it was only after the mid seventeenth century that the industry detached itself from stove manufacture and expanded. Factories set up by Dutch refugees at Hanau in 1661 and by the Frenchman Jean Simonet at Frankfurt (fig. 39) in 1666 made wares in the Dutch style, particularly Simonet's factory which enjoyed a smart clientele through its subsequent owner J.C. Fehr. Scattered flower and bird decoration (*Vogelsdekor*) was much used on everyday wares during this period. In Berlin, factories were set up by G. Wolbeer in 1678 and by the Dutchman C. Funcke; and a factory was started at Kassel in 1680. Some of the pottery made by these factories was selected by *Hausmaler* of Nuremberg and Augsburg as a base for their wonderfully accomplished enamel decoration. Johann Schaper (fig. 40) stood out above the others, who included J.L. Faber and W. Rössler.

In order to supply the new demand for tea and coffee wares and decorated beer mugs, a clutch of new factories sprang up: in Franconia, at Nuremberg in 1712, Ansbach in 1708–10 and Bayreuth in 1714; in Thuringia, at Rudolstadt and Abstbessingen; and in Hesse, at Fulda (fig. 41) in 1741 and Höchst in 1746. The success of many of these major factories was attributable to their close links with porcelain manufacture (Höchst, Ludwigsburg and Fulda made both materials), and especially to the defection of A.F. von Löwenfinck from Meissen in 1736 and his subsequent introduction of enamelled 'India Flowers' at many factories. J.P. Dannhöfer, having worked at the du Pacquier factory in Vienna, provided high-quality landscape painting, and later Nilson engravings in the rococo manner were copied. At the end of the century, the rise of the Thuringian porcelain factories and the upheavals of the period rendered German *fayence* more or less obsolete.

In the eighteenth century, tin-glaze eventually reached Hungary, Slovakia and even Poland. However, it was in Denmark and its dependency Schleswig-Holstein, and in Sweden that the new material was found ideal for general use and where a homogenous Scandinavian style and range of forms (notably *faience* table-tops) evolved. Johann Wolff of Nuremberg, having established a pottery at Copenhagen in 1721, moved to Rörstrand near Stockholm, where his factory later flourished, employing as many as 17 painters by 1754. Both Rörstrand and its rival factory at Marieberg used enamelling and transfer-printing, and both turned to creamware in the 1770s. The Copenhagen factory, with a protective privilege which

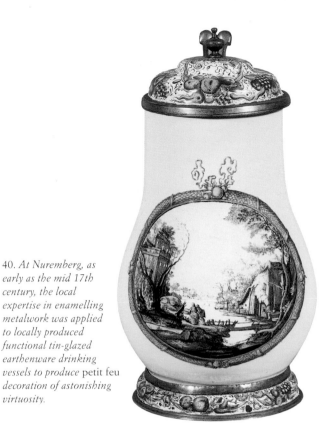

40. *At Nuremberg, as early as the mid 17th century, the local expertise in enamelling metalwork was applied to locally produced functional tin-glazed earthenware drinking vessels to produce* petit feu *decoration of astonishing virtuosity.*

forbade imports, made mainly blue-painted wares along with other smaller potteries. More ambitious wares were produced at Schleswig-Holstein in the second half of the century, while at the factory in Kiel, founded in 1763, noble patronage ensured a sophisticated output which rivalled Strasbourg. Norway, then forming part of Denmark, also had a factory at Herrebøc in 1758–78.

Antwerp, having achieved ascendancy over Bruges at the end of the fifteenth century, became a major mercantile and manufacturing centre. Not unnaturally, emigrant Italian makers of crystal glass and *maiolica* were attracted to the commercial possibilities of a country still dependent on these imported luxury goods, and in 1512 a pottery was established there by Guido Andriesz. Antwerp *maiolica* (mainly tiles and pharmaceutical pots) did not achieve great distinction, but members of the Andriesz family left to set up potteries in Middleburgh (Netherlands) in 1564 and in Norwich (England) in 1567. With the disruption to Antwerp during the Spanish Wars, further potteries were established in the Netherlands at Haarlem in 1573, Delft in 1584, Dordrecht in 1586 and Rotterdam in 1612.

The major event for Dutch ceramics of the seventeenth century was the capture of the Portuguese galleys *San*

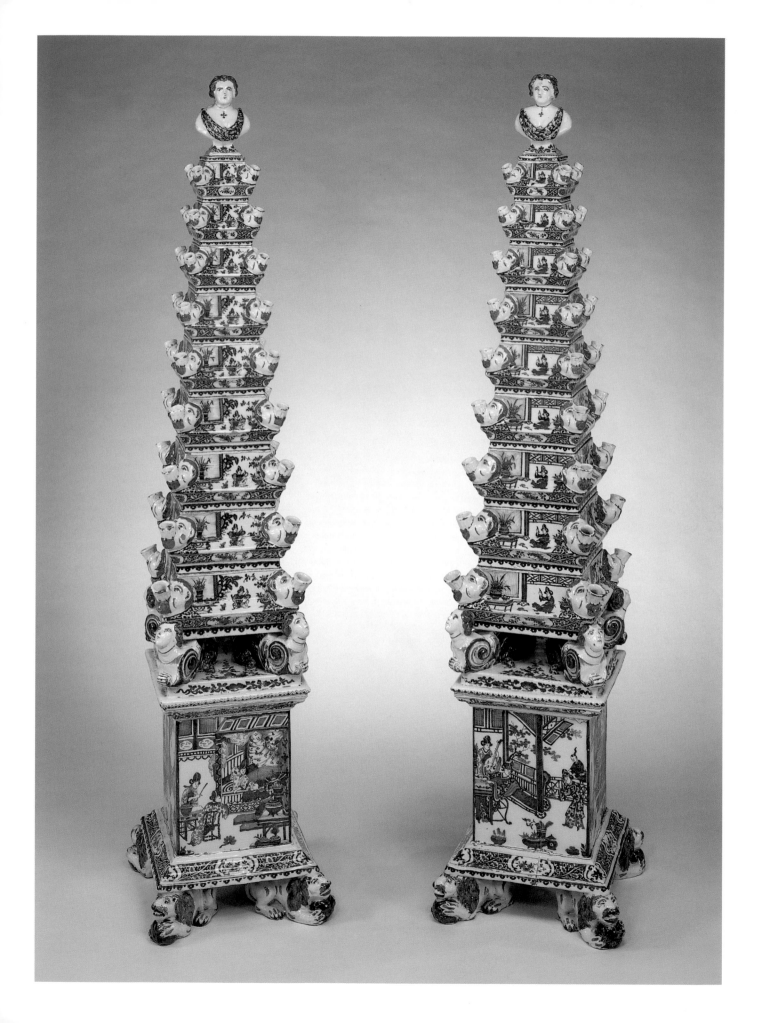

Iago in 1602 and *Santa Caterina* in 1604, bringing to Holland the first consignments of Chinese porcelain. Henceforth, the trade was controlled by the new Dutch East India Company (VOC) centred on Batavia and Delft. Between 1602 and 1657, three million pieces were imported. However, the death of the Emperor Wan-Li in 1619 caused a hiatus in the supply which gave the Delft potteries the chance to make acceptable substitutes and later to copy the Transitional Style. Former breweries were adapted, keeping their old names (such as The Golden Flowerpot, The Porcelain Bottle, The Three Bells and The Metal Pot) and eventually semi-mass-production techniques were adopted for repeat patterns, using pricked paper designs, the glossy surface imitating Chinese porcelain through a final dusting of clear glaze (*kwaart*). In the second half of the century talented artists, such as F. van Frytom and Rochus Hopprstyn, were attracted to potteries, but standard production wares of the highest quality made Delft famous. The Greek A factory (fig. 42) under Samuel van Eenhoorn and later Adrianus Koeks excelled at elaborate wares painted in Kangsi style, using designs by the Dutch Court architect Daniel Marot. *Famille verte* was faithfully reproduced and large garnitures or *Kast-stel* sets for cupboard tops were notable products. The golden period lasted 50 years from about 1670, assisted (as at Rouen) by the introduction of the dark-red pigment after about 1700. Increasingly, novelty wares (such as polychrome enamelled dressing table sets, violins and birdcages) were made until the industry's final creative demise at the end of the eighteenth century.

Besides the fine table and decorative wares of Delft, tiles and tile pictures for walls and fireplaces continued to be made in vast quantities at the potteries in Rotterdam, Gouda and Haarlem, and later at Harlingen and Makkum in Friesland, largely for export to France, Germany and Britain. Continued production in the nineteenth century relied on the reproduction of earlier wares and their marks, and on repetitive pastiche; many later products are merely blue-painted white earthenware.

The delftware potteries of Britain enjoyed a long and prosperous life without ever achieving the glories of Italy, Holland or France. Early imports of Antwerp *maiolica* did little to encourage respect for tin-glaze, and it was to make tiles and drug pots that Jaspar Andries (Andriesz) and Jacob Jansen came to Norwich in 1567. Jansen's petition to Queen Elizabeth in 1570 to make tin-glaze at Aldgate 'after the manna of Turkye Italye Spayne and Netherland with purtraict and colours' was optimistic; and it was only when the Dutchman Christian Wilhelm settled at Pickleherring Quay in Southwark about 1618 that steady production was forthcoming. The 1613 patent of Hugh Cressey and Edmund Bradshawe did not prevent Wilhelm from obtaining a 21-year monopoly in 1628. From this point, polychrome mugs, jugs and especially grand chargers whose decoration combined elements of Italy, China and the Netherlands (figs 43 and 44) were produced for a local city market, as well as common white wares and, for the first time in England, plates for the dining table (many were exported to the New World). No royal or noble patronage was ever forthcoming, and although much silver was melted down during the Civil War, delftware was never adopted by the

41. (right) *In order to emulate porcelain and to take advantage of itinerant porcelain painters, such as the former Meissen decorator C.H. von Löwenfinck, German fayence factories greatly refined their wares and succeeded in making their tin glaze whiter even than contemporary porcelain.*

42. (opposite) *The influence of Holland and the Dutch love of tulips were strongly felt in late 17th century England under William and Mary. Pairs of pyramids for flowers or tulips, many of them made by the Delft Greek A factory, adorned Hampton Court as well as many great houses.*

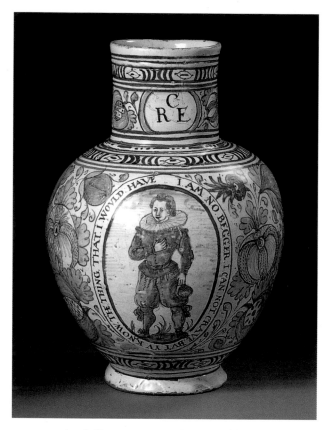

the availability of cheap basic Chinese porcelain and the invention of fine Staffordshire stoneware tablewares in the 1720s and of creamware in the 1760s effectively prevented the sort of development that took place in Spain, France and Germany, where, visually at least, the material was a serious rival to porcelain. Some attempts to raise its status were made and armorial services are not unknown. In Liverpool in the mid eighteenth century overglaze enamelling was practised, and in London and Bristol lacey patterns in the white *bianca-sopra-bianca* technique were introduced by Magnus Lundberg from Rörstrand. Coal-firing was attempted in Dublin, and transfer-printing was highly developed in Liverpool, almost exclusively for the flat tiles for which it was so well suited. With the notable exception of Joseph Flower and John Bowen at Bristol, almost all delftware artists remain anonymous, and none are known to have painted on porcelain. Yet the painting of *chinoiseries*, often inspired by decorator's pattern books such as *The Ladies Amusement*, was superb, especially in Bristol; and the hazy 'Fazackerley' palette used in Liverpool was an artistic success. When Staffordshire products caused the final collapse of the industry about 1780, very few potteries were in a position to turn to creamware. They closed and the art of some of their painters is evident in delftware's natural heir – the blue-painted pearlwares of Staffordshire, Yorkshire and elsewhere.

gentry and nobility as it was in Spain and later in France. Thus, throughout the seventeenth century, the potteries at Southwark, and later at Lambeth, survived by making basic tablewares and storage vessels, notably the inscribed drug jars (fig. 45) for which delftware was ideal. After the Restoration of 1660, the number of potteries increased and potters moved to Brislington and, in 1683, to Bristol. The quality of painting improved considerably after the adoption of the Chinese Transitional Style of scattered clouds, rocks and groups of almost abstract figures, and the range of shapes was considerable. Too soft for successful tewares, delftware tended to be classed with pewter as expendable tableware and, with a high manufacturing wastage rate, relied on mass-production to become profitable.

The eighteenth century saw delftware potteries spread to Liverpool, Glasgow, Dublin (fig. 46) and Belfast, ports with access to raw materials and export potential. Tiles formed a significant part of the output, important enough that Nathaniel Oade of the Gravel Lane Pottery in Southwark should hire a Dutchman in the early eighteenth century to paint them. The New World and expanding British Empire provided ready markets, but

43 (opposite above). *After starting with basic drug jars and tiles, the early 17th-century Southwark delftware potters soon developed attractive polychrome painting which contained elements of Dutch and Italian styles.*

44 (opposite below). *Despite the melting down of huge quantities of silver and gold plate during the English Civil War (and its die-stamping as temporary coinage), the use of delftware was never accepted at a high level of society. The original owners of some of these grand chargers are known to have been tradesmen in the City of London.*

45 (right). *Tin-glazed earthenware drug jars, which could so easily be 'labelled' in cobalt-blue and simply decorated to make a fine massed display for the shelves of the pharmacy, were so practical that they continued to be made in London until the early 19th century.*

46 (below right). *In the 18th century, the best painting on delftware was to be found at Bristol, Liverpool and especially Dublin. The subtlety of hazy manganese-purple painting on the soft white ground recalls British watercolour painting.*

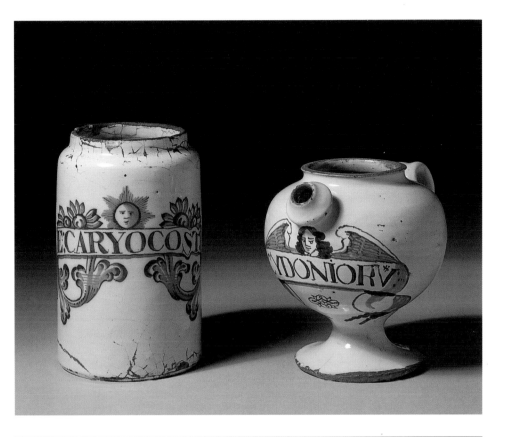

Piccolpasso

A potter's methods and secret formulae were normally handed from father to son, or from Master to apprentice. Studies of particular trades by scholars with enquiring minds are rarities, and we are much indebted to John Dwight in the late seventeenth century for his notebooks on salt-glazing, and later to Josiah Wedgwood for his writings on traditional Staffordshire potting techniques. However, for Renaissance *maiolica*, we are fortunate to have an exhaustive analysis of the whole craft and artistry of tin-glazed earthenware. Cipriano Piccolpasso (1523/4–79) was born in Castel Durante and, while pursuing a career either working for the Church or holding public office, dabbled in engineering, building and, especially, the art of fortification. A talented artist and illustrator, he wrote his manuscript treatise on the potteries of his native Castel Durante in homage to Cardinal de Tournon, some time in the middle of his career. In an age when trades and professions were championed and espoused by scholars, poets and members of the ruling classes, Piccolpasso's research was not so remarkable, but undoubtedly he was motivated partly by pride in his native town which was one of the most important *maiolica* centres of the sixteenth century. For the modern reader, his descriptions and on-the-spot sketches provide a fascinating insight into the practices of Renaissance pottery workshops. A passionate child of his Age, Piccolpasso was disgraced by a street-fight and expelled from Perugia, after which he returned to Castel Durante for minor public office and a knighthood during his final years.

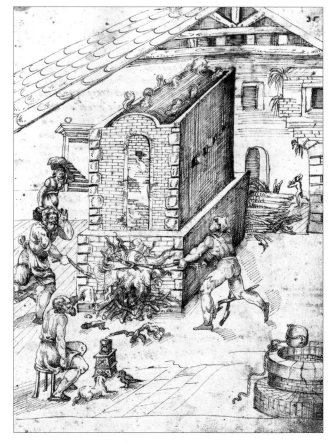

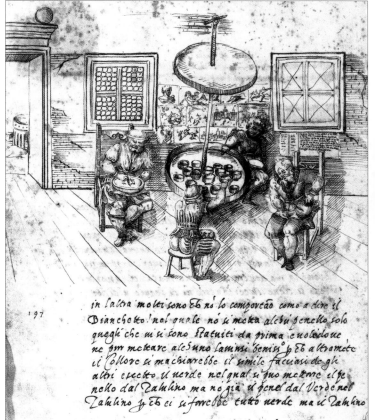

47. The kiln shown is of the simple up-draught wood-fired type, such as were used by the delftware potters of England in the 17th – 18th centuries. Temperature control relied on the personal skill of the kiln-men, and it is likely that painted *maiolica* was fired with very great care.

48. Pottery painting demanded natural light, space and, as here, pattern drawings or engravings pinned on the wall to copy. For a globular object, working on the knee and angling it towards the light was found to be the best method, particularly as the surface with its unfired pigments painted onto unfired glaze was extremely fragile. Painters were considered the élite of these workshops and probably outnumbered other pottery workers by two to one, as in England in the 18th century.

49 (below). Long and mistakenly thought to represent Raphael himself, this plate nonetheless shows the high status of the best *maiolica* painters in the 16th century. In the Renaissance spirit, the socially superior couple observe with interest the method of work and the progress of a plate that perhaps they have commissioned.

50 (right). Moulds were much used for *maiolica* from the Renaissance onwards, and, surprisingly, Piccolpasso states that these were of plaster. However, it is clear from the text that these moulds, sometimes in several parts, were used for pressing, not slip-casting. Thin slabs of clay were cut from a ball of prepared clay, not rolled like pastry. Hollow wares such as tureens and forms imitating embossed metalwork could easily be made.

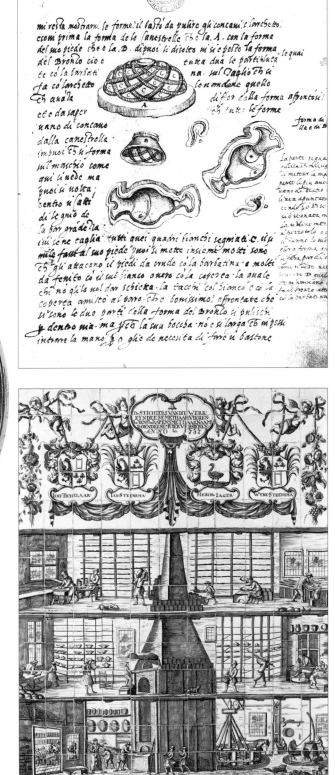

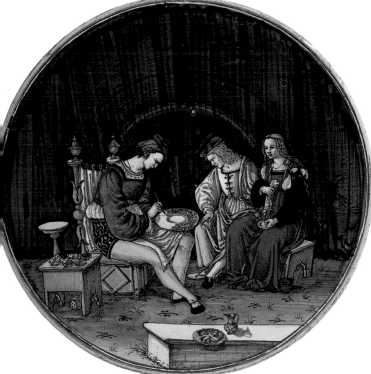

51 (right). Even in the 18th century, many of the same techniques were used. Mass-production of tin-glaze in Holland was made possible by well-organised specialist potteries such as this, where all the heat of the kiln and its chimney was put to good use. On the ground floor, painters worked and materials were ground or mixed with the help of mules; on the floor above, throwers made and dried a range of vessels; and, on the top floor, tiles were made in wooden frames and dried on their edge – as they would later be fired. The kiln was loaded through the high arch.

Tiles

It is to the early medieval church builders that Europe owes the introduction of the lead-glazed earthenware tile. At first, decoration was confined to the use of a stylised stamped ornament filled with contrasting white pipe-clay, but soon larger patterns or simple pictures, formed from many tiles, became usual, particularly for large monastic or cathedral floors. By the sixteenth century, painted tin-glazed tiles – highly decorative, but less durable – from Italy, Spain and the Netherlands were available for domestic use. In England copies were made by immigrant Dutch delftware potters, but the technically difficult manufacture of thin wall tiles was only introduced at the end of the seventeenth century.

Painted polychrome tiles continued to flourish as architectural embellishment in the hot climate of Southern Europe. In the North, this was restricted to moulded brick and, in the nineteenth century, moulded terracotta cladding. For internal use, lead-glazed tiles proved ideal for making the stoves popular in the German-speaking countries. In England,

the demise of delftware manufacture in the late eighteenth century also marked the end of tile-making, until the Church revival of the 1830s encouraged the reproduction of brown and white medieval tiles. This was followed quickly by the efficient mass-production of almost indestructible multi-coloured encaustic tiles and the widespread use of floor and wall tiles in new houses, schools, hospitals and public buildings. Such tiles became a vehicle for the designs of Pugin and, later, Dresser. Transfer-printing and *majolica* coloured glazes were successfully adapted to tile manufacture. Later, the imitation of Turkish Iznik patterns was perfected by William de Morgan, and sinuous art nouveau floral designs were successfully produced by the tube-lining technique. The plain tiles with simple printed designs favoured from the 1920s have recently given way to more adventurous types. Today, tin-glazed tiles are still made in Holland, while vast quantities of tiles for new conservatories and house restoration are mostly supplied by Italian and Spanish factories.

53. (left) Open fires for large medieval castles and country houses in Northern Europe were primitive, dirty and inefficient. With great ingenuity, deep, hollow lead-glazed tiles were used to build clean, closed stoves which were mounted against a wall, behind which were the stoke-hole and the chimney. Moulded designs, often moralistic and sometimes narrative, were made in great variety. Apart from rare use in the palaces of Tudor England, these stoves were used almost exclusively around the cold German-speaking countries of the North; in Switzerland, highly decorative stoves were built with painted tin-glazed earthenware tiles.

52 (above). Monastic potters also made tiles, the conventional patterns of which were usually reproduced by stamping with carved wooden blocks and filling the depressions with white pipe clay. At Tring, however, an exceptionally gifted monk produced a series of amusing 'strip cartoon' tiles, drawing and gouging the design through a layer of slip into the unfired clay with an unerring eye. These unique tiles reveal, on a large scale, a talent for drawing which would normally have been applied to manuscript illumination.

Membland Hall, the grand country house newly refurbished and enlarged for Lord Revelstoke.

54 (above). In Holland, the great popularity and mass-production of wall tiles led to the development of tile pictures. Although often painted in polychrome and highly decorative, effective use was made of simple cobalt-blue drawing to depict topography or scenes associated with fishing and whaling.

56 (left). The influence of Islamic art, with its intricate floral patterns, is clearly discernible in the applied arts of Europe during the second half of the 19th century. The collaboration of two great names – the designer-entrepreneur William Morris and the artist-author-potter William de Morgan – created a set of sumptuous tile panels for the bathroom of

55 (above). Semi-automated tile manufacture enabled vast quantities to be made. This hand-operated press, of the type patented by Prosser in 1840 and then used by Mintons, could produce 150 tiles per hour, and could be used either for 'dust pressing' with dry powdered clay (for which a pressure of 30 tons was needed), or for damp clay. Eventually, the press was adapted to make heavy inlaid 'encaustic' floor tiles.

57 (below). Tin-glazed earthenware was quickly revived whenever painting on tiles was required. After the Omega Workshop closed in 1919, one of its chief painters, Duncan Grant, continued to decorate pottery, here with an almost abstract portrait of the aesthete Lytton Strachey.

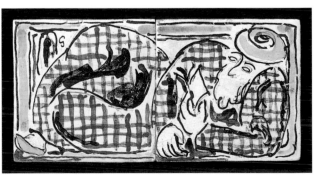

THE INVENTION OF PORCELAIN

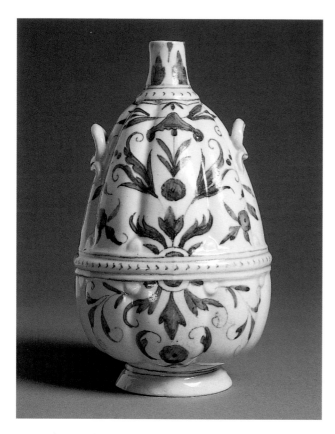

58. *'Medici Porcelain', composed of white Vicenza clay and ground glass, was the first European soft-paste. Cruets and vases have survived whereas most of the plates have perished.*

In Europe, as late as the sixteenth century, even the poor export-quality Chinese hard-paste porcelain was regarded with reverence, so much so that better pieces were sometimes richly mounted in precious metal. Before the age of chemical analysis, its secret was safe and the link with China via Persia merely stimulated the *maiolica alla porcellana* copies made in Italy. Yet to one obsessive Renaissance prince the challenge to make the magical substance proved irresistible. In about 1575 Grand Duke

Francesco I de'Medici hired a potter from the Levant and instructed his workshop manager Buontalenti to produce porcelain. The resulting 'Medici Porcelain' (fig. 58), a frit-ware made from white Vicenza clay and ground glass, combined a beautiful soft-paste body with hazy painting and eggshell glaze; but it did not outlive its patron, who died in 1587. The next serious attempt was by John Dwight in Fulham, whose 1672 patent for 'transparent Earthen ware... by the names of Porcelane or China' achieved red stoneware of Yixing type and a glassy porcelain paste which proved unable to withstand the firing. In 1673 Louis Poterat at Rouen obtained a licence and began experimenting in secret to produce a glassy soft-paste, similar to that made later at Saint-Cloud in 1710–20 under the patronage of the Duke of Orleans. These successful porcelain substitutes possessed a soft white surface which was more sympathetic than the cold greyness of true hard-paste, and which proved ideal for enamel decoration.

Whereas the Jingdezhen potteries in China improved their kiln technology over several centuries to the point at which it was discovered that their local materials (china-clay and china-stone) would produce a new material known as porcelain, in Europe these vital clays were not only difficult to identify, but also widely scattered. Against the odds, the secret was unravelled in 1708, but only as an accidental by-product of other research. Johann Friedrich Böttger, a brilliant young chemist, was studying medicine at Wittenberg University when he was engaged by the Elector of Saxony, Augustus the Strong, to make gold from base materials. Failing in this, he worked with the physicist Count von Tschirnhaus on another fruitless task, namely to make hardstones by fusing mineral compounds, during the course of which he

59 (opposite). *Böttger's early porcelain combined Oriental decoration with many original forms. Like imported wares from Dehua* (blanc-de-chine), *the fine material could be left plain.*

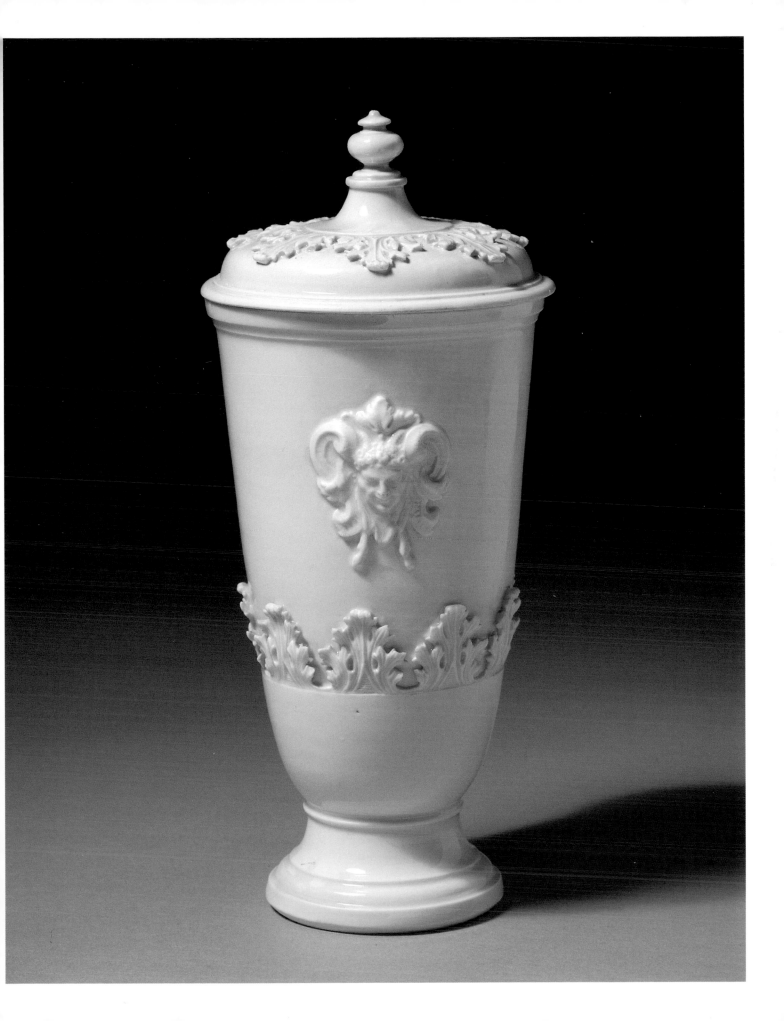

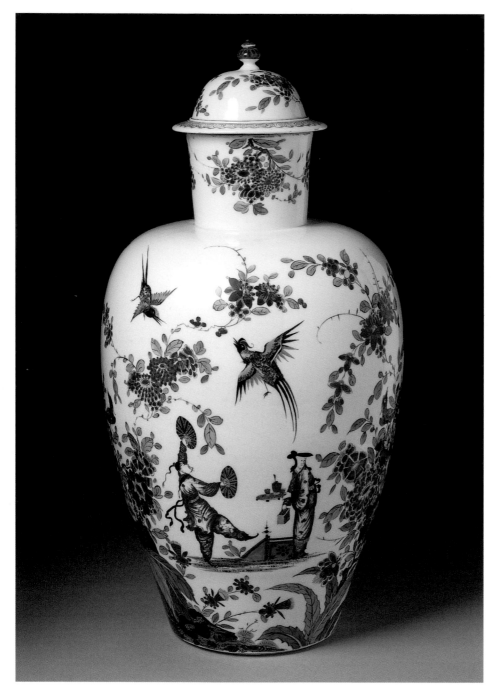

60. *Augustus the Strong remained by far the biggest customer of his own factory at Meissen. Pieces made for his many palaces were marked AR.*

discovered instead the hard red stoneware of Yixing type (pp. 68–69). This flinty material, like the locally made glass, could be cut and polished on the wheel, and glazed black to resemble Oriental lacquer. Simply by substituting the white clay of Saxony for the iron-rich red, he made the hard-paste porcelain that led to the Meissen factory being established in 1710 (fig. 59).

The entire spread and artistic development of hard-paste porcelain throughout Europe can be attributed to this discovery and to the house-style created under Böttger before his death in 1719. With generous royal patronage (fig. 60), abundant clay and cobalt, trained modellers and artists, and the expertise of the Augsburg enamellers, the Meissen factory flourished, eventually

61. *The* deutsche Blumen *style of flower-painting at Meissen was based on botanical illustrations, as opposed to the earlier fanciful Oriental styles.*

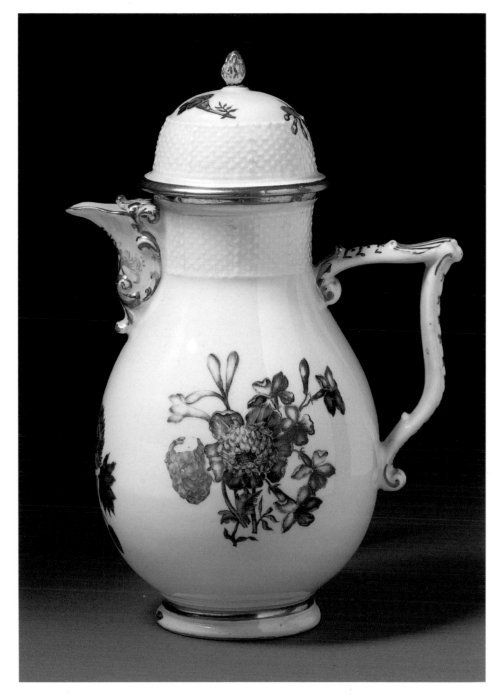

exporting widely and providing the Paris *marchands merciers* with luxury goods to mount in *ormolu* or fit into travelling boxes for the aristocracy. Böttger's creamy white porcelain became greyer under his successor J.G. Höroldt, who introduced many new enamel colours and the fantastic minutely detailed *chinoiseries*, harbour scenes, 'India Flowers', the naturalistic 'German Flowers'

(fig. 61), and the underglaze cobalt-blue (fig. 62) that characterise early Meissen. By 1731, 40 painters were employed, so it was inevitable that the skill and artistic repertoire would disperse. One of the most talented painters, A.F. von Löwenfinck, left in 1736 to pass the enamelling secrets to a number of German *faience* factories whose refined products could then rival porcelain.

The Meissen porcelain body also proved to be excellent for modelling, the first notable modeller being Gottlieb Kirchner, employed to model the life-size animal figures for the Japanese Palace. In 1731, the arrival of J.J. Kaendler added a huge range of baroque *kleinplastik* porcelain sculpture, with sets of grotesque and fanciful figures and characters from the *Commedia dell'Arte* modelled as centrepiece themes for the wealthy dining tables of Europe. Some measure of their popularity was conveyed by Horace Walpole in 1753: 'Jellies, biscuits, sugar-plums and creams have long given way to harlequins, Turks, Chinese, and shepherdesses of Saxon china… .' Copies were made, notably at Chelsea.

The Meissen factory entirely lost its ascendancy after the Seven Years War of 1756–63. Such successes as the 2,200-piece 'Swan Service' made for Count Brühl in 1738 were never to be repeated; hard-paste was being made

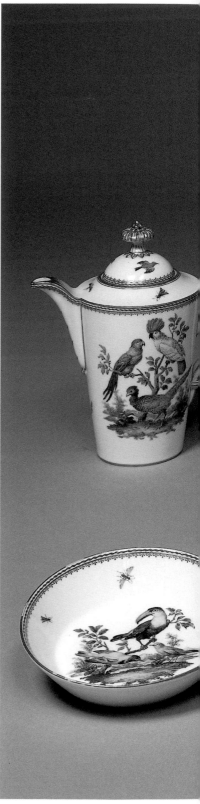

63 (right). *The Meissen factory never fully recovered from the Seven Years War, and later attempts to adopt the neo-classical style were hampered both by the fame of its earlier products and by greatly increased competition from new factories.*

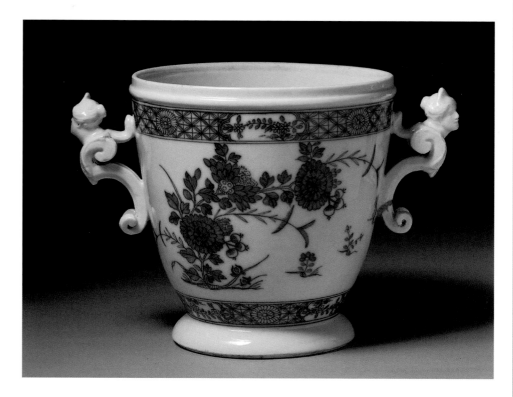

throughout Germany, and in France the new Sèvres factory of Louis XV had taken over the market in rich luxury porcelain. Nevertheless, it revived to some extent and adopted first the rococo style and then, at the end of the century, the neo-classical forms (fig. 63) and biscuit porcelain groups for which the grey paste proved particularly suitable.

62 (above). *After the economical Chinese technique of underglaze cobalt-blue decoration was re-invented at Meissen, the hitherto exclusive European porcelain gradually became available to a wider market.*

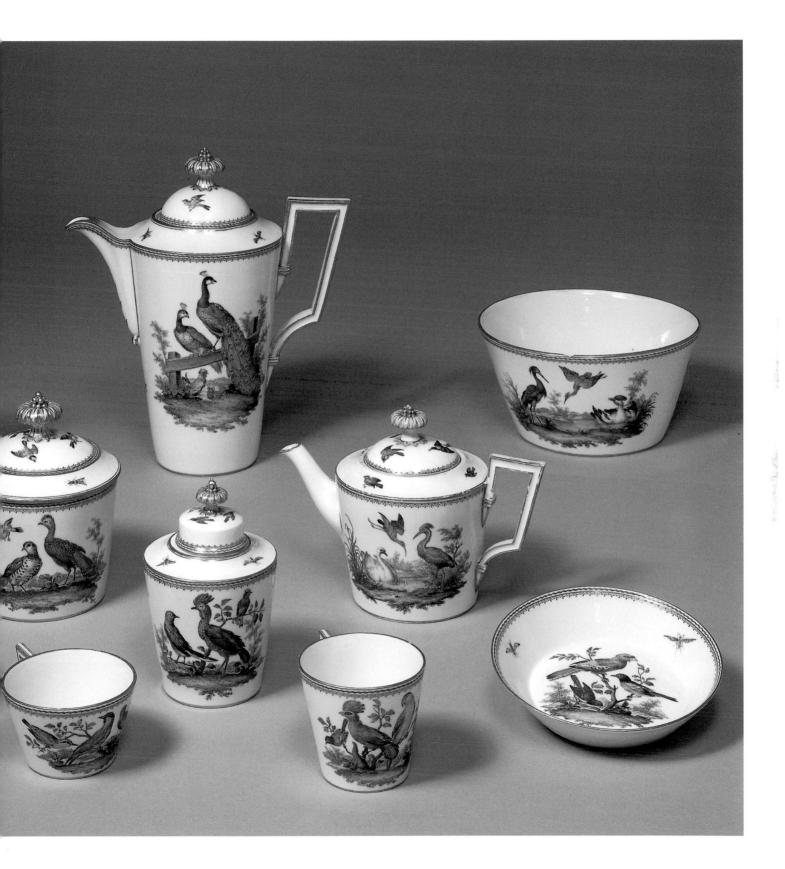

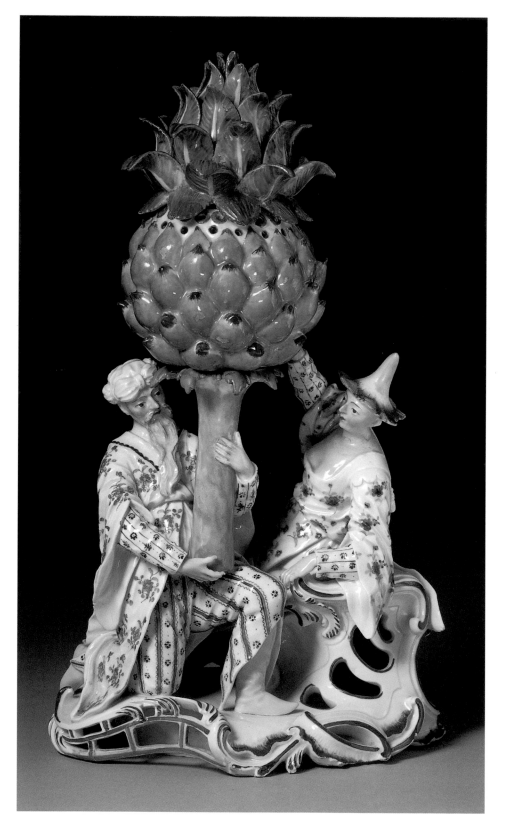

64. *The quality of small-scale sculpture produced by the German porcelain factories depended wholly on the talent of factory modellers. The figures of J.F. Lück at Frankenthal were particularly imaginative.*

It was from Meissen that the secret of hard-paste porcelain was spread throughout Germany. In 1719, the secret was transferred by a Meissen gilder, C.C. Hunger, to Vienna, where it was immediately exploited by an enterprising courtier called du Paquier. Porcelain of excellent quality, with decoration in the formal style derived from ornamental engravings such as those of Bérain, were not enough to ensure financial success, so that in 1744 the factory was taken over by the Empress Theresia to become a symbol of Austrian prestige.

Other porcelain factories were established by a potter, J.J. Ringler, who stole the secrets and defected from Vienna in 1750, to become the first successful 'arcanist' to travel around Europe and set up factories wherever he could find patrons: first to Höchst in 1750, then Strasbourg in 1753, and finally to Frankenthal (fig. 64) in 1755. Princely factories were also set up at Nymphenburg and Ludwigsburg, using identical Viennese kilns and clay from Passau. In the 1750s, two of Ringler's assistants left Höchst to make porcelain at Fürstenberg and Berlin (fig. 65). Without the benefit of skilled painters such as von Löwenfinck, these new establishments concentrated on high-quality tablewares and particularly on figures, for which they employed the notable modellers S. Feilner at Fürstenberg and J.P. Melchior at Höchst. At Nymphenburg from 1754 the brilliant professional sculptor Franz Anton Bustelli was employed (fig. 84).

As in France, the secret of hard-paste manufacture became known in the second half of the eighteenth century. Independent of Ringler's arcanist activities, the first of many factories in Thuringia – a traditional potting area well-supplied with clay and fuel – were established at Volkstedt, Kloster-Veilsdorf, Wallendorf and Limbach, making useful wares and figures influenced by Meissen. More independent still were the establishments in Switzerland, in Zürich in 1763 and Nyon in 1780, which concentrated on tablewares.

As the art of making *faience* had spread to Northern Europe from Spain and Italy, so the secret of porcelain spread south from Germany to Italy. After taking the Meissen secret to Vienna, the defecting Meissen gilder C.C. Hunger set up a factory in Venice with Francesco Vezzi (fig. 66) in 1720. When Hunger left after seven years, the supplies of imported Saxon clay dried up. A later Venetian establishment by Geminiano Cozzi thrived in 1764–1812, making distinctive tablewares. Also in Northern Italy, the enterprising Antonibon family's *faience* factory at Le Nove near Bassano made porcelain

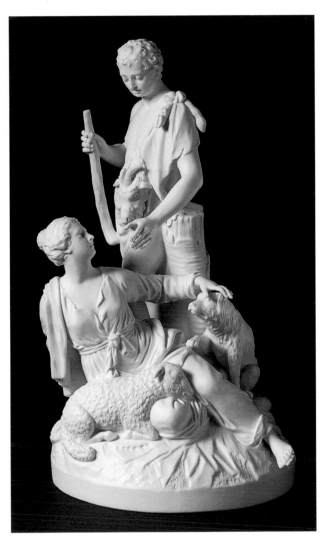

65. *In the neo-classical period, the hard-paste porcelain formula was adjusted to enable the production of large unglazed or 'biscuit' figures inspired by Greek and Roman sculpture, notably at the Berlin factory.*

in 1765–73. A more successful factory was set up at Doccia near Florence by Count Ginori, whose paternalistic management extended to building a model village for his workers. Here the coarse clays were extravagantly modelled, their surface whitened by a glaze containing tin, with high-quality decoration by the Viennese painter, Anreiter. Delicate figures with fine stipple painting were a Doccia speciality (fig. 67). In the South, a factory making soft-paste of French type was established in 1743 at Capodimonte (fig. 68) under the patronage of Charles IV of Sicily, soon after to become King of Spain. Production solely for the King continued after a move to Buen Retiro near Madrid, using German and Italian

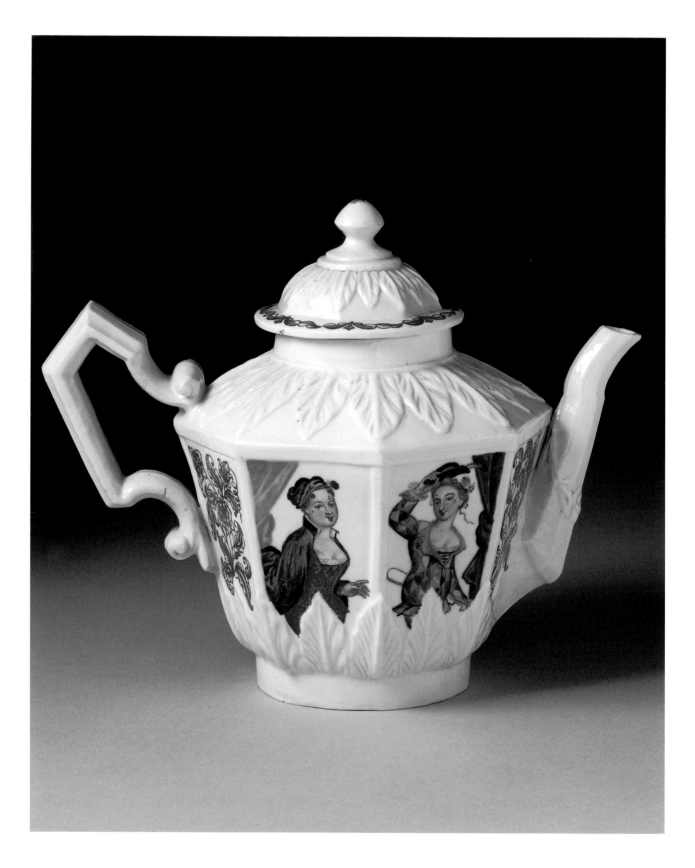

66 (opposite). *Through a defecting Meissen gilder, C.C. Hunger, the secret of porcelain-making was taken in 1720 to Venice, where Francesco Vezzi made distinctive forms with lively enamel decoration.*

67 (below). *The porcelains made at Count Ginori's factory at Doccia, notably the remarkable figures which display lively modelling as well as sensitive painting, have enabled it to remain a successful commercial venture.*

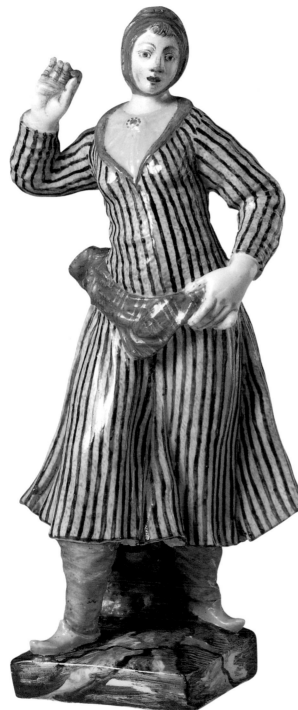

painters, and turning to hard-paste manufacture before the factory was destroyed in 1812 during the Napoleonic Wars. The combination of glassy French-type paste and Italian stippled painting, as well as the exclusivity of a royal factory, has lent considerable glamour to all the products. Indeed, the delicate white material was exploited to the full and was used to clad still-surviving complete rooms at the royal palaces at Portici, Aranjuez and Madrid.

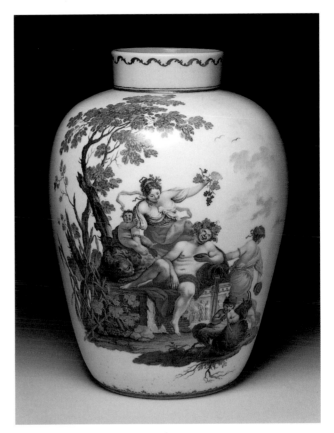

68. *The glamour of royal patronage is inseparable not only from the richly decorated products of Sèvres, but also the glassy porcelains of Capodimonte with their lush painting, made for the exclusive use of the King of Spain.*

C.C. Hunger also attempted to set up a factory at Copenhagen in the 1730s. He was followed by another peripatetic German arcanist, J.C.L. von Lücke in the 1750s. Eventually, in 1759, soft-paste porcelain was made briefly under Louis Fournier, formerly of Vincennes and Chantilly. In 1775, the factory was successfully re-established under Müller, using local kaolin and drawing artists from Germany. As with so many other factories, in 1779 it was taken over by the King to become the Royal

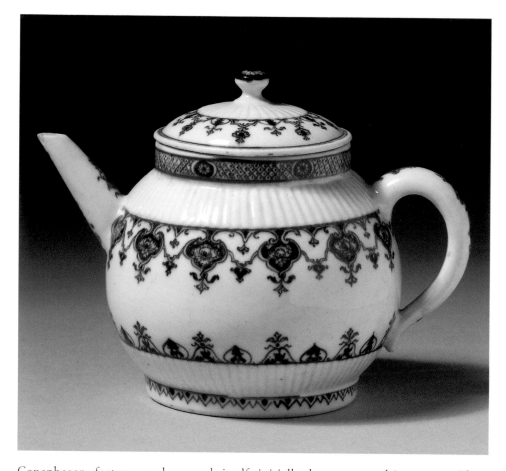

69. *For the 100 years before kaolin was discovered at Limoges, glassy soft-paste porcelain was the only type made in France. The body used at Saint-Cloud had many of the qualities of Chinese imports from Dehua* (blanc-de-chine).

Copenhagen factory, and proved itself initially by producing the well-known 'Flora Danica Service' in 1789–1802, a prelude to its great success in the nine-teenth century. A porcelain venture at Marieberg in Sweden from 1759, first with hard-paste by a German and then with soft-paste by a Frenchman, survived only until 1782. Holland also adopted porcelain manufacture in the 1750s, when D. McCarthy set up a factory at Weesp. Later, German artists were employed, as at the other Dutch factory in The Hague. The Dutch were noted for their enamel studio decoration, originally developed in the late seventeenth century for copying *famille verte*, and then used to embellish plain imported Chinese wares and English creamwares. In The Hague, the studios of the Lyncker family manufactured porcelain from 1776 to 1790.

After leaving Stockholm in 1744, C.C. Hunger went to St Petersburg to start a factory for the Empress Elizabeth. Its fortunes were revived under Müller in 1758, after which the patronage of Catherine II and the adoption of artists and styles from France and Austria ensured its success. The remoteness of Russia, where a wealthy aristocracy looked to France for both language and culture, encouraged further factories, such as Gardner's and Popoff's near Moscow, making hard crisp porcelain not dissimilar to that made by the many Paris factories.

In the absence of any known supplies of kaolin, French potters pioneered soft-paste porcelain, first at Rouen and then at Saint-Cloud (fig. 69), where the Chicaneau family made a delicate glassy body under the patronage of 'Monsieur', the Duc d'Orleans and brother of Louis XV. Its body proved ideal for imitating imported *blanc-de-chine* wares with their moulded prunus blossom decoration. The prestige of owning a porcelain factory was such that other nobles soon obtained the formula and became rivals of Saint-Cloud. By the 1740s, the factory established at Chantilly in 1726 by the Prince de Condé used brightly enamelled *chinoiseries* to comple-ment its glassy white paste, and later its famous blue-and-white sprig patterns; and the Mennecy factory established in 1748 at the chateau of the Duc de Villeroy

was making small exquisite objects with naturalistic flower painting. In a rare collaboration between French and English workers, the factory at Tournai on the Belgian border combined Meissen-style moulded table-wares with blue painting like that found in England at Caughley.

At Vincennes, a serious attempt was made by workers from Chantilly to start a factory in 1738, using the Saint-Cloud soft-paste formula. Their ambitions were rewarded with a decree in 1745 allowing them to use the royal *fleur-de-lis* as their mark, after which the factory's output of delicate pinch-modelled porcelain flowers proved ideal for the Paris *marchands merciers* to embellish their *ormolu*-mounted imported Meissen figures. Having proved its ability not to make money but to make quite exceptional porcelain, the King himself became principal shareholder in 1753, when over the following three years a new model factory was built at Sèvres, close to the chateau of the King's mistress, Madame de Pompadour.

Although the story of Sèvres is well known, modern appreciation of its products has been considerably blunted by the thousands of cheap imitations produced in the succeeding two-and-a-half centuries. From the first, lacking the ingredients for hard-paste porcelain, the factory set out to make the most elegant and most desirable soft-paste in Europe. It was an opportune moment, bearing in mind that Meissen had only just taken up the rococo, and was shortly to be ruined by the Seven Years War. With the patronage and close involvement of the most powerful ruler on the Continent, and a ready market in Paris for luxury products, the most talented artists, designers, gilders, sculptors and chemists were

employed. The soft-paste formula as developed at Sèvres was extremely expensive to produce, the clay body being kiln-fritted and ground to powder up to three times before reaching the potters' hands. Order and discipline were tight: minutely detailed records of all the production (including the kiln-firings) survives to this day, and each piece bore a date-letter (starting with 'A' for 1753) and usually the cyphers or initials of at least one of the artists (for example, '2,000' for the gilder Vincent), framed by the royal mark of interlaced Ls.

Of the many skilled decorators employed at Sèvres, some were truly outstanding. Evans and Ledoux specialised in landscapes, and Viellard and Dodin painted romantic pastoral scenes and children's games, often inspired by the work of François Boucher. An idealised miniature world was created in reserve vignettes surrounded by a rich enamelled ground-colour (fig. 70). Although this idea had been used at Meissen with pale lilac and green, and even yellow, at Sèvres it was developed and used to sumptuous effect, becoming one of the most admired and envied aspects of their repertoire. Yellow (*Jaune*) – the most desirable colour and one of the

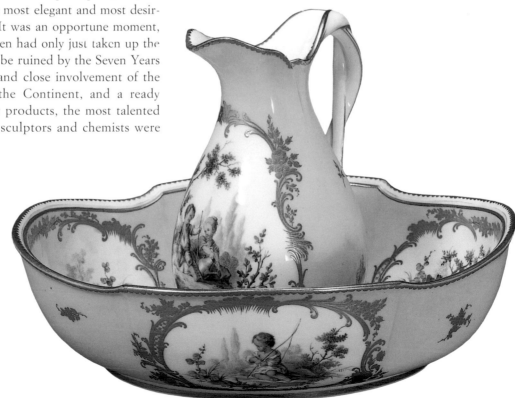

70. *The highly prized yellow* (Jaune) *ground colour was the first to be perfected at Vincennes in 1751. Brilliant effects were achieved by combining it with painting in bright blue enamel.*

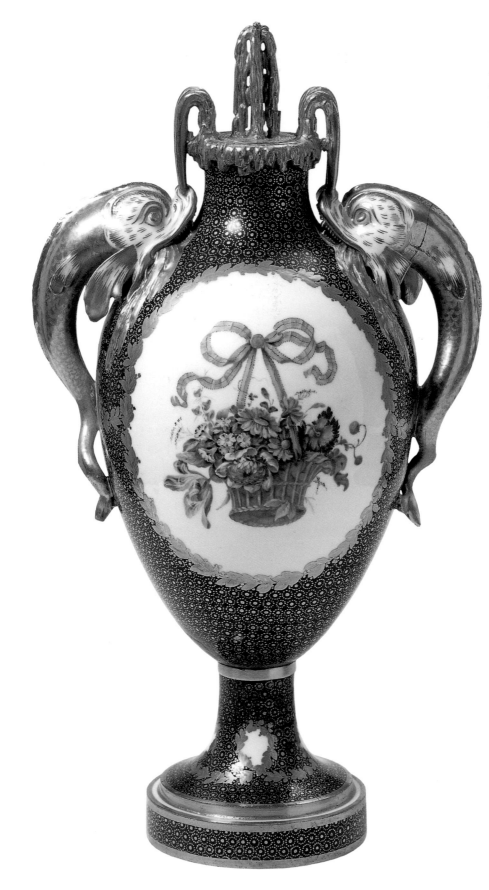

71. *Even when neo-classical forms began to dominate the products of Sèvres under Louis XVI, a strong sculptural element remained, seen here in the dolphin handles which allude to the Dauphin.*

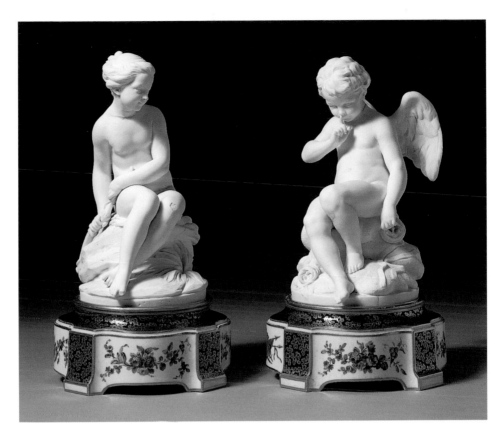

72. *At Sèvres, the best modellers in France were employed to make full use of their biscuit porcelain, which proved so successful at reproducing the subtleties of the human figure.*

most difficult to achieve – was perfected as early as 1751. *Bleu Lapis* of 1752 was the first of many blues (fig. 71), followed by the turquoise *Bleu Céleste* in the next year, and the so-called '*Rose Pompadour*' in 1758. Having more in common with enamelled jewellery than with ceramics, these ground colours admirably suited the heavy gilding, enamel painting and *ormolu* mounts with which they were embellished. At the same time, a fine series of sensuous biscuit figures were modelled by sculptors of the calibre of Boizot and Falconet (fig. 72).

As a royal factory, Sèvres supplied diplomatic gifts, such as the services for Catherine II of Russia, and the Kings of Sweden and Denmark, but tea and table services with plainer patterns, although never cheap, were affordable by those at a lower social level. Some grand services were exported, even to England, where the taste for 'Old Sèvres' lingered until the end of the nineteenth century. However, the advent of neo-classicism in the 1770s ill-fitted the luxurious soft body, which from 1772 was increasingly replaced by a new, more plastic hard-paste body which proved suitable for monumental vases and biscuit groups. The factory, which had been the plaything of Louis XV (who died in 1774), lost money under his

successor, and, although re-established in 1780, never fully recovered before it was ruined by the Revolution of 1793. Within a few years, however, it found itself restored under a brilliant new manager, Alexandre Brogniart, who immediately abandoned soft-paste in order to supply the monumental painted porcelains which were to confer credibility on the new Imperial regime.

Apart from Paul Hannong's venture into hard-paste at Strasbourg in the 1750s, and the existing soft-paste makers at Saint-Cloud, Mennecy and Chantilly, porcelain manufacture in other parts of France was severely restricted by protective privileges granted to the Vincennes/Sèvres factory in 1747, 1760, 1779 and 1784. With the discovery of kaolin at Limoges around 1768, however, rival factories soon sprang up in Paris, some in outright defiance of the law and others under the protection of noble patrons. Bitter legal wrangles, the precarious state of the Sèvres factory and the desertion of its decorators to rival establishments, finally resulted in concessions that allowed a wide range of excellent table-wares to be manufactured by many factories within the city. In Limoges itself, the hard-paste factory bought by the King in 1784 did not survive the Revolution, and gave

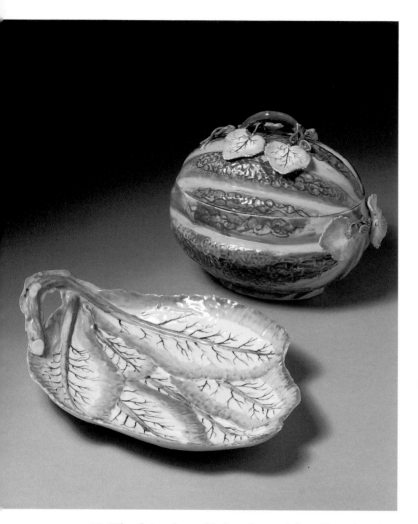

73. *When fruit and vegetable forms became fashionable in the mid 18th century, the plump melon proved ideal as a model for tureens, the plant stem sometimes modelled as a ladle.*

little indication of the huge industry that would develop in the next century.

In Britain, Dwight's porcelain experiments were not followed up for 50 years. Meanwhile, the East India Company, controllers of the trade, held regular sales of Chinese porcelain of all grades, for distribution to all parts of England; the gentry and aristocracy could also commission polychrome enamelled armorial services, or, after about 1740, armorials could be added to imported porcelains by English decorating studios. Items of Meissen porcelain, especially figures, were imported in the second quarter of the eighteenth century. For the poorer households, there was cheap Staffordshire salt-glaze, pewter and delftware. The Hanoverian Kings, away

from their native competing German states and well supplied with imported luxury goods, offered no incentive for the establishing of a porcelain industry in Britain. In fact, the impetus finally came from Staffordshire, in the form of major technical advances (slip-casting in plaster moulds and enamelling) in about 1740 and the first patent applications in 1743. However, in order to combine technical and artistic skills with entrepreneurs and a wealthy market, London rather than Staffordshire was the obvious location.

The year 1744 saw Nicolas Sprimont, favourite silversmith of the Prince of Wales, leasing his factory premises in Chelsea, and the first Bow patent application by Thomas Frye and Edward Heylyn. In the following year came the start of the short-lived Limehouse factory. White soft-paste 'Chelsea wares', heavily influenced by the trade and nationality of their proprietor, appeared, eventually to be followed by enamelling in the styles popular at Meissen, with the novel use of illustrations from Aesop's Fables (fig. 74). The best painters in London, together with the talented Flemish modeller Joseph Willems from 1750 and the moulded rococo designs of Sprimont, did give the factory limited royal patronage in the form of encouragement from the Duke of Cumberland and, in the 1760s, a service for the Queen's brother, the Duke of Mecklenberg-Strelitz. The 'gold anchor' period (1758–69) combined Meissen applied flowers, Sèvres ground colours and extravagant moulded forms in an unparalleled way. However, just as the Sèvres soft-paste failed to reproduce neo-classical forms, so Chelsea lost its impetus and was taken over by Derby in 1770, finally closing in 1784. The parallel 'Girl-in-a-Swing' factory run by Charles Gouyn made many of the 'toys' (seals and scent bottles for which Chelsea was also famous) during its brief life of 1749–54.

While Chelsea strove to attract the nobility to its annual sales, the Bow factory, styling itself as 'New Canton' and built according to a Chinese prototype, aimed at traditional buyers of Oriental porcelain. With Staffordshire workmen and a reliable formula containing calcined bone ash patented in 1749, the firm flourished by concentrating on modest tablewares in blue and white and Kakiemon polychrome, as well as a range of delightful figures. In the 1750s other factories were quick to join

74 (opposite). *Using the miniature painting style and palette of earlier Meissen decoration for their soft glassy white porcelain, artists at Chelsea invented a new genre deriving from Aesop's Fables.*

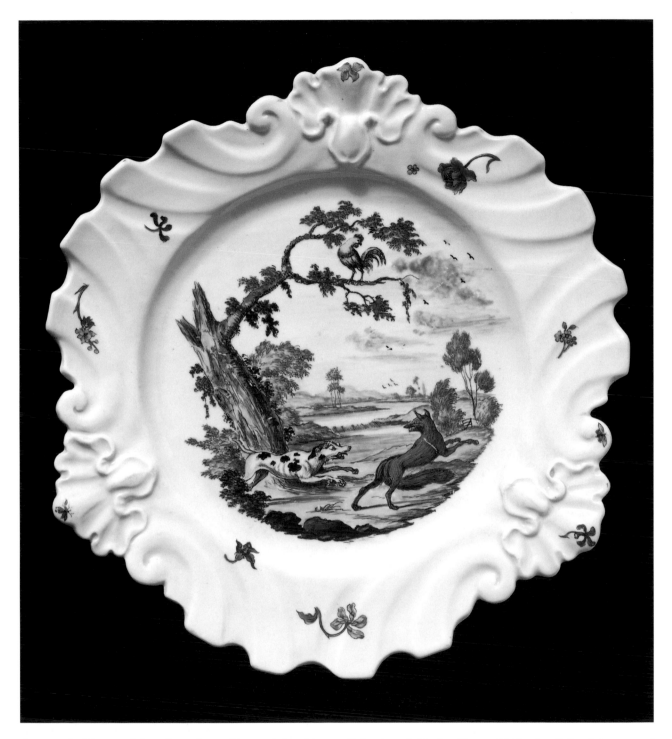

the race: in Liverpool four factories making mainly table-wares; at Longton Hall (fig. 73) in 1759 the first Staffordshire venture, using William Littler's own paste; and at Lowestoft, where bone-ash was also favoured. Of more lasting importance were the establishments at Bristol and Derby. From 1748, the Bristol factory of Lund & Miller used a soap-rock formula, the products of which were resistant to boiling water. In 1752, this formula was acquired by the new well-organised 'Worcester Tonquin Manufacture', with the intention of

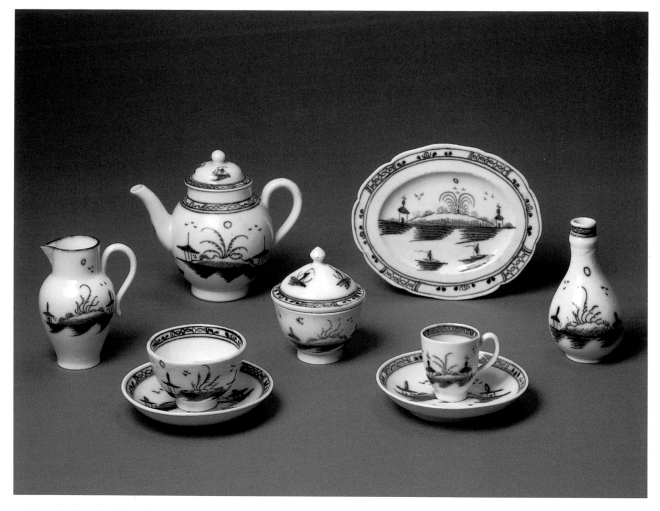

75. *Towards the end of the 18th century, English porcelain factories began making affordable sets of blue and white tableware, pioneered at Worcester and soon taken up at Caughley and elsewhere. Surprisingly, some complete toy services have managed to survive.*

making wares 'in imitation of Dresden'. The large-scale production of excellent tablewares was assisted by the introduction of overglaze transfer-printing in 1757, and the more technically demanding underglaze-blue printing about 1760. The closure of Chelsea in 1769 left a gap in the market for porcelain with rich ground colours and fine enamel painting porcelain in the Sèvres manner, to be fully exploited at Worcester not only by the hiring of Chelsea artists but also by a successful collaboration with the noted London decorator James Giles. An off-shoot at Caughley (fig. 75) was absorbed by Coalport at the end of the century. The factory at Derby, established in 1750, prospered after William Duesbury joined in 1756 to the extent that Duesbury termed it 'The Second Dresden'.

Here a bone-ash soft-paste body was used to make a wide range of tablewares and fine figures. In particular, the special biscuit body responded with great sensitivity to the skills of their excellent modellers. Having first emulated and then eliminated Chelsea, the factory embraced neo-classicism and, as well as taking a share of the market for armorial table services, developed a remarkable repertoire of stylish vases and landscape painting towards the end of the century.

Although soft-paste porcelain of various types was made by almost all English factories, the existence of the china clay and china stone for making hard-paste had been discovered by William Cookworthy as early as 1745. His patent of 1768 was used with some success first at Plymouth and then at Bristol under Richard Champion's management before being offered to Wedgwood and eventually sold in 1781 to a consortium of Staffordshire potters who built the New Hall factory (fig. 76) at

76. *With the development of cheap porcelains – either forms of hard-paste as at New Hall or the new bone-china – silver shapes, often a few years old, were utilised as models for the fashionable complete tea services.*

Shelton. Just as the London glasshouses declined in favour of major new establishments in the West Midlands, so the decline of Chelsea and Bow was accompanied by the creation of new factories in Staffordshire, hitherto the great stronghold of pottery manufacture. Streamlined production methods now dictated the mass-production of utilitarian porcelain tableware; and, from 1789, James Neale began to develop his new paste which combined the bone-ash formula used at Bow and elsewhere with the patented ingredients of hard-paste – with the intention of producing a fine, stable, white and durable body that might be described as a porcelain equivalent of creamware. When the East India Company ceased importation of Chinese porcelain in 1791, and after the Cookworthy/Champion hard-paste patent expired in 1796, the way was open for this new bone-china to be taken up with vigour by energetic new factories such as Spode, Davenport, Miles Mason, Minton and Coalport.

The years around 1800 did create a watershed for the porcelain factories of Europe, both in terms of style and material. The glamorous soft-paste of Sèvres, so redolent of the rococo style of the *Ancien Régime*, had given way in France to cheaper and more practical hard-paste; the superb baroque modelling and painting of Meissen, although faintly echoed by a growing number of smaller factories, were never to be repeated. In England, the native preference for soft-paste combined with French, German and Oriental styles was firmly re-established by the invention of adaptable bone-china. It could be said that eighteenth-century porcelain in general encapsulated qualities which succeeding factories in the following century would strive ceaselessly to reproduce.

Princely Porcelain Rooms

From small beginnings at the start of the seventeenth century, the import of Chinese porcelain soon became regular enough to fuel a desire for blue and white, which could only be satisfied by tin-glazed earthenware copies. Interest in the Orient was intense and, at first, the fashion was applied to architecture, inspired by the legendary 'Tower of Porcelain' near Peking. After the French East India Company was founded in 1665, a pleasure pavilion, the 'Trianon de Porcelaine' was erected on the orders of Louis XIV for his mistress, Madame de Montespan, in 1670–1. Built of soft Rouen *faience*, it did not survive many winters; but from that point onwards blue and white, whether Chinese, Japanese or European, was avidly collected and used *en masse* to furnish rooms in royal palaces. These Oriental ceramics were combined indiscriminately with lacquer and mirrors to create an exotic fantasy world; and rivalry between the royal families of Germany and Austria led to extravagant schemes by, for example, the Elector of Bavaria and the King of Prussia. At Hampton Court, Queen Mary adopted the blue and white theme by commissioning luxurious tiles, pans and vases from the Greek A factory at Delft for her dairy, the whole scheme designed by Daniel Marot. About 1715, Augustus the Strong of Saxony, an obsessive collector of antiquarian artefacts and *objets d'art*, began amassing porcelain with which, by 1719, he had filled the 20 rooms of his Dutch Palace. A new Japanese Palace at Dresden was then built to contain his collections which grew in the 1720s to 57,000 pieces of Oriental and Meissen porcelain. The major castles of almost every German principality thereafter could boast a porcelain room of some kind, either for grand entertainment or an intimate 'cabinet'. The fashion for porcelain rooms lasted longer than the taste for blue and white, making a last great appearance under the King of Spain, who had a room at the Portici Palace at Naples entirely lined with 3,000 enamelled Capodimonte porcelain plaques for Queen Maria Amalia in 1757–9. After the factory moved to Buen Retiro, similar schemes followed at palaces at Aranjuez and Madrid in the 1760s and 1770s – extravagant gestures, perhaps, for Spain's decaying monarchy.

77 (above right). On their accession to the English throne in 1688, William and Mary introduced the French-Dutch style of their Court designer, Daniel Marot. Queen Mary's collection of Oriental and Dutch blue and white was displayed at Kensington Palace and Hampton Court, where Marot's Water Garden included a dairy equipped with the best products of the leading Greek A factory at Delft.

78 (below right). Daniel Marot (1661–1752), a French Huguenot who fled to Holland to become a designer at the Court of Prince William of Orange, was highly influential in promoting the taste for China closets through his engravings. Delft pottery, Oriental porcelain and lacquer were combined with mirrors in an overall architectural framework to produce a rich and exotic effect.

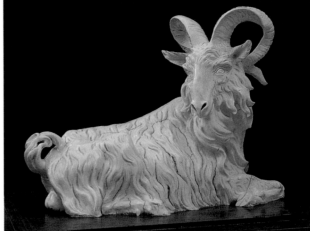

79 (above). When Frederick I of Prussia inherited his mother's collection of Oriental porcelain, he rebuilt Oranienburg Palace in 1688–95 to accommodate it, adding a new porcelain room measuring 30 by 40 feet, and following designs by a pupil of Jean Marot (Daniel Marot's father). Gilt wood pyramids supported massed tiers of porcelain, backed by mirrors. In 1703 much of this display was moved to a new porcelain room at Lützenburg for Queen Sophie Charlotte. After her death, the palace was re-named Charlottenburg.

80 (above). The porcelain collections of Augustus the Strong of Saxony reached such a size that, in the early 1720s, he began a new Japanese Palace to display the wealth and power of Saxony. The 18 ground-floor rooms contained Oriental porcelain, while the main floor above was furnished by his factory at Meissen, notably the astonishing gallery of life-size porcelain animals modelled by J.J. Kaendler and J.G. Kirchner. In 1732, he ordered 214 animals and 218 birds.

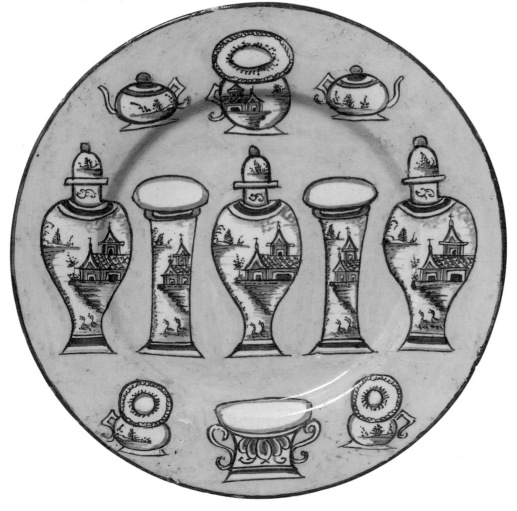

81 (left). The concept of ornamental vases came to Europe from China. In particular, matched sets of vases (garnitures or Kast-stels, meaning 'cupboard sets') for the decoration of mantlepieces, the wide ledges over grand doors and the five ledges on high-topped Dutch cupboards became highly fashionable in Holland.

Figures

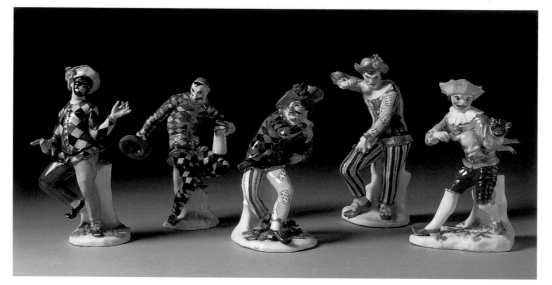

82 (left). The new porcelain figures devised by J.J. Kaendler at Meissen in the 1740s proved ideal for creating miniature set pieces for the centre of aristocratic dining tables. Effectively toy theatres with mirror glass, these settings lent themselves naturally to the highly popular characters of the *Commedia dell'Arte*, such as Harlequin (shown here), Columbine, Pantaloon, the Doctor and the Lawyer. This raucous, bawdy, satirical travelling theatre was to metamorphose in the 19th century into Punch and Judy.

There is evidence that clay images were made at least 25,000 years ago. Caricature figures are not uncommon from Classical times onwards; but the use of small figures as ornaments on mantelpieces seems to be no older than the mid seventeenth century, when presumably the figures were imported Chinese porcelain. Attempts to make figures in thickly glazed *faience* were not notably successful. It was not until the hiring of professional modellers at Meissen in about 1730 that porcelain came to be regarded as a suitable medium for serious sculpture – and even then only as a replacement for the sugar and marzipan figures used for the elaborate table decoration then in fashion. The models of J.J. Kaendler in particular started a craze for these miniature sculptures which was taken up elsewhere in Europe, changing in the mid eighteenth century from the baroque to the lighter rococo and whimsical *chinoiserie*. In England, modellers from the Continent found ready employment. By the 1760s, at Chelsea, Bow and Derby, these appealing figures had acquired a leafy bower or 'bocage' and moved from the table to the mantelpiece – often mounted with candle-arms – where such figures have remained ever since. With the increasing interest in classical marble sculpture, biscuit porcelain was much used at Meissen, Berlin and Sèvres for depicting the nude. At the same time, earthenware figures for a more popular market were continually developed in Staffordshire. At first, competent modellers and attractive coloured glazes were used. From the early nineteenth century, these figures began to reflect popular culture, eventually becoming the mass-produced 'flat-back' which adorned almost every cottage mantelpiece in the country. In just over a century, ceramic figures had evolved from aristocratic table ornament to fairground knick-knack. However, the invention of Parian ware in the 1840s and the continuing employment of talented modellers by the larger European porcelain factories ensured the continuation of both skill and demand.

84 (below). By the time that the Nymphenburg factory was established in 1747, the cool beauty of German hard-paste porcelain was unrivalled. In the hands of Franz Anton Bustelli, the chief modeller engaged in 1754, this material could be made to swirl and undulate as though it were weightless and alive. At this time, groups of figures were replaced by elaborate single table centres.

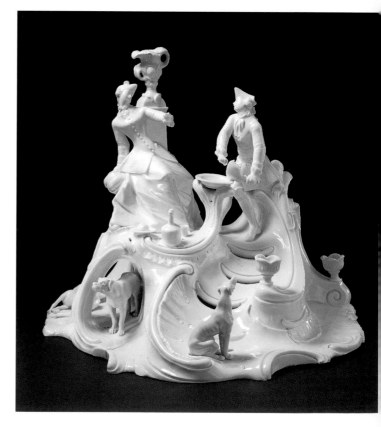

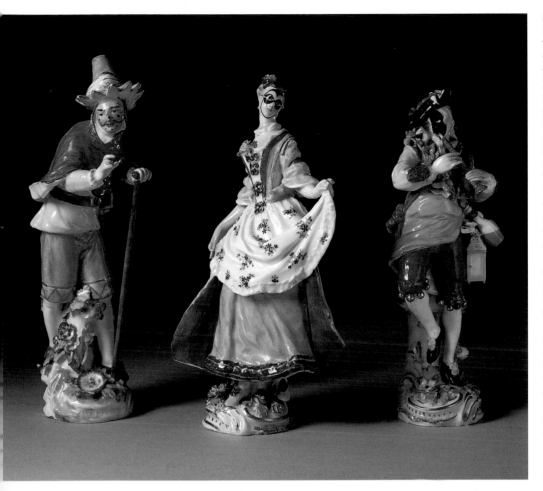

85 (left). In Chelsea, the Flemish modeller Joseph Willems set the factory style for the 1750s, breaking away from mere copying of Meissen. These figures represent masked revellers (masqueraders) who might have been seen at the popular pleasure gardens at Ranelagh (near Fulham) or across the Thames at Vauxhall, where fashionable men and women could enjoy food, drink, music, conversation and assignations within the walls of a leafy urban Arcadia.

83 (below). The genre of porcelain figures produced by Meissen included the miniature and the life-size. Pairs of exotic beasts, modelled after engravings and naturalistically painted were popular as ornaments for side tables and library desks. Before the Sèvres factory had been established, such desirable objects were eagerly imported by Parisian merchants and made yet more precious by the addition of crisp fire-gilt *ormolu* mounts.

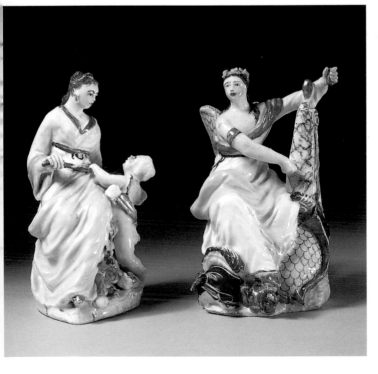

86 (left). The unpretentious range of figures produced at Bow, which specialised in good mass-produced tablewares in the Oriental style, have a direct and enduring appeal. Although anonymous and perhaps not professionally trained, the so-called 'Muses Modeller' was a master of his genre, his figures having distinctive extended arms, small heads and waif-like faces; when coloured, the enamelling appears to have been hastily applied.

Tea and Coffee Drinking

Surprisingly, it was during the Civil War in 1645, that tea first reached England, after its introduction into Europe by the Dutch East India Company in 1610. Perhaps as a relief from the austere Puritan regime of the Commonwealth, the first coffee house, which also sold hot chocolate, was opened in Oxford in 1650. Despite subsequent heavy taxation (Pepys's diary mentions the enormous price of 60 shillings per pound) and differing opinions about its medicinal properties, the habit soon became established and divided the sexes: the urban coffee houses for gentlemen and men of business, and the domestic tea parties for ladies.

At first, tea was made in bulk and sold in barrels, but soon new vessels were devised for making fresh tea and the taste for tea spread rapidly. By the end of the eighteenth century, coffee houses were extinct and the 24 million pounds of tea imported annually were consumed by all social classes, later to be condemned by William Cobbett as a 'troublesome and pernicious habit' amongst the poor, which deprived them of the nutrition traditionally provided by beer. Efforts to grow the plant in the British colonies resulted in the first imports of tea from India in 1839, and faster ships meant fresher tea. Consumption *per capita* doubled during the period 1841–63. Elsewhere in Europe, the fashion for coffee and chocolate took hold, but Britain has remained the major consumer of tea.

88 (left). In the early eighteenth century, wealthy and fashionable families would choose to be portrayed taking tea. The social status of the family here is shown by the extensive use of silver vessels, most of which would very soon be copied in cheap Staffordshire white stoneware and become available to a mass market.

87 (below). The £10's worth of 'porcelain' included in the first cargo of tea imported by the East India Company in 1669 probably consisted of red stoneware teapots made at Yixing (right), especially favoured by the Chinese.

Direct copies were made in Holland and in England by the Elers. In Saxony, the Meissen red stoneware was dense enough to cut and polish. In Staffordshire, sprigged ornament and engine-turning were used (left).

89 (above). A much less posed family tea party is shown on this tray, the shape of which imitates the top of a contemporary mahogany tea table. Small teapots (often of red stoneware and seldom matching the Chinese porcelain cups and saucers) were re-filled by a servant with an iron kettle.

90. In France, the serving of tea was confined to wealthy or aristocratic circles. No ritual or ceremony accompanied tea drinking, which was an intimate extravagance enjoyed alone or shared between two, for which the tiny 'Cabaret' service on a tray was invented. The exotic and jewel-like design of these objects suggests that they were aimed almost exclusively at ladies.

91. In England, matching porcelain tea sets were produced from the 1760s. With the invention of bone-china in about 1800, production of inexpensive but extravagantly decorated tea services expanded rapidly. Here, the teapot and milk jug closely imitate contemporary silver, while the cup shapes display the increasing ornateness that accompanied the rococo revival of the 1820s.

92 (right). By the late 19th century, the teapot had become a symbol of ceramic form and a vehicle for avant garde design. The spirit of functionalism promoted by Christopher Dresser in the 1870s was taken to extremes in Germany of the 1920s, where the Bauhaus architect-designers reduced objects to their functional minimum.

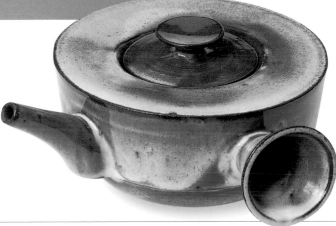

POTTERY: FROM CRAFT TO INDUSTRY

By the end of the seventeenth century, Britain was well on the way to becoming self-sufficient in luxury goods for the dining table. The perfection of lead glass had rendered the import of Venetian glass superfluous, London-made stoneware mugs and bottles now took the place of Rhineland imports, and cheap blue and white delftware provided the mass market with basic plates, mugs and bowls. However, it was not yet possible for Britain to shake off its dependence on imports from China. Although the secret of making red stoneware teapots was known to John Dwight and the Elers brothers, its commercial exploitation was a failure – Dwight lacked ready access to the iron-bearing Staffordshire haematite clay, while the Elers bankrupted themselves by basing their manufacturing methods on silversmithing techniques. As for the magical flint-hard white porcelain, its secrets had eluded that great experimenter Dwight, whose pottery in Fulham was forced instead to concentrate on making his patented salt-glazed stonewares.

Hitherto, the drive for ceramic development had come mainly from London, whose large population led the fashions and whose merchants (headed by the Glass Sellers' Company) played the major part in importing, re-exporting, distributing and making ceramics and glass. (Oriental ceramics were also imported and sold exclusively by the East India Company in London.) Yet London had no raw materials in its vicinity. Almost everything had to be imported by sea, including wood fuel, coal from Newcastle, sand and clay from the West Country and Kent, lead from the North and tin from Cornwall. Thus, it was only the combination of London's network of shipping routes with the corresponding isolation of the land-locked counties of the Midlands that made centralised pottery manufacture in London economically viable.

Rural pottery centres, such as those in the West Country, were unaffected by fashion and developments in London. Making full use of the plastic qualities of local clays (fig. 93) and simple decoration, the making of these traditional pots (for example, the *sgraffito* wares of Donyatt) survived until the nineteenth century.

Of the rural potting centres with natural resources, Staffordshire began to emerge after about 1680 as the most promising. Plentiful and easily accessible coal, together with tough marl clays suitable for making kiln-bricks and saggars comprised the heaviest and most used materials in the pottery industry, while local red and yellow clay beds and white pipe clays satisfied the needs of small, undemanding family-owned potteries. Refinement of pottery took the form of slip-decoration of the surfaces rather than improvements to the materials.

93 (left). *Communal drinking, and the practice of 'wassailing' on Twelfth Night, persisted from the 17th century until well into the 19th century in rural areas such as the West Country and Wales. Such basic red earthenware with dark brown glazes and elaborate multi-handles was incapable of rivalling the fine lathe-turned wares developed in Staffordshire.*

98 (opposite). *Stained clays wedged together, forming haphazard intricate patterns, could successfully be press-moulded, but not thrown.*

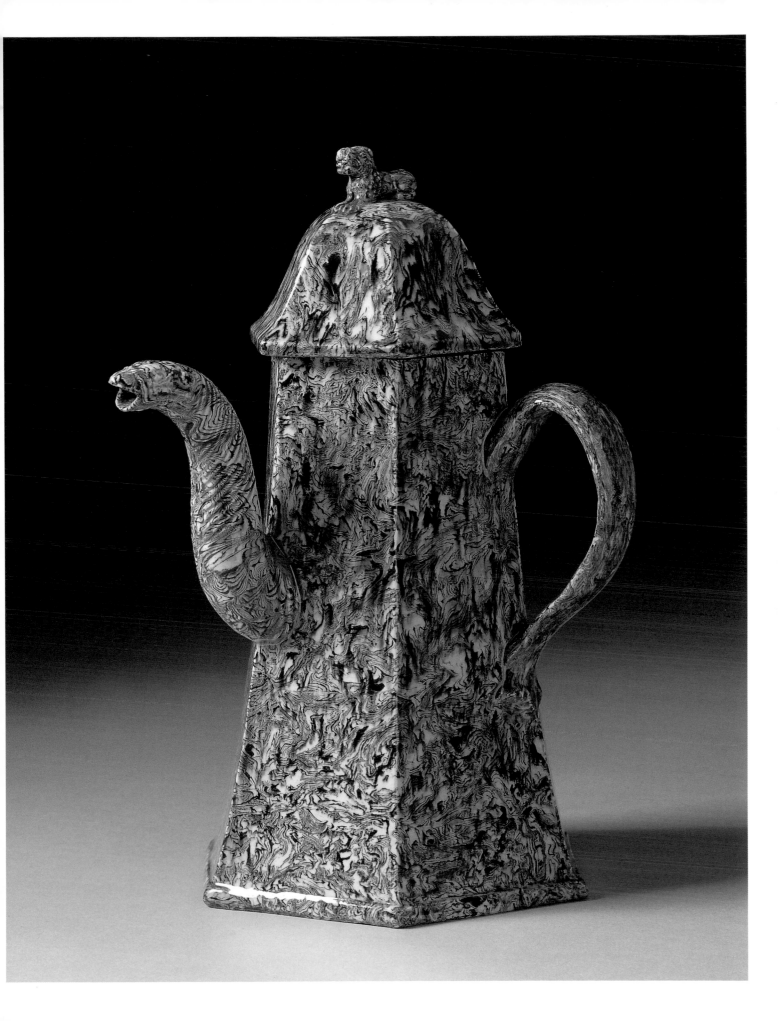

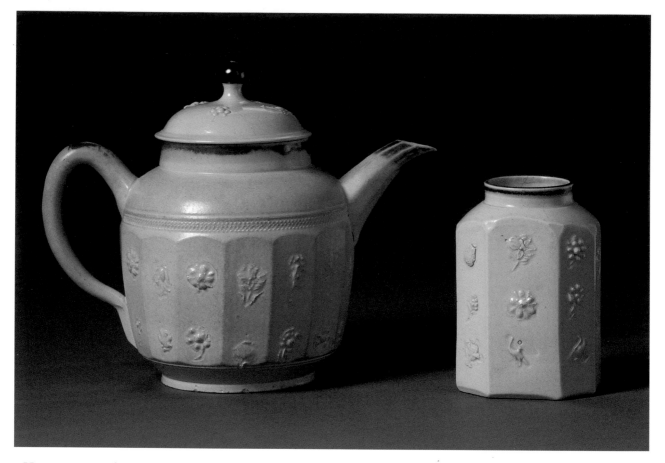

However, soon the example of Chinese porcelain, the growing demand for tea and coffee wares which needed to withstand hot liquids, and the semi-secret activities of the Elers brothers making red stoneware at Bradwell Wood in the 1690s, stirred enterprising local potters into blending and refining their local clays until they would withstand the weakening process of lathe-turning, and into raising their kiln temperatures by the simple expedient of adding more fire-mouths to their traditional bottle ovens. The resulting fine earthenware copies of John Dwight's stonewares, dipped in a lustrous mottled lead-iron-manganese glaze, were almost immediately followed by the successful unravelling of the secret of salt-glazing in Staffordshire – not from the secretive Elers brothers who had admitted knowing the process and probably used it at their other pottery in Vauxhall, but perhaps through industrial espionage or a defecting potter from one of the London potteries. This single discovery paved the way for the development of all the fine wares to be made in Staffordshire during the eighteenth and nineteenth centuries.

Although abundant clay and coal were available locally, and although the technical skills of dynastic Staffordshire potting families were already unparalleled in England, the initial lack of outlets for their products offered potter-farmers little incentive to abandon agriculture and concentrate on pottery. In the early eighteenth century, the products of these small independent potteries clustered around the town of Burslem, including lathe-turned brown stonewares and the heavier slip-decorated earthenwares, were distributed locally by 'cratemen', whose wicker backpacks, with perhaps the luxury of a packhorse, could supply the market within a radius of a mere 30 miles from the place of manufacture. Nonetheless, some of these excellent wares reached London and, from there, North America. Increased demand, and the gradual realisation of Staffordshire's unique natural advantages for pottery manufacture, led to improvements in the turnpike road system and, eventually, in 1733, to the opening of the River Weaver to navigation, which linked part of Staffordshire directly with Liverpool. As the need for plates was already satisfied by soft blue-

94 (opposite). *With the perfection of a white stoneware body about 1720, Staffordshire potters quickly developed a range of cheap, practical and elegantly shaped teawares.*

95 (right). *Until they developed the technical expertise to imitate Yixing red stoneware, Staffordshire potters used red earthenware as a substitute, with decoration of very English type.*

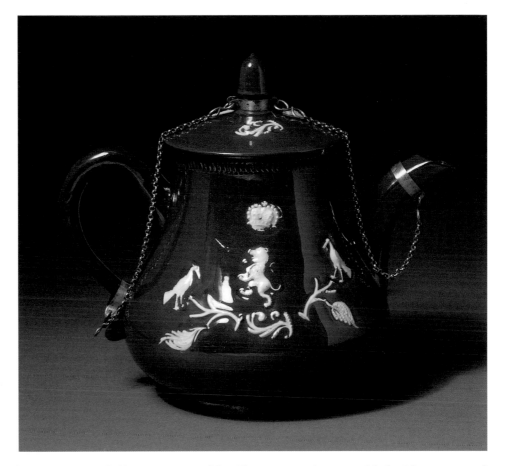

painted delftware and the cheaper types of Chinese porcelain, Staffordshire potters concentrated on perfecting the teawares for which delftware was quite unsuitable; and, for this purpose, they searched for a body that would be almost white, light in weight, very strong and elegantly potted with an eye to both economy and function. Thus, the local grey stoneware body was first whitened by dipping it in refined white clay slip. Then, about 1720, white-firing clays from Bideford and up to 25 percent of ground calcined flint (improvements ascribed by the early nineteenth-century historian Simeon Shaw to the potter Joshua Astbury) were added to produce the stable white body for salt-glaze which not only remained unchanged for the following 60 years, but which later was to provide the basic ingredients for cream-coloured earthenware.

It was now possible to make light but tough stoneware teawares at a fraction of the cost of imported Chinese porcelain. Most of these teapots, cups, mugs and bowls were thrown, lathe-turned and left unadorned. Lacking the technology for enamel painting, and perhaps influenced by Chinese porcelains moulded with prunus and tea-plant, Staffordshire potters did, however, begin to decorate their plain surfaces with applied 'sprig' motifs made in brass moulds, to roulette bands of simple ornament and to cut bold facets by hand (fig. 94). Potteries needed to be versatile to prosper, so that stoneware-makers also produced the full range of popular earthenwares, for which the adoption of biscuit-firing during the 1720s had offered reduced kiln-losses and the possibility of underglaze decoration to compensate for the extra firing. Following the fashion for red teapots, and unable to replicate the fine stonewares made in secret by the Elers brothers some 40 years earlier, many potteries also developed a range of red earthenwares decorated with small but elaborate white sprigs (fig. 95). As a variation, Samuel Bell of the Pomona Pottery, Newcastle-under-Lyme, took out a patent for marbled redwares in 1729. Using the red clay body, glossy black-wares with an iron-manganese glaze were applied with Chinese-inspired trailing white sprigged leaves and hand-modelled stems. The lustrous plain glaze could also be

embellished with size-gilding in imitation of Chinese lacquer (fig. 96).

The years around 1740 were crucial for ceramic innovation in both Staffordshire and London. In a climate favourable to the first porcelain ventures at Bow, Chelsea and Limehouse, skilled Staffordshire workmen lent their expertise at all three factories. In Staffordshire itself, the potters' direction was about to change radically with the discovery (presumably adopted from the Continental porcelain factories) of plaster-of-Paris moulds for both pressing and casting, and of low-temperature enamel colours. From that point onwards, the cheap but severely plain thrown salt-glaze could be embellished with bright polychrome at a growing number of specialist decorating studios in Staffordshire and elsewhere. In addition, the use of moulds, designed and made by the new skilled trade of blockmaker, enabled the pots to be made by less skilled artisans in a limitless range of extravagant light-weight hollow forms according to the latest whims of fashion (fig. 97). Even more important in economic terms was the use of convex plaster moulds to produce moulded plates – traditionally the exclusive province of delftware makers. The markets were hungry for such strong, cheap and functional teawares and tablewares; elaborate forms were soon matched by new clay bodies, notably the marbled 'solid agate' which could be successfully press-moulded into novel forms (fig. 98). In 1744, a 'White Stone teapott' could be bought for fivepence (about 2 new pence), whereas a more fashionable 'marble' version was one shilling and fourpence, more than three times as much but still about half the cost of an enamelled Chinese cup and saucer.

Once the possibilities of skilled painting by freelance artists on white salt-glaze were fully realised, and once complicated and highly decorative hollow forms could be produced crisply at minimal expense by moulding (fig. 99), the status of the fine but cheap products of Staffordshire automatically rose. A dip of glossy blue enamel ('Littler's Blue') which proved most suitable for gilded decoration was developed by William Littler and Aaron Wedgwood (fig. 100). In the decades before enamellers began to work exclusively for individual factories, their hands may be detected in the painting on thinly turned Staffordshire salt-glaze as well as on Bow and Longton Hall porcelain (fig. 101).

Simeon Shaw, writing in 1829, stated that until 1740 just one kiln was considered sufficient for an average pottery, which would employ a slip-maker, a thrower, two

96 (above). *The effect of Oriental lacquer could easily be simulated with gilding on a glossy iron-manganese glaze.*

97 (opposite above). *The major technical advance of the slip-casting process may be dated to about about 1740, when these two objects – one cast, the other turned and sprigged – were made to commemorate the same event.*

99 (opposite below left). *Plain salt-glaze of conventional type, extremely rarely marked or dated, is known to have been mass-produced long after the introduction of creamware.*

100 (opposite below right). *The ability of cobalt-blue to withstand stoneware firing temperatures was fully exploited by Staffordshire potters, with the invention by William Littler and Aaron Wedgwood of 'Littler's Blue'.*

turners, a handler, a fireman, a warehouseman and 'a few children', while versatile skilled workers would practise all the trades and hire themselves out to different potteries. It is a tribute to the close-knit working and family ties of the Potteries that such a mutually beneficial system survived the major upheavals caused by the introduction of sub-divided labour and the rapid expansion in trade – seen in the increasing number of kilns serving each works. Account books show that the largest white salt-glaze makers John and Thomas Wedgwood of the Big House, Burslem, bought in wares from at least 20 other potters and supplied 50 others. Moulds made by the Wedgwood brothers' blockmaker, Ralph Wood, found

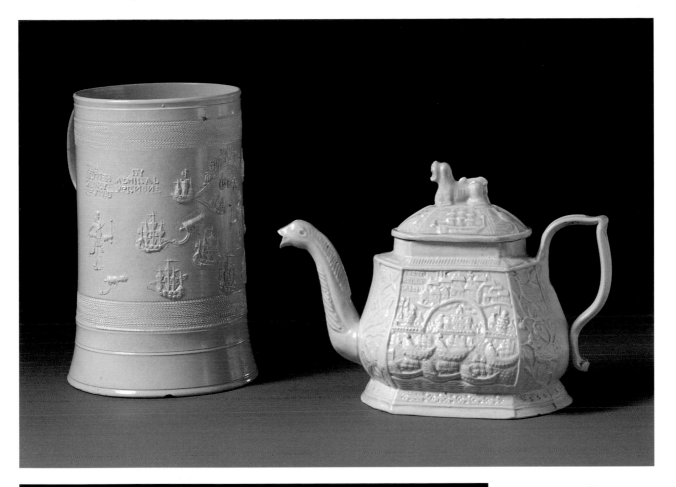

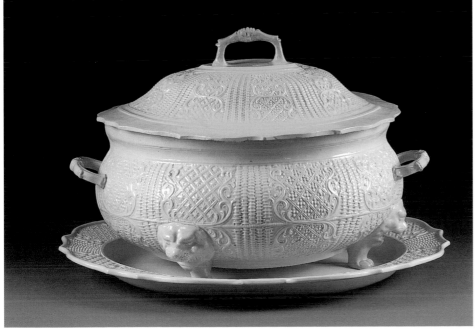

101. *After about 1740, independent enamelling workshops sprang up in Staffordshire and elsewhere, making full use of a limited palette.*

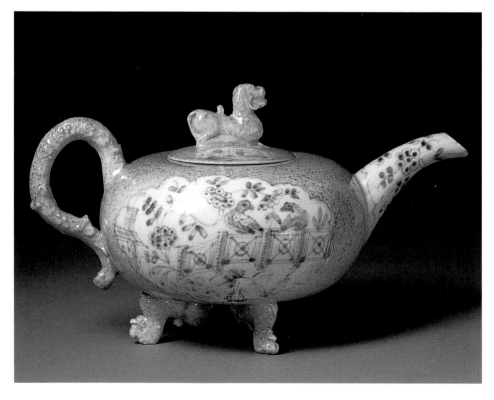

102. *It would seem that Enoch Booth's experimental creamwares were decorated by migrant delftware painters, using the technique of a 'powdered' ground with painted reserve panels.*

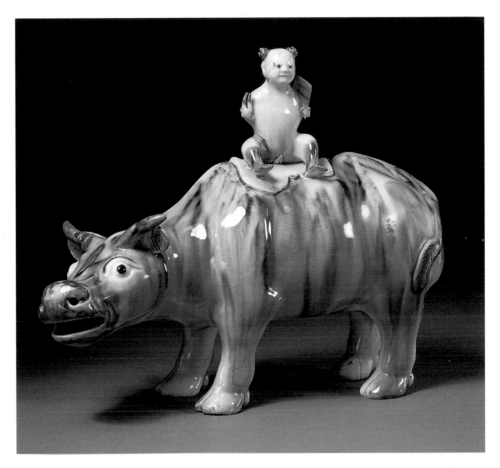

103. *Despite their earthenware body and typically Staffordshire use of underglaze oxide colours, early figures were rarely original models, but usually based on white Chinese porcelain prototypes.*

their way elsewhere and were perhaps lent or traded. Goods were enamelled locally, and the wares of different makers were considered interchangeable, in both shape and quality. By the end of the 1740s, the experimental creamwares of Enoch Booth of Tunstall (fig. 102) had borne fruit in the use of a standardised 'cream colour' body, and the ambitious Thomas Whieldon had established his major factory at Fenton Vivian. Although pottery was cheap to buy, it was very much cheaper to make, and cheaper still when mass-produced. With constantly improving transport and a network of Staffordshire warehouses opening in every large provincial town, a master potter's fortune could now be made in a working lifetime.

As the concept of a matching tea set was slow to develop, the re-invention of the individual red stoneware teapot in the mid 1750s was an immediate success. Superb potting, combined with very sharp sprigged decoration, made these pots superior in every way to those imported from Yixing. At the same time, the development of 'cream colour' invited new forms of decoration,

in the form of sponged oxides, imitating marble or tortoiseshell, applied after the biscuit firing onto tablewares or figures (fig. 103). All these types of pottery were made by the leading potters, amongst whom Thomas Whieldon was the most prominent – excavations have revealed a full repertoire of forms and materials, but especially white salt-glaze, including scratch-blue (fig. 104). Indeed, it was to Whieldon that the young and ambitious Josiah Wedgwood, having managed his own small pottery for five years, turned for a constructive working partnership in 1754.

The history of the meteoric rise of the Staffordshire potteries in the second half of the eighteenth century is inextricably linked with Wedgwood, almost to the exclusion of the other great potters such as Humphrey Palmer, James Neale and John Turner, none of whom has left behind such a legacy, in terms of either marked pottery or factory archives; and, as the leading potter of his generation, Wedgwood had the opportunity literally to write his own history. Intellectual curiosity, hunger for fame and fortune, a scientific mind, keen judgement of people and

77

smart London trade, while marriage to his heiress cousin in 1764 brought him capital with which to plan a new factory. An unsolicited commission for a tea set for Queen Charlotte was turned into 'Queen's Ware' and a royal appointment, for the first time raising a practical earthenware potter to the same footing as the Derby and Worcester porcelain factories. The buttery creamware was soon whitened to be more effective for the neo-classical shapes already made in silver and particularly in Sheffield plate, as well as for the black printing executed for him by Sadler & Green in Liverpool and the enamel painting added by Robinson and Rhodes in Leeds. From 1768, Daniel Rhodes managed Wedgwood's new Chelsea decorating studios, which then supplied, along with the Worcester and Derby porcelain factories, a growing demand for English armorial services to replace the dwindling imports from China.

Apart from a huge output of creamware aimed at Wedgwood's 'middling class' and efficiently made at his old Bell Works in Burslem, fashion and the advice of Bentley now conspired to make Wedgwood a major contributor to the 'Vase Madness' of the time (fig. 107), which provided both the impetus and the name for his new factory 'Etruria', intended to be the most modern in Europe. As with everything, Wedgwood's planning and timing were faultless, as in 1767 he bought an estate through which the Trent and Mersey Canal would shortly

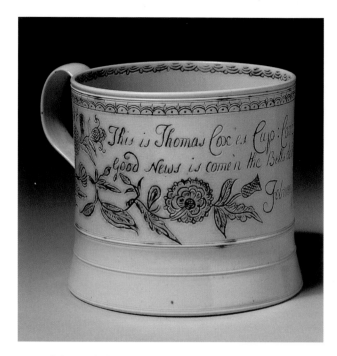

104. *Whilst very little white salt-glaze is closely datable, pieces with 'scratch-blue' decoration often include elaborately drawn foliage, inscriptions and dates – here commemorating Britain's alliance with the King of Prussia.*

boundless energy, all combined with good fortune and timing to make Wedgwood a household name. His life and successes have been well chronicled, and it is impossible to chart the Staffordshire pottery revolution – one which ultimately affected *faience* and porcelain production as far away as France, Germany, Scandinavia and Italy – without copious reference to the man and his achievements. However, it is important that the story of his life is seen as a paradigm for the lives of his contemporaries.

While in partnership with Whieldon in 1754–9, Wedgwood perfected his green and yellow glazes which were used on a new class of tableware moulded as cauliflowers, pineapples (fig. 105) and melons (the inspired ideas of their blockmaker, William Greatbatch). Wedgwood also set about finding the glaze to match his refined cream-coloured earthenware body – a body which would be good enough to be left plain – and took this invaluable secret with him when he branched out on his own. A partnership with Thomas Bentley (fig. 106) in 1762 presented vast opportunities for broaching the

106. *Without his partnership with the cultured Thomas Bentley (left) in 1762, the ambitious Josiah Wedgwood could never have entered the smart world of fashionable London.*

105. *The combination of William Greatbatch's wonderfully inventive moulds and Wedgwood's perfected cream body and coloured glazes was highly successful.*

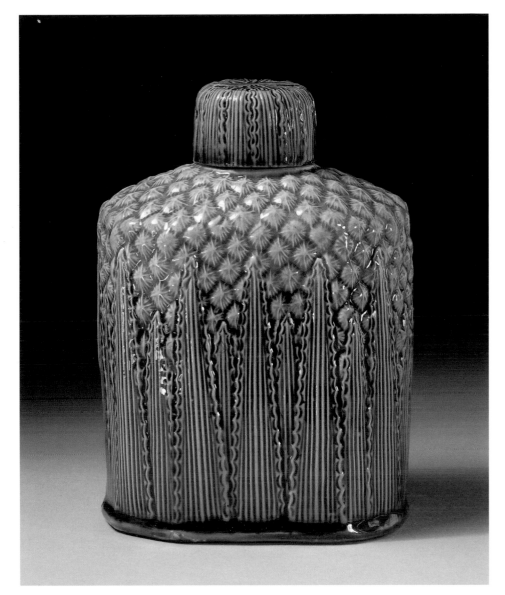

be built, linking the River Humber with the River Mersey by 93 miles of new waterway. Here, he proceeded to construct a model works under one roof along 150 yards of the canal, with the Ornamental Works run in partnership with Thomas Bentley at one end for his smart customers, and the Useful Works managed by his kinsman Thomas Wedgwood at the other. With labour sub-divided and all processes streamlined and rationalised, the works were described by a contemporary visitor as 'a marvel of organisation', a place to be visited by the gentry like the model factory of Matthew Boulton at Birmingham. From 1771, all his products were marked, and, with the strict discipline at the factory and rigorous quality-control, his

reputation for both quality and style enabled him to charge consistently higher prices than his rivals. The initial large investment in building Etruria was repaid by lower production costs, expanding production and the cutting of freight costs by some 85 percent on the new canal – enabling Wedgwood to offer free delivery anywhere in Britain, and facilitating the export trade to America.

In fact, although Etruria was absolutely modern and conceived on a scale hitherto unknown in the Potteries, it was by no means the first efficient ceramic works to be built. In 1735 Marchese Ginori had built a model factory at Doccia, run along paternalistic lines, and in the 1740s the Bow factory was copied from a Chinese model, with

107 (left). *The craze for vases in the 1770s, then known as 'Vase Madness', was ably supplied by Wedgwood's clever translation of earlier engraved designs into refined earthenwares.*

108 (opposite). *Wedgwood's 'Frog Service' made for the Empress Catherine II of Russia enabled creamware not only to rival porcelain, but to surpass it. His use of topographical decoration was also an innovation.*

all processes carried out under one roof and the works well heated by flue-pipes. In Worcester in 1751, manufacturing processes were rationalised in a new works built along the River Severn. However, in industrial terms, the most efficient was probably that built at Strasbourg in the mid eighteenth century by Joseph Hannong, who issued one of the first factory printed catalogues and price lists in 1771. Unfortunately, Hannong's attempts to make porcelain failed, while at the same time the factory's remarkable *faience* was rendered uneconomical by the importation of Wedgwood's unpretentious creamware.

By virtue of clever marketing, the perfected 'Queen's Ware' (humble earthenware with smart decoration) was immediately accepted at all social levels, feeding the market for sophisticated but inexpensive matching dinner services which accompanied the general rising prosperity and refinement in British table manners during the last quarter of the eighteenth century. Even before Wedgwood had transferred his creamware manufacture from Burslem

to Etruria, his production capabilities were put to the ultimate test by an order in 1773 from Catherine II of Russia for a 952-piece creamware dinner service for her La Grenouille Palace, known as the 'Frog Service' (fig. 108). With no certainty of being paid, Wedgwood launched into the project, hiring many extra painters for the topographical views to be enamelled at his Chelsea studio. After completion, he capitalised on his great royal commission by exhibiting the entire service for the benefit of fashionable society in London.

Wedgwood's experiments in finding a black body to reproduce Greek vases (then thought to be Etruscan) were handsomely rewarded – his 'basalt' body, coloured by the iron-bearing water that seeped through coal seams, was first marketed in 1768. Although he chose not to patent the 'basalt' material, he did patent his enamel 'encaustic' painting (fig. 109). The fashion for antique gems spurred Wedgwood to his most important original invention, the porcellanous 'Jasper' body which needed

109. *Considerably larger than the original Greek* volute krater *from which it is copied, this huge basalt vase of about 1785, with Wedgwood's patented encaustic painting, was later owned by the London retailer and glassmaker, Apsley Pellatt.*

110. *Although refined white Staffordshire stoneware clay could easily be moulded, the first attempts at figure-making treated the material like pastry, rolled, cut and built up.*

no glaze and could be tinted to match the fashionable architectural schemes of Robert Adam, James Wyatt, Sir William Chambers and 'Athenian' Stuart – influential leaders of taste whose support and advice Wedgwood now enjoyed, along with antiquarians and collectors such as Sir William Hamilton, the Duke of Bedford and the Earl of Bessborough. In 1773 he issued the first *Catalogue of Ornamental Ware*, followed by the *Catalogue of Queen's Ware* in 1774. Other bodies were developed in the 1770s, such as white terracotta stoneware, *rosso antico* and, eventually, the troublesome caneware, which was made from local clays. The professional modellers William Hackwood and John Flaxman Jr, were engaged, a studio was set up in Rome in 1778 to feed the hunger for what he described as 'new combinations of old ornaments'; and, for the less scholarly, Wedgwood used the sentimental designs of Lady Diana Beauclerk, Lady Templetown and Emma Crewe for his highly popular applied decoration. Basalt proved ideal for making large busts for desks and libraries, using models from John Bacon and the London plaster shops of John Cheere and Hoskins & Grant. The final great achievement came in about 1790 with the first successful stoneware copies of the Roman cameo-glass Portland Vase. By this time, the design or decoration of Wedgwood's products at all levels was linked to some of the most important British architects, artists and sculptors

of the period, and his wares (of which 80 percent were now exported) could be seen in great and small houses throughout Europe, supplied by agents in Holland, Russia, Germany and Italy. After the important trade treaty of 1786, the opening up of the French market spelled the end of the French *faience* industry.

From humble beginnings, the great Staffordshire tradition of figure or 'image' making also developed in the second half of the eighteenth century. Early attempts (fig. 110) using rolled clay cut and joined like pastry were succeeded by little press-moulded 'toys', and eventually by a range of superior richly coloured moulded earthenware cottage ornaments, some of which were based on porcelain originals. The models of Ralph Wood are outstanding (fig. 111), including figures and Toby jugs.

Elsewhere in England, the model of Staffordshire's success was taken up – albeit rather late. The declining delftware potteries, ill-equipped to make refined earthenwares, closed and their painters turned to pearlware, while the delftware *grand feu* palette of oxide colours was applied successfully to cheap moulded earthenwares made in Staffordshire, Yorkshire and elsewhere – known as 'Pratt Wares' after one of the few marked pieces (fig. 112). However, in Bristol the stoneware potteries of the Ring and Pountney families did produce respectable creamware, while in the North the changing partnership that formed the Leeds Pottery in 1770 mass-produced excellent creamware partly for a local market but especially for export to the Continent. Existing enamel-painting expertise in the area, along with the novel use of cleanly pierced decoration, ensured success for this factory as well as others in Rothwell and Swinton, and

111. *The Woods, a dynastic Staffordshire family of talented blockmakers and modellers, were noted for their huge range of simply made but sophisticated models with rich lead glazes.*

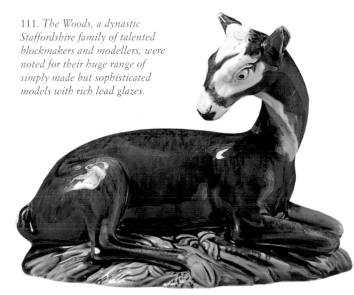

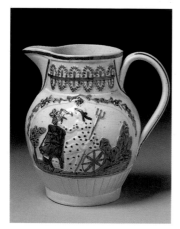

112. *After the demise of delftware at the end of the 18th century, the same limited palette of high-temperature colours was applied instead to moulded earthenwares. The whole class of Pratt Ware is named after this jug marked 'Pratt'.*

acquired by Wedgwood in 1763 after seeing them in use at Matthew Boulton's factory) were widely used, particularly on red stoneware. The commonly known formula for making Wedgwood's Basalt led to the vast production of teapots; in the same way, caneware was made by other potteries with equal proficiency, and led to the fashion for biscuit-coloured dry-bodied stoneware such as that patented by Turner. Coloured porcellanous stoneware of Jasper type was made by several contemporaries of Wedgwood (fig. 113). As for the huge range of sprigged decoration developed by Wedgwood this provided models and inspiration for other makers (fig. 114), for nearly 50 years.

When the buttery colour of creamware – which, despite the continued manufacture of cheap salt-glaze, provided the mainstay of most potteries at that time – fell out of favour with the public, it was replaced from the mid 1770s by the blue-toned pearlware with its 'China glaze' and underglaze painting. This then provided a substitute not only for the waning delftware, but also the cheaper grades of Chinese porcelain. With mass-production came further rationalisation, whereby processes previously farmed out to specialist studios were gradually drawn to the area of manufacture and then incorporated into new factories built on a grand scale. The first printer to set up business in Burslem was John Robinson, formerly employed by Sadler & Green of Liverpool, to be joined by others in the 1790s. Enamel decorating shops, often employing children for repetitive work, soon formed part of every pottery. The Potteries became host to the makers of machinery for the potting trade, special paper for transfer-printing and enamel colours, as well as the workshops producing engraved plates for the new underglaze-blue printed earthenwares (fig.115), the successor to creamware which would play such a vital role in Staffordshire's success during the next century.

later in Don and Castleford. Functional creamware was made even later in Newcastle and Sunderland. Further afield, wares of Staffordshire type were made at Bovey Tracey in Devon by Littler during his stay at West Pans in Scotland, and, by the end of the century, in Belfast. On an even more functional level, the refined brown Nottingham stoneware ale mugs, made with methods unchanged for 100 years, could no longer compete with either creamware or the more efficient potteries of Derbyshire, where mocha ware was also produced from the end of the century. London potteries abandoned delftware, but continued making stoneware until they found a new role in providing sanitation and commercial containers for a rapidly expanding London and British Empire.

It might be said that Wedgwood, by making much gold from base materials, succeeded where Böttger in Dresden had failed. Certainly, Wedgwood's factory methods and wealth offered a lesson not only to his fellow potters but also to the Continental royal porcelain factories, many of which were isolated and comparatively inefficient. However, like all his Staffordshire contemporaries, he lived virtually 'over the shop', and so close was his involvement with the factory that his death in 1795 robbed it of its driving force. By this time, however, the Staffordshire potteries, clustered in the Five Towns that today comprise Stoke-on-Trent, had forged themselves into a high-powered industry, after 1770 legally bound together by their Price Agreements. Creamware catalogues in several languages were available for the export trade, while the larger manufacturers such as Neale and Spode also had showrooms in London. New mechanised and highly organised factories were built. Steam engines were used at the Wedgwood and Spode factories for preparing materials, and engine-turning lathes (first

113 (opposite above left). *This superb example of Neale's Jasper Ware, equal in every way to the products of its inventor Wedgwood, commemorates the 1786 trade treaty with France which was of vital importance to the Staffordshire potting industry.*

114 (opposite above right). *New strong, but light, stoneware bodies, which included felspar and the ingredients of hard-paste porcelain, proved ideal as vehicles for the continued use of 18th-century Wedgwood sprigged decoration.*

115 (opposite below). *The need for British-made blue and white tableware increased greatly after 1791, when the import of Chinese porcelain ceased. Delftware was succeeded by pearlware, then, from about 1800, by mass-produced transfer-printed wares.*

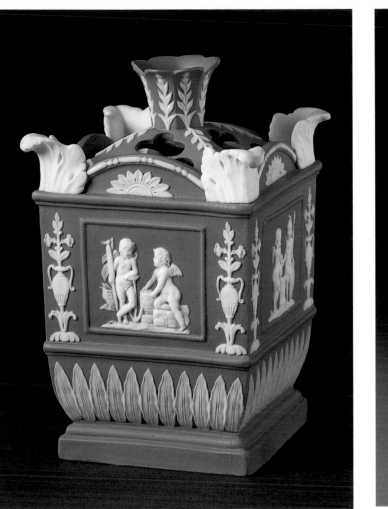

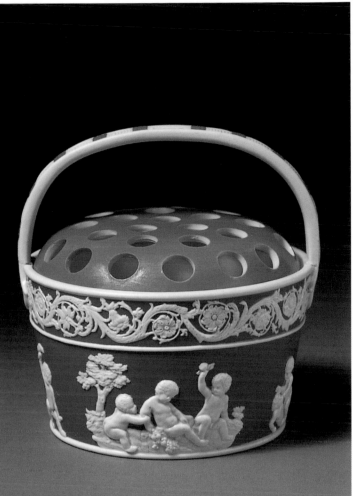

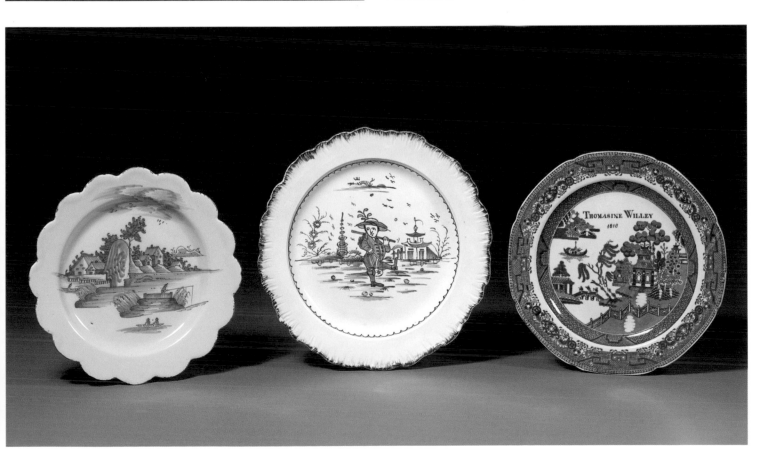

Creamware

From the 1720s a ceramic body with calcined Norfolk flint and white-firing West Country clays was used for salt-glaze, but no attempt was made to adapt it to lead-glazed earthenware until the pioneering experiments of Enoch Booth in the early 1740s. Although his underglaze-blue decoration at the biscuit-fired stage pointed the way forward, at first the new 'cream colour' was decorated with sponged oxides or 'tortoiseshell' decoration. Its future possibilities, however, were seen by Josiah Wedgwood who perfected a matching body and glaze by about 1760, which, although at first used mainly for coloured moulded wares, was refined enough to be transfer-printed, enamel painted or left unadorned. Queen Charlotte's approval of the tea service supplied by Wedgwood in 1765 guaranteed universal acceptance of comparatively cheap earthenware for the smart dining table. The material was produced not only by makers in Staffordshire, but also by those in Bristol, Bovey Tracey, Swansea, Liverpool, the North East and, especially, in the potteries around Leeds. Glutted with creaminess, the public taste was steered towards the blueness of 'pearlware' in the mid 1770s, after which it was adapted for blue and white transfer-printing. However, the taste for plain creamware, made increasingly white to complement or compete with bone-china, survived into the nineteenth century, the last Wedgwood *Catalogue of Shapes* being produced as late as 1880.

116 (below). The austere neo-classical style lingered until the early 19th century, when the whitened creamware provided a perfect background for the fashionable botanical painting. Each piece of a dessert service in this style would bear a different specimen, most of which were copied from engravings in contemporary botanical dictionaries such as those of William Curtis.

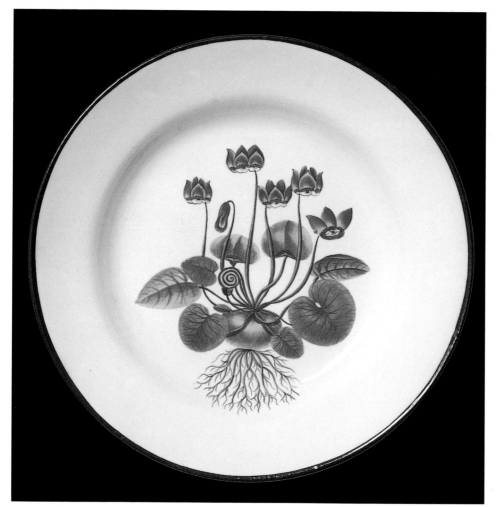

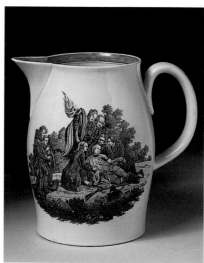

119 (above). The introduction of transfer-printing creamware in the early 1760s provided the opportunity for mass-produced ceramics to reflect social, political and military events. Overglaze black prints, with their simple message, admirably suited the smooth pale jugs and ale mugs. Wolfe's capture of Quebec in 1759 was cause for national celebration, even as late as 1776 when the hugely popular print after Benjamin West's picture of 1771 was published.

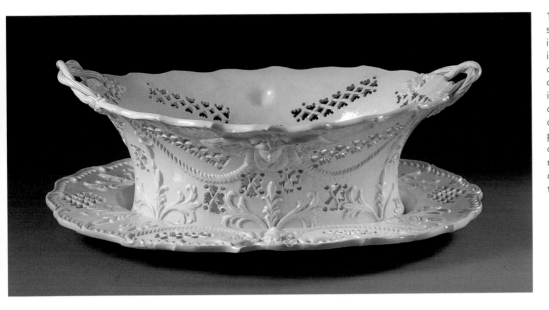

117. The Leeds Pottery, started by a consortium of investors in 1770, immediately produced creamware of excellent quality. Although they were influenced considerably by contemporary Staffordshire creamwares, the Yorkshire potteries achieved a distinctive style of their own, notably with intricate pierced decoration and delicate twisted handles.

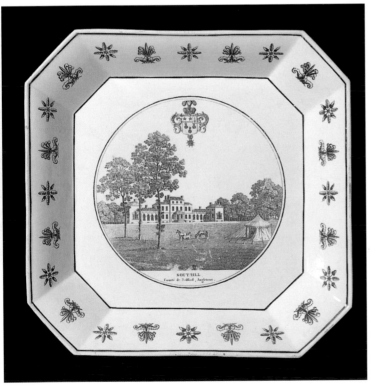

118 (below). The commercial possibilities of Wedgwood's first 1774 *Catalogue* of *Queen's Ware* were obvious to other manufacturers, particularly those intending to export their wares. With ready access to Hull, the Leeds Pottery produced a catalogue in 1794, followed closely by one from the Castleford Pottery, the Don Pottery and, finally, from Sewell of Newcastle as late as the 1820s. The text was often printed in several languages, for example French, German, Spanish and Danish.

120 (above). Versions of English creamware were made in France from the early 1770s, most of the ventures assisted by potters from Staffordshire. At the combined Creil and Montereau factories, the English proprietors had their French-inspired wares printed by a specialist firm in Paris. After the battle of Waterloo in 1815, the return of the French monarchy made English style and views of country houses highly popular in France.

The Staffordshire Factory

Until the mid eighteenth century, many factories subsisted on the output of one kiln, and with such a small number of employees, skilled workers were prepared to turn their hand to any of the various trades involved. Orders were filled, as required, from identical wares made by several potters – a satisfactory arrangement that continued throughout the eighteenth century and beyond. Great master potters, such as John and Thomas Wedgwood of Burslem and Thomas Whieldon of Fenton Vivian, had no ambitions beyond making money from huge quantities of technically perfect but unexciting salt-glaze. When Whieldon retired a rich man in 1780, he became sheriff for the county and demolished his nearby factory to make an ornamental garden. Josiah Wedgwood, however, had dynastic as well as artistic aspirations – after renting existing pothouses, he felt confident enough to make the large investment required to build his 'Etruria' works along the path of the new Trent and Mersey Canal. A model of efficiency in layout, sub-division of labour and factory discipline, the factory's resulting economy and excellence of products (assisted by his invention of the Pyrometer to measure kiln temperatures) provided an example to Staffordshire and the rest of Europe. Benefiting from all this, the next generation of great factories, such as those of Enoch Wood, Josiah Spode and Thomas Minton, were dynastic establishments rather than simply a means of acquiring short-term wealth. The number of kilns increased throughout the nineteenth and early twentieth centuries, earning the largest of the Five Towns the local nickname 'Smoke-on-Stench'. After the Clean Air Act of 1956, electric tunnel-kilns made pottery production an entirely clean process.

121. Josiah Wedgwood called his new factory 'Etruria' in the mistaken belief that the black vases which provided prototypes for his 'Ornamental Works' were Etruscan rather than Greek. Started in 1767, and planned with great care, the factory was producing fashionable vases two years later; but the making of 'useful' wares was only finally moved from the Bell Works, Burslem, in 1773.

122 (below). Enoch Wood's factory, built at Fountain Place, Burslem, in 1789, prospered greatly through mass-producing everyday pottery. Vast quantities of blue-printed wares were exported to North America in the second quarter of the 19th century. In common with all factories, lead-glazing (which gave a brilliant finish) was performed by unskilled labour, often women, in the knowledge that life-expectancy for glaziers was little more than 30 years. Safe substitutes were developed from the early 19th century onwards, although lead-glazing was not banned until after the Second World War.

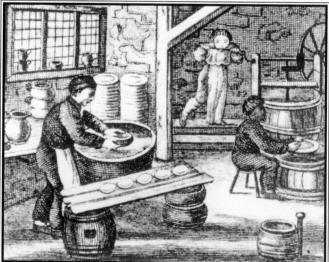

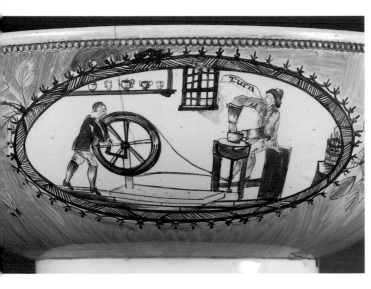

123 (left). Turning the potter's 'great' wheel was traditionally a job for boys, perhaps as young as eight. The well-orchestrated actions which involved the weighing of balls of clay allowed the thrower to work without unnecessary interruption. Finished pots would be lined up on long boards, to be carried away to the 'handler' or 'stouker' and then allowed to dry out before firing. So efficient was this entirely manual system that, at first, steam-power was used only to crush and prepare materials.

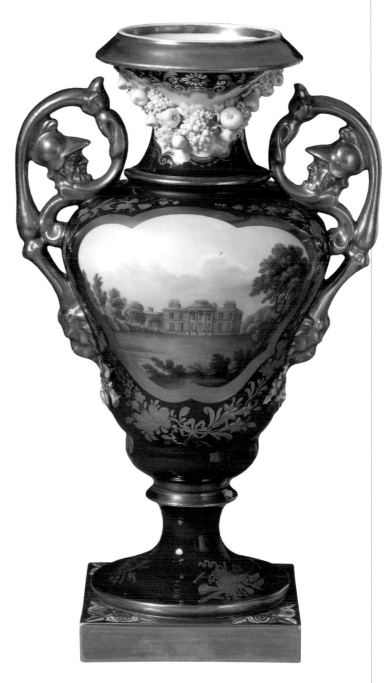

124 (above). Solid salt-glazed 'master' moulds, from which innumerable plaster moulds could be formed, were produced by a few specialist block-makers. As a result of their usefulness and inherent strength, many have survived. The footrims of plates were formed with a profiler (made of creamware) while they were on a spinning convex mould. For tiny applied 'sprigs', factories would acquire a stock of fired earthenware or plaster press-moulds. As working tools, many were inscribed and dated.

125 (right). Within three generations, the Spode family became the most prominent potting family. The earliest and best blue-printed earthenwares, as well as excellent porcelain, was channelled through their London showrooms. In the early 19th century, Josiah Spode II had 48 houses for his workers built at Penkhull in Stoke; then he had his own elegant mansion built (the Mount, shown here), which by 1827 was surrounded by some 50 acres of park.

Transfer-printing

Although John Brooks of Birmingham developed a method of printing enamel boxes in 1751, it was the independent discovery of John Sadler at Liverpool and his patent application of 1756 that applied overglaze printing to ceramics. Printing of flat delftware tiles was soon abandoned in favour of an exclusive contract in 1762 to decorate Wedgwood's creamware. At Worcester, overglaze printing was practised from 1756, and, by 1760, the factory had devised a method of fusing prints onto biscuit porcelain before glazing – a crucial development that was taken up with spectacular success by earthenware-makers after about 1780.

Several transfer methods were employed. At first, a thin flexible 'bat' of gelatinous glue would be pressed onto an engraved plate charged with oil; the bat and its oil outline would be applied to the glazed pot and the resultant sticky print carefully dusted with powdered pigment and fired in a muffle kiln. This method also worked well with the stippled grey 'bat printing' of the early nineteenth century. When fine tissue was invented, this could be printed in a press from a heated copper plate charged with oily enamel pigment (usually cobalt blue) and the paper then cut-up and firmly pressed directly onto the biscuit body. This method facilitated the production of vast quantities of underglaze blue-printed pottery during the nineteenth century. Different colours could be used for printed outlines, which could be almost concealed by enamel decoration. By the 1830s, experiments were afoot to make colour prints, at first simply by inking the same plate with three compatible colours. At the same time, Jesse Austin was perfecting his multi-plate system, whereby separate coloured parts were carefully aligned to produce a whole colour image. This reliable and cheap process was applied especially to pot lids. By the 1880s, lithographic printing methods were being developed.

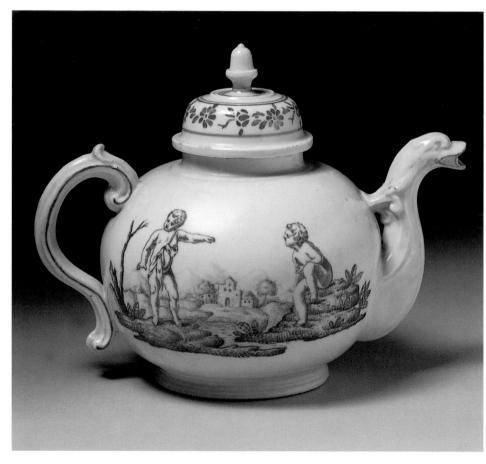

126. Although it was in England that transfer-printing was fully developed for reproducing patterns for tableware, in Italy (probably in the 1750s) the Doccia factory experimented with underglaze printing and stencilling.

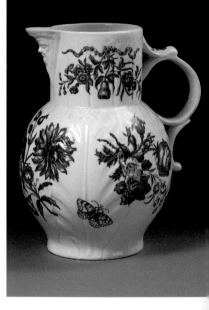

127. At Worcester, where Robert Hancock took his printing expertise in 1757, the technique of underglaze printing was soon perfected. It was even possible to adapt their prints to porcelain moulded in complex shapes, which allowed complete dinner services to be produced with matching decoration at minimal cost.

128. The delicate grey effect of a pencil drawing or lithograph could be reproduced on pottery or porcelain by the stippled 'bat print'. A wide variety of these prints, including topographical views which formed oval vignettes, were used on the chalky white bone-chinas of the early 19th century, especially by the Mason, Spode and Minton factories.

129 (below). By the 1820s, simple bone-china teawares for the modest household were being made by many small potteries. Elaborate *chinoiserie* decoration could be added to these by the use of printed outlines, hand-painted by semi-skilled labour, evidently including children.

130 (left). The blue-printed earthenware that rapidly made the Spodes' fortune was eagerly taken up by many potteries in Staffordshire, Yorkshire, the North East and Scotland. By the 1820s, the technical perfection of these mass-produced objects was astonishing. This jug, estimated to hold 30 gallons, was made as a showpiece for the London dealers Neale & Bailey.

LIBERTY, IMPERIALISM AND MASS-PRODUCTION

By 1800, it had become apparent that the differences between the industrialised ceramic industry of Britain and the subsidised royal porcelain factories of Europe were irreconcilable, and, further, that national attitudes had become hardened. On the one hand, English earthenware was admired throughout Europe for its practicality and low cost, while, on the other hand, Continental porcelain was considered to be expensive and designed for display rather than use. The desire of the prosperous British makers to be taken seriously in terms of art, and the corresponding efforts of the Continental factories to shed their élitist image and to make their inefficient factories profitable, was a dominant preoccupation throughout the first half of the century.

Perhaps inevitably, it was post-Revolutionary France that was to break the traditions and set the trends which the rest of Europe would follow. By the 1790s, the *faience* industry, having adopted elaborate *petit feu* decoration to rival porcelain, had fallen victim to the tough, cheap creamwares imported from England, leaving the Sèvres factory to uphold French supremacy in porcelain in the face of increasing competition from a vigorous band of new Paris factories. The close involvement of Sèvres with the *Ancien Régime* ensured its neglect but not its destruction by revolutionaries, until the enlightened appointment by Napoleon of the scientist Alexandre Brogniart as art director in 1800 set the factory on a new course.

Brogniart's scientific and analytical approach to the factory's problems were highly successful. Abandoning the expensive soft-paste in 1801 and clearing old stock from the warehouses, he concentrated on making a range of simple and strong neo-classical forms in a fine improved hard-paste. Extravagant painting of the plain surfaces (fig. 131) rendered these ideal for diplomatic gifts and for re-furnishing the royal palaces. The so-called

'Marshall's Table', designed by Napoleon's architect Charles Percier (creator of the Empire style) and painted with miniature portraits by Isabey demonstrated the full possibilities of the marriage of porcelain, architecture and painting. As Paris prospered, so the factory was patronised by a new aristocracy. Brogniart had complete artistic control over the factory's output and employed the best painters available. However, as France was unable to export during the Napoleonic Wars, the pioneering use of decoration in the Gothic and Turkish styles, and even imitation cameos and Florentine micro-mosaic, was not immediately taken up elsewhere.

In 1804, the factory became 'Manufacture Impériale de Sèvres' and, despite increasing its staff numbers to pre-Revolutionary levels and maintaining the family structure (whereby up to six generations of workers were successively employed), it even became profitable until the restoration of the monarchy in 1814. In common with other Continental factories, the fortunes of Sèvres were entirely dependent on the political situation. These in turn were deeply affected throughout the nineteenth century by the rise of nationalism, the collapse of the old ruling houses and the formation of a unified Germany. In the case of Sèvres, its subsidy and patronage varied with the tastes of the monarch and the status of France in Europe. Brogniart's innovations were not appreciated by Louis XVIII and Charles X; and, after the July Revolution of 1830 (when Louis-Philippe was elected by parliament to the throne) and in the absence of extravagant royal spending (fig. 132), only the increasing wealth

131 (opposite above). *All-enveloping painting of plain porcelain shapes characterised the Empire style, here shown to full advantage in the richly coloured interpretation of de la Fontaine's* Fables *by Charles Develly.*

132 (opposite below). *To the disappointment of the Sèvres factory and its director Brogniart, Louis-Philippe's choice of porcelain for the Royal Palaces in the 1840s was distinctly austere.*

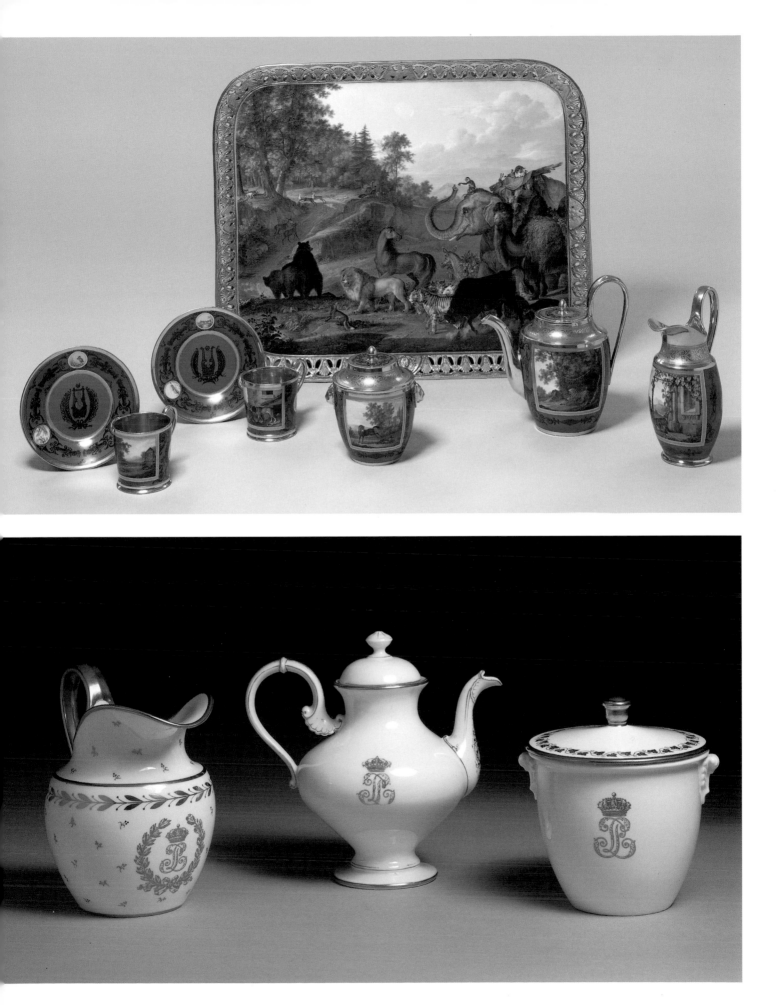

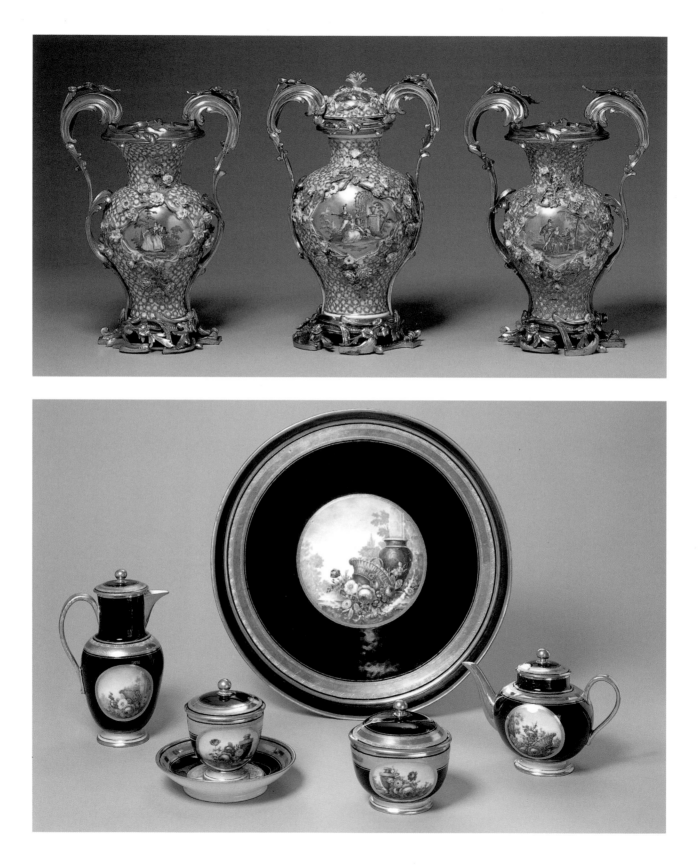

of the bourgeoisie provided adequate patronage for such superb porcelain. With the employment of skilled artists, painting styles were heavily influenced by the Romantic Movement; from there, it was but a short step to the copying of Old Masters onto porcelain, and to scenes from the glorious early history of France. By the time of Brogniart's death in 1847, the factory, like the rest of Europe, was immersed in historicism.

From as early as 1798, exhibitions of industry and the industrial arts had been held in Paris, an example soon followed by Stuttgart, Munich and Leipzig. These attempts to create a fusion between art and industry – exemplified by Brogniart the scientist's Service des Arts Industriels painted by Charles Develly in 1835 – characterised the first half of the nineteenth century. Besides the technical improvements necessary to make factories efficient, the training of artists and the provision of subjects and models for copying was taken very seriously. The opening of the Sèvres Museum in 1824 (the result of many years of active collecting), although intended to inspire French ceramic artists in general, also undoubtedly enabled the factory to produce its copies of Old Dresden and Limoges enamels at the 1849 Exhibition of French Industry in London.

The example set by Sèvres, in its management by a scientist, its perfection of a reliable paste, its highly accomplished painting on a limited range of Empire-style vases (for example, the popular 'Medici'), and its dependency on the past for inspiration, was copied by many of the major Continental factories. In a difficult economic climate, factories fell or prospered according to their ability to modernise and adapt to changing fashion. The first and most famous factory at Meissen had, by the 1820s, lost ground to Berlin and Vienna and was in danger of closure. Only improved management, the re-manufacture of old Kaendler figures and flower-encrusted vases for the English market (fig. 133), the

making of newly invented lithophanes, the development of a cheap liquid 'gloss gold' and a change to state control in 1831 eventually made the Meissen factory profitable. Further economies included making wares in moulds intended for pressed-glass.

In Berlin, the new director appointed in 1832 was Georg Frick, a chemist whose workable paste and new colours, combined with vessel shapes designed by Schinkel and his circle, helped to maintain its position and its aristocratic patronage. Other factories protected from economic reality were Nymphenberg, where King Ludwig I supported the lavish production of royal commissions in the neo-classical style until his death in 1848, and St Petersburg (fig. 134), where no industrialisation was allowed and where the Empire-style crater and amphora continued to be made in the old ways. Under Tsar Nicholas I (1825–55) copies of eighteenth-century Sèvres and Meissen were added to the repertoire, while other major factories, such as Gardner in Moscow (fig. 135), made stylised but evocative sets of figures of Russian peoples. In Italy, the Doccia factory survived unscathed by making objects in the universal Empire

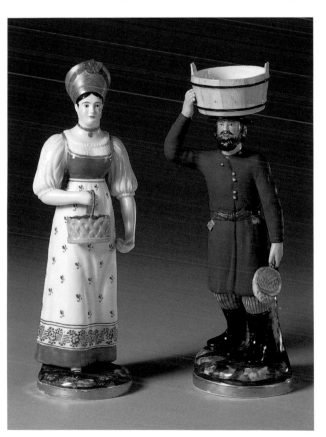

133 (opposite above). *The revived 18th-century porcelains made at Meissen from the 1820s onwards were of the highest quality. These ormulu-mounted vases have only recently been re-assessed as dating from the 19th century.*

134 (opposite below). *By the middle of the 19th century, the products of the Tsar's porcelain factory at St Petersburg, although technically excellent, were somewhat old fashioned.*

135 (right). *The Gardner factory in Moscow excelled in making fine porcelain figures of peasants and peoples of the Russian Empire, with all their colourful and widely differing costumes.*

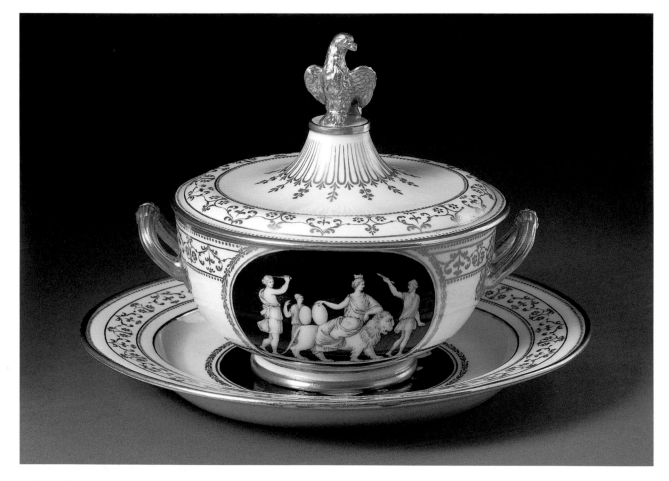

style, and later the famous stipple-painted moulded bas-relief porcelains which were also copied in Germany. The Naples factory also depended heavily on neo-classicism (fig. 136).

Age and reputation were no guarantee of survival. At Fürstenberg, the factory declined until the Duke of Brunswick had to lease it in 1859. In Vienna, the factory flourished until the 1820s after which, rather surprisingly, it declined in the 'Biedermeier' period of the 1830s to 1840s, despite the appointment of a chemist as director in 1827. The mistaken use of a cheap paste, which cut costs to the detriment of standards, hastened the final closure in 1866 – after which the famous shield mark was used by a multitude of imitators.

For the earthenware mass market, besides the traditional slipwares which continued to be made in Eastern Europe as well as Germany (fig. 137), Austria and Switzerland, more refined earthenware tablewares, especially copies of English creamwares and transfer-printed wares were mass-produced in Germany and Scandinavia.

136. At Naples, the influence from nearby Herculaneum and Pompeii lingered on. Cameos, and wall-paintings were adapted to decorate the rich soft-paste.

Taking advantage of the continuing exports from Britain, migrant English potters also established factories abroad, taking with them moulds and copper-plates. Although closely based on Staffordshire prototypes, these products eventually acquired national characteristics, as shown in the catalogues issued by Gustavsberg and Rörstrand in Sweden. Besides the utilitarian tablewares, pottery soon found a new role in supplying the demand for historicist ceramics, as described below. However, in the numerous small porcelain factories, major advances were taking place.

By 1800, relatively cheap porcelain tableware was widely available; and as the material itself now held no mystery, it was the decoration that became of paramount importance. Following the success of the interdependent Staffordshire factories, and the victories obtained by small Parisian factories over the Sèvres monopoly in the

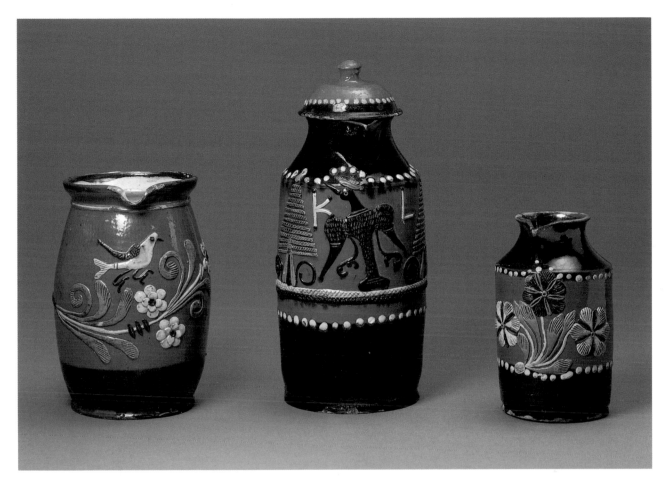

137. *The slipware tradition, often quite unaffected by historicism, continued through the 19th century in Eastern and Northern Europe, as well as in Britain. At Marburg, the stained clay was treated like pastry or marzipan.*

years before the Revolution, it became clear that money was to be made by small progressive new factories at the expense of the cumbersome older establishments. In Paris, popular porcelains in the Empire style quickly adapted to the neo-rococo (fig. 138) and the Gothic styles that became fashionable from the 1830s under Louis-Philippe. The principal exponent, Jacob Petit, prospered until the 1860s, by which time the unstable political situation and the high cost of importing raw materials had driven porcelain manufacturers towards the source of the kaolin, Limoges, which was linked to Paris by railway from 1857. In Germany, 20 new factories were founded in the ancient potting district of Thuringia in the first half of the nineteenth century, with a further 15 shortly afterwards and subsidiary factories near the source of kaolin in the Bavarian forests. Similar develop-

ments occurred in Bohemia, where the Schlaggenwald and Pirkenhammer factories excelled during the Biedermeier period. In Russia, a grouping of porcelain factories formed in the Gzhel area.

In Britain, the beginning of the nineteenth century heralded a number of changes in direction after the cost-effective production methods pioneered in Staffordshire by Wedgwood and his contemporaries. In the absence of state or aristocratic patronage, the porcelain factories had relied entirely on the skill of their management, often consisting of a partnership between entrepreneurs and practical potters; and, as the greatest demand was for cheap elegant but sturdy tablewares to replace those formerly imported by the East India Company, it was the old London firms (hampered by expensive production costs) that foundered while in the provinces Worcester and Derby prospered. With the establishment of New Hall at Shelton, and the invention by Neale of bone-china, by 1800 the mass-production of utilitarian porcelain had become centred on Staffordshire. Unlike

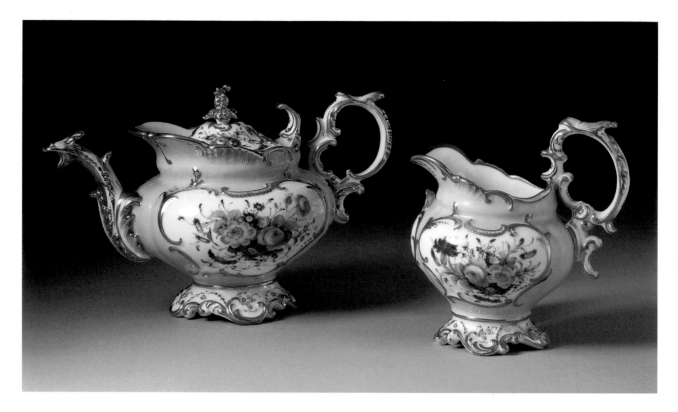

138 (above). *When the Parisian factories adopted the neo-rococo style in the 1830s, it was to contemporary Staffordshire models that they turned.*

139 (right). *Much of Billingley's output at Swansea and Nantgarw was decorated in London, but his own famous roses admirably suited the snow-white soft-paste, which attempted to copy Sèvres porcelain of the eighteenth century.*

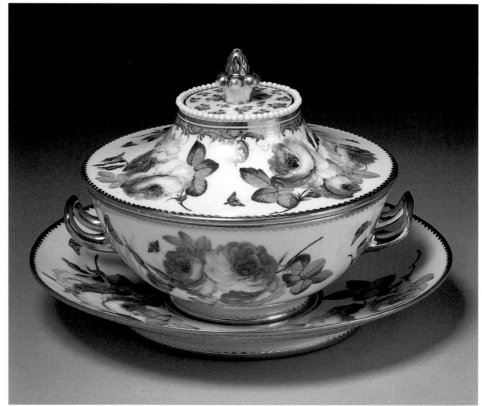

140. (right) *In the early 19th century, Thomas Baxter's enamelling studio in London was responsible for some of the highest quality painting on the porcelains of Worcester, Coalport and others.*

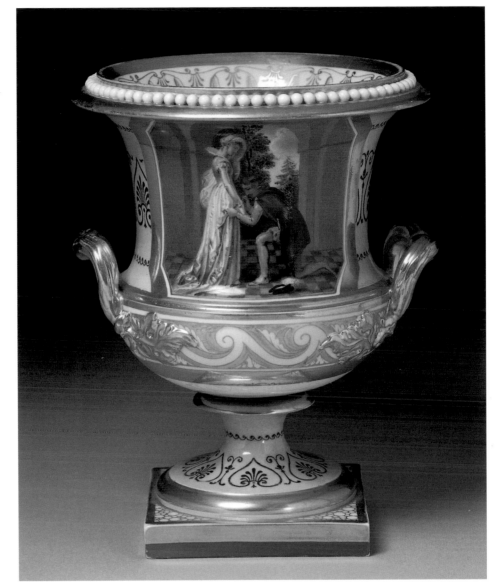

the Continent, where new exclusively porcelain factories had sprung up around kaolin deposits, in England the new firms such as Spode, Davenport, Mason, Minton and Ridgway preferred the proven benefits of a Staffordshire location and the versatility of a complementary range of useful pottery and decorative bone-china. The makers of hybrid hard-paste, and by 1812 even New Hall itself, all converted to bone-china. So reliable was the formula (half hard-paste ingredients and half calcined bone-ash) that, by the 1820s, it was widely used for cheap printed cottage teawares and ornaments (fig. 129). It had become, in fact, the porcelain equivalent of creamware. Meanwhile, traditional soft-paste porcelains continued to

be made at Derby and Worcester, providing an excellent background for the painted landscapes, shells and flowers of the early nineteenth century. Many Derby decorators can be identified, as can the work of the Daniels at Spode. The superb work of Thomas Baxter on neo-classical vases (fig. 140), although on a smaller scale, may justly be compared to Continental painting of the Empire period.

At the same time, the enduring taste for obsolete French soft-paste led William Billingsley to develop his glassy paste at Nantgarw and Swansea (fig. 139). The secret of Sèvres soft-paste – whitened with alum and glazed with lead – was unknown, but in the early 1820s

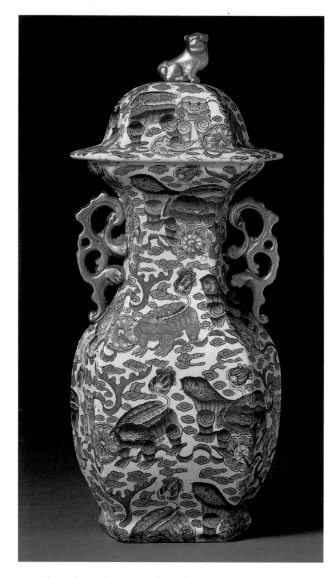

142. *The traditional Mason products shown at the Great Exhibition just before the firm's closure showed that Ironstone, although enduringly popular, was incapable of stylistic advance.*

products of Coalport (fig. 141) and Rockingham, proved an enduring fashion. Vast amounts of bone-china tableware were produced by firms such as Ridgway, Coalport, Spode and Minton, with the rococo forms coarsening gradually by the middle of the century. Figures – mainly copies of old models – continued to be made. However, reminiscence over the perfection of Derby and Sèvres biscuit prompted the simultaneous experiments by Copeland and Minton that in the 1840s produced an entirely new and highly successful ceramic body called 'Statuary Porcelain' or Parian (p. 112). Glazed Parian was later made at Belleek (Ireland), using the nacreous glaze patented by Brianchon in 1857.

Not surprisingly, given the predominance of the Staffordshire pottery industry, it was in earthenware and stoneware that the most radical changes took place. From about 1800, Josiah Spode began successfully retailing his thinly potted and crisply printed earthenwares through his London showrooms, so that by 1806 even Wedgwoods had turned to transfer-printing. *Chinoiserie* and the ever-popular Willow Pattern (fig. 115) soon gave way to views of India plagiarised from travel books, as well as fanciful villas and classical ruins. Inky blue paled in the 1820s and became the dark blurred 'flown blue' of the 1840s, to be joined by pink, green and later grey. A much cheaper form of printing, using cut sponges dipped in coloured pigments, was developed by the Scottish potteries, mainly for export. For other markets, equally practical but more colourful wares evolved. Mason's Patent Ironstone of 1813 (fig. 142), a heavy and highly durable material usually outline-printed and painted with the 'Japan' patterns equally popular on porcelains, was widely imitated and is still made. Lustre – silver (from platinum) and copper – was re-invented in 1806 and used for printed earthenware jugs, particularly in Sunderland. The inclusion of hard-paste ingredients gave refinement and translucency to a variety of relief-decorated drybodied jugs, mugs and teapots, notably the moulded 'Castleford Ware'.

Basalt and caneware remained popular forms of stoneware, culminating in the putty-coloured drabwares of the 1820s, and, by 1835, the first press-moulded jugs were made in bewildering variety by firms such as Ridgway, Charles Meigh and later William Brownfield. Stoneware was also used in the floor-tile industry, pioneered in earthenware by Chamberlains at Worcester,

Coalport, Spode and Minton created a successful new body using felspar; and, by the 1840s, serious copies of Sèvres models were being made, the exactness of which was ensured by links between Minton and Sèvres. These coincided with the beginnings of collecting of Sèvres, which, occurring simultaneously in France, was not discouraged by Brogniart who had originally fostered the taste by authorising the disposal of Sèvres blanks to dealers and decorators in 1802 and 1815. Besides the craze for Sèvres soft-paste, from the 1820s the neo-rococo style of applied flowers in 'Dresden' style, typified by the

141 (opposite). *The rococo revival of the 1820s brought back the taste for 18th-century Meissen, soon taken to excess at Coalport.*

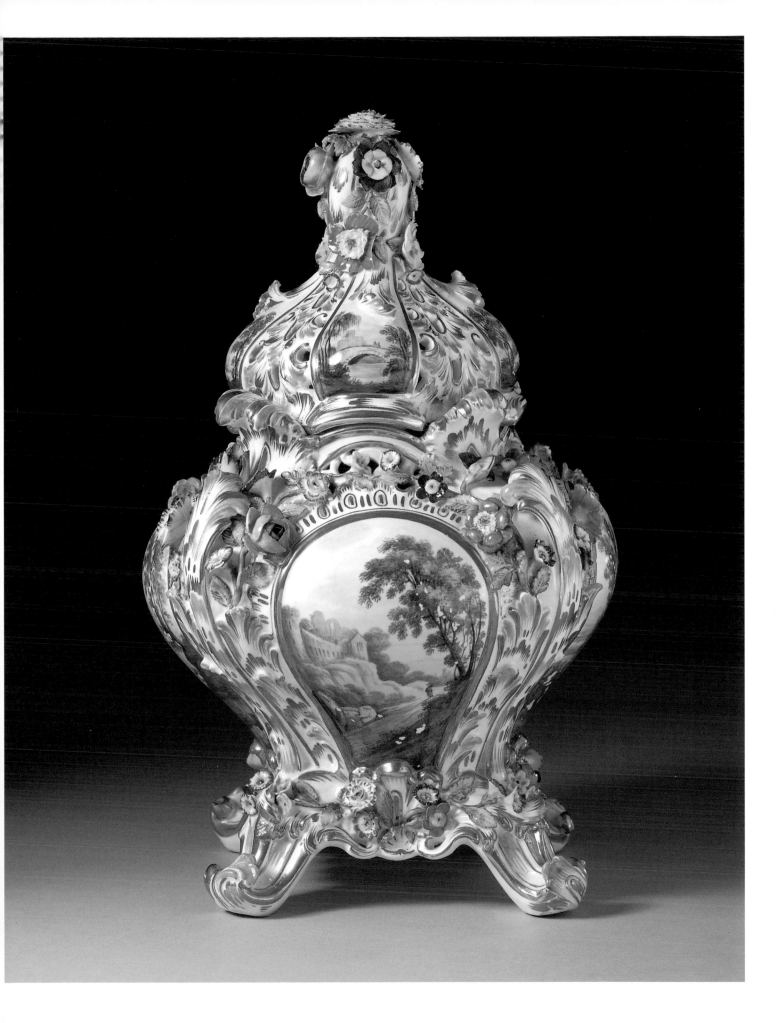

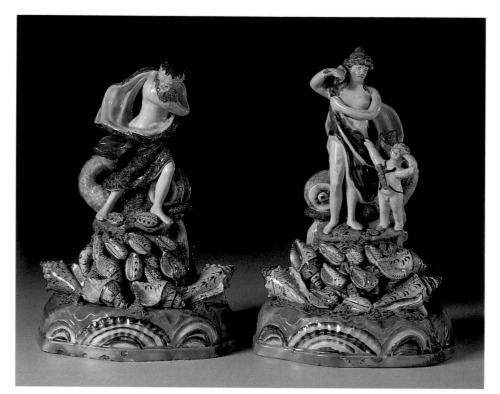

143 (left). *Between the austerity of pearlware figures and the gaudiness of flatbacks, Staffordshire figures of the early 19th century achieved a high point, copying porcelain models but using bright red, green and yellow chrome colours in rainbow effects.*

144 (opposite). *Joseph Paxton's engineering and architectural triumph, the so-called Crystal Palace of 1851, which enclosed the largest trade fair the world had seen, encouraged rising earthenware and stoneware potters such as Charles Meigh to produce outstanding show pieces.*

but carried to its ultimate development at Mintons, where screw presses enabled huge numbers of tough encaustic tiles to be made for the nineteenth-century building boom. In the second half of the century, enterprising new tile-makers, such as Maw & Co. of Broseley and Craven Dunnill & Co. of Jackfield, set up ultra-efficient factories near the source of suitable clay and coal.

Cheaply press-moulded figures formed almost the entire output of many small Staffordshire potteries. From the partly moulded and partly hand-modelled figures of the early nineteenth century – usually decorated in bright colours, including the new chrome pink, green and yellow (fig. 143) – evolved the 'flatbacks' of the 1840s onwards which were simply made in two-piece moulds and aimed at the popular market.

The huge advantages of the excellent and practical ceramic bodies available in Britain might not have been fully exploited but for the happy collaboration of the most important Staffordshire potter, Herbert Minton, and the inspired educationalist Henry Cole. As elsewhere in Europe, growing concern about design was expressed as early as the 1830s: the London Art Union, which drew prizes for its subscribers and which later was to popularise Parian Ware, was established in 1836, and the London School of Design was established the following

year. Copyright protection afforded by Design Registration was available from 1842, and by 1849 Mintons had appointed a new art director, Leon Arnoux, whose moulded *majolica* decorated with brilliant translucent glazes appeared almost immediately. At this juncture, in an attempt to redress a general feeling of national inferiority in design, a combination of the great wealth of Britain, the passionate interest of Minton and Cole and the patronage of Prince Albert gave birth to the Great Exhibition of the Works of Industry of All Nations 1851, the 'Great Exhibition' (fig. 144). Henceforth, the styles and forms adopted by the ceramic arts of Europe, constantly held up for comparison in the exhibitions which followed (Paris 1855, London 1862, Paris 1867, Vienna 1873 and Paris 1878, 1889 and 1900) may be considered together as international.

The final fading of the Empire style around the middle of the century coincided with a management crisis at Meissen, where the head painter and head modeller retired or died, at Berlin where Frick died in 1848, at Nymphenberg where Ludwig I abdicated in 1848, and at Sèvres with the death of Brogniart in 1847 and another Revolution the following year. At Meissen, the technical director, Kuhn, took over and transformed the efficiency and standards of production, relying particularly on

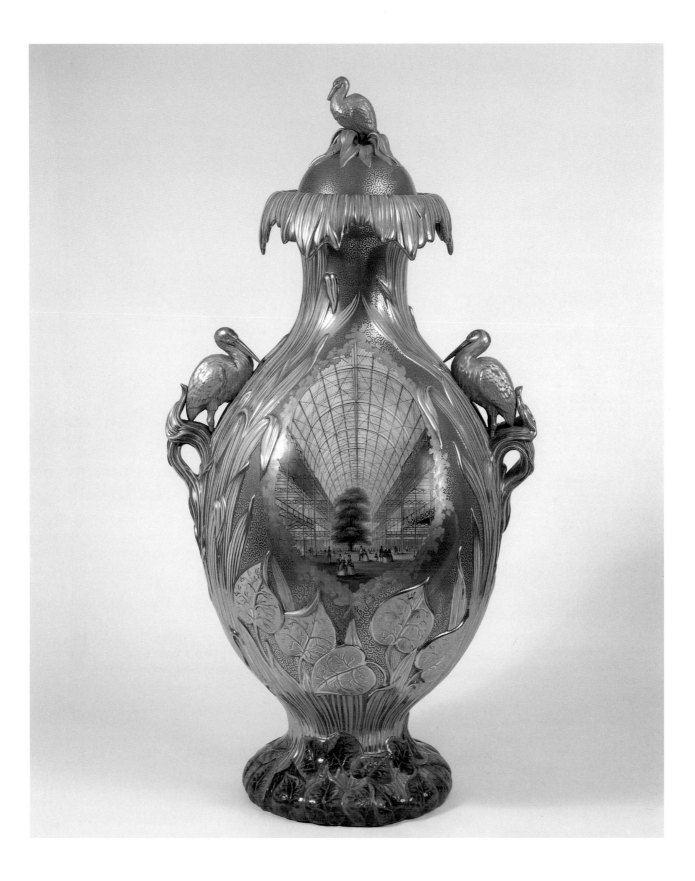

figures, both old and new. At Berlin, where the new director, Kolbe, who started a factory museum to provide models, was succeeded by the famous Seger (inventor of the Seger Cone Pyrometer), a taste for sumptuous painting was soon allied to the third rococo style. Elsewhere, the rapidly increasing numbers of Thuringian factories – notably Carl Thieme at Potschappel and those at Sitzendorf and Rudolstadt – re-created and enhanced a lost world of eighteenth-century gallants, culminating in the 'crinoline' figures using real lace dipped in porcelain slip. At Damm in Bavaria, eighteenth-century models by Melchior were reproduced in earthenware from the old Höchst moulds, and later in porcelain by Franz Mehlem of Bonn.

While old styles continued and overlapped with new fashions, one notable success of the Great Exhibition was the combination of modern technology with historicist form and ornament to produce the 'neo-Renaissance' style, which was first expressed, in a consciously purist way, through the medium of earthenware, and which

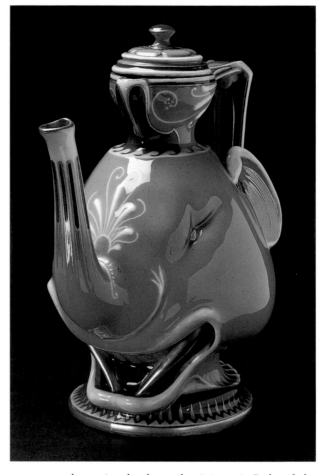

145 (left). *The neo-classicism of the mid 19th century was more commercial. Samuel Alcock applied transfer-printing and a porcelain body to make pastiche Greek vases.*

146 (right). *Marc Louis Solon's fertile imagination was harnessed to the production of high-quality porcelain at the Sèvres factory, shown (as this example) at the 1862 Exhibition in London.*

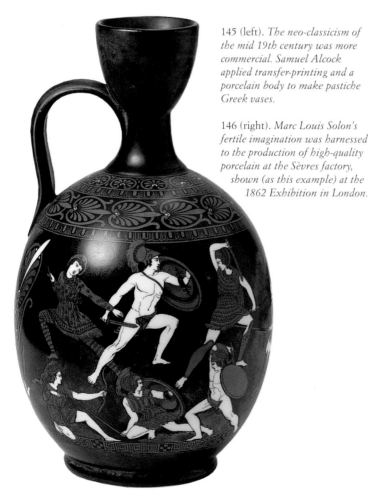

represented a swing back to classicism via Italy of the fifteenth and sixteenth centuries. In France, Avisseau, Pull and Landais (fig. 25) made versions of Palissy wares; and the new Minton *majolica* in the style of Palissy proved so popular that the Sèvres factory set up a rival earthenware studio in 1852. Ceramics moved closer to architecture, so that tile-makers (notably Mintons) produced architectural schemes based around brightly glazed *majolica* cladding. Convincing copies of Raeren and Westerwald stonewares came from the revived Rhineland potteries, just as the old Venetian glasshouses took on a new life by re-discovering the techniques of making Renaissance-style glass. Symmetrical surface ornament, strapwork and grotesques abounded. The models provided by museums, such as the Musée de Sèvres and Henry Cole's great establishment at South Kensington (built with profits at the Great Exhibition), were copied directly by modellers from the more progressive potteries. True *maiolica* was reproduced in Italy, particularly after 1878 by the Cantagalli factory at

147. *The possibilities of* pâte-sur-pâte *decoration, which admirably reproduced the painting of Limoges enamels, were extensively explored by Solon before his move to Mintons in Stoke in 1870.*

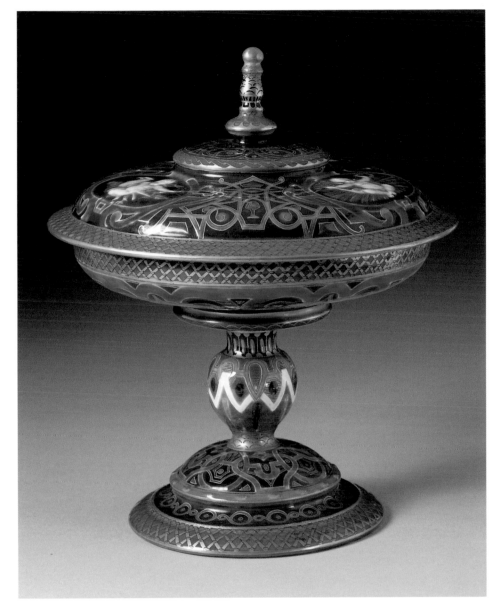

Florence, just as the eighteenth-century *faience* of Rouen and Nevers was reproduced in France. In England, Mintons experimented with a version of *maiolica* painted with the somewhat academic designs of Alfred Stevens, William Wise and others; the fullest expression of this being the Minton Art Studio in Kensington (1871–5) operating under W.S. Coleman.

Eventually, porcelain was applied to these neo-Renaissance wares, even to the imitation of Greek red-figure vases by firms such as Samuel Alcock (fig. 145). The technically brilliant copies of black and white Limoges enamels made by the Minton and Worcester factories were made possible by the introduction of the *pâte-sur-pâte* decoration which had been developed at Sèvres by Gély in the 1850s, and subsequently used there to great effect by Marc Louis Solon (figs 146 and 147). Solon's appointment as art director at Mintons in 1870 represented the happy combination of British wealth and the French artistic excellence which eventually led, after the Franco-Prussian War, to a considerable colony of French ceramic artists settling in the Potteries.

Whether or not the Great Exhibition 'revealed a style-less eclecticism without practical purpose and an orgiastic celebration of the machine's technical prowess' (Robin

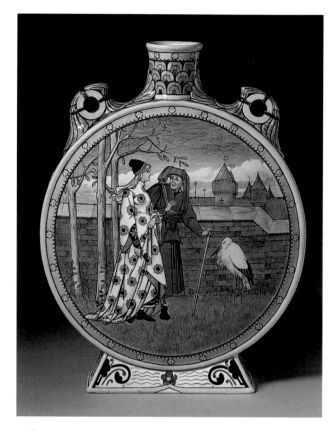

148 (above). *Yearnings for the simple and chivalrous medieval past found expression in the writings of William Morris and in the art of H. Stacy Marks.*

149 (right). *By the 1880s, the cult of Japan had penetrated the market for commercial pottery, which still included elements of Adam and Louis XVI. In the eclectic decoration of these household articles, it is also possible to detect Egyptian influence.*

extravagance of the third rococo. If Japanese ceramics offered comparatively little scope for direct reproduction, the possibilities of adapting the neat patterns of Japanese *cloisonné* enamels were fully exploited by Dr Christopher Dresser, whose training as a botanist also enabled him to convert natural forms to geometrical patterns suitable for the applied arts, particularly Minton porcelains with crisp profiles and decoration. More literal borrowings were made at the Royal Worcester Porcelain Co. with James Hadley's moon vases.

The love of pattern, fuelled by works such as Owen Jones' *Grammar of Ornament* (1856) also found expression in borrowings from the Islamic world, epitomised by the lustre designs of William De Morgan (fig. 150). At the same time, art pottery attracted creative artists whose designs combined fantasy of form and decoration (fig. 151). The love of nature, however, as popularised by the writings of Dresser, gradually fused with a growing interest in handcrafts and the simple ways of the past (exemplified by the pre-Wedgwood Staffordshire slipware pottery of the type shown in Enoch Wood's factory museum from as early as 1816, and avidly collected by

Spencer, 1972), the seeds of destruction of this neo-Renaissance style were already being sown in the 1850s by the emerging Pre-Raphaelite Brotherhood and the Utopian medievalism of William Morris and his followers (fig. 148). Morris's London furnishing firm, established in 1861, and his writings, carried great weight in Europe as did those of John Ruskin. The associated Gothic style propagated through the designs of Pugin, was embraced as an architectural form based on pure structure. It was not a major leap from this to the supposed architectural purity of Japan, which began to trade with the West after its first showing at the 1862 London Exhibition. Although more readily applicable to furniture, the Japanese style rapidly took over the avant garde ceramics market, leaving less-fashionable products (fig. 149) to reflect the taste of Louis XVI, the Adam brothers and eventually the ornate

M.L. Solon) and the liberating effects of Japanese influence of the 1870s. Dresser's hand was to be seen in the loose forms and streaky glazes of potteries such as Linthorpe and Swadlincote (fig. 152), while old country potteries turned their hands to making 'ancient' wares to furnish fashionable houses, old and new. Of more immediate importance was the revived interest in salt-glazed stoneware and its random glaze effects. Highly idiosyncratic one-off pots, heavily influenced by Japanese Satsuma wares, were made by the eccentric Martin brothers at Southall (fig. 21), while commercial pots, originally based on Renaissance German prototypes but individually decorated by students of the Lambeth School of Art, were produced by the largest maker of functional brown stonewares, Henry Doulton of Lambeth.

While the cult of Japan was adopted by the aesthetic movement and served to release the arts from the restrictive conventions of classicism, in France it was the showing of rough Bizen and Seto stonewares at the 1868 Paris Exhibition that provided the stimulus for a completely new movement which wholly abandoned

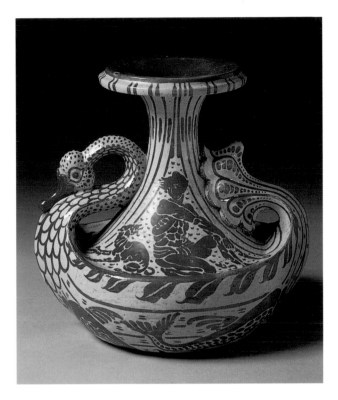

150 (left). The lustre designs of William de Morgan, inspired by Hispano-Moresque and Near-Eastern pottery, were unparalleled in Europe in the last quarter of the 19th century.

151 (right). Besides his role as art referee for the South Kensington Museum, Walter Crane was a noted illustrator and designer, especially for series of printed tiles.

ornament. Already tending towards abstraction, French painters were joined in the second half of the nineteenth century by *ceramistes* whose artistic wares looked towards Turkey (fig. 153) and the Far East. The earliest of these, Théodore Deck, collaborated with the painter and printmaker Félix Bracquemond when he turned to ceramics in 1867. Bracquemond in turn worked at Sèvres and Limoges, and Deck developed special porcelain pastes for the *flambé* (copper transmutation glazes) and *crystalline* wares made at Sèvres. Despite running at a loss until its drastic re-organisation in 1896, the factory managed to employ the sculptors Carrier de Belleuse (1876–86) and Auguste Rodin (1879–82) as well as other leading artists of the period. From 1900, it found a new role in making huge vases in the full-blown art nouveau style with swirling glazes, as well as stoneware designed by the architect of the Paris Metro, Hector Guimard. At the 1900 Paris Exhibition, Chaplet exhibited *flambé* glazed porcelains, while high quality stonewares were shown by the leading ceramists Dalpayrat, Delaherche (fig. 154), Lachenal and Doat.

Meanwhile, however, the initiative had passed to Denmark, where the national severe neo-classicism of the sculptor Thorvaldsen had been abruptly replaced in the 1880s by a craving for exoticism. The 'Heron Service' in

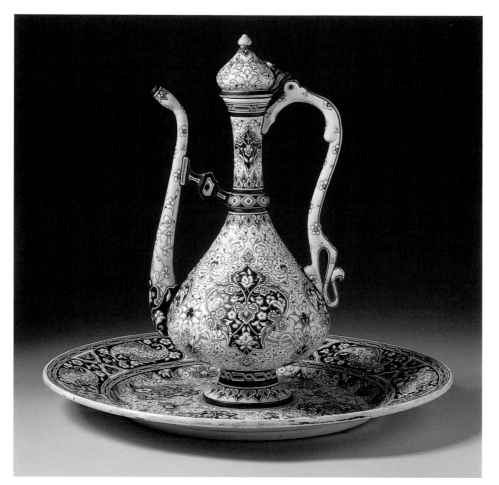

153 (left). *In France, influence from the Near East was especially strong after the mid 19th century. Cloisonné shapes and decoration were freely translated into ceramics.*

152 (below left). *Although Christopher Dresser was well known for his geometric plant-form decoration, his three-dimensional organic designs for several art potteries have an unexpected freedom.*

154 (below). *The quest for the secrets of high-temperature copper-transmutation glazes was a major preoccupation of 19th-century French artist potters. August Delaherche was one of the most successful.*

155 (opposite). *The beginnings of art nouveau, combined with the contemporary Japanese taste, appeared early in Denmark, where Pietro Krohn designed the 'Heron Service', which was shown at the 1889 Paris Exhibition.*

Japanese taste designed by Pietro Krohn at Bing & Grøndahl in 1886–8 exhibited marked leanings towards art nouveau (fig. 155), while at the Royal Copenhagen factory the architect and painter Arnold Krog invented misty grey underglaze slip-painting. His uncompromisingly modern figures derived their forms from a deliberate dependency on the single-mould slip-casting process, after the manner of moulded jellies. The further abstraction offered by the invention of *crystalline* (zinc-silicate) glazes by the Royal Copenhagen factory's chemist, Clement, in 1886, as well as the appointment of Alf Wallander as art director at Rörstrand in 1900, heralded the successes of Denmark and Sweden at the 1900 Paris Exhibition and the importance of Scandinavia in the next century.

Empire Style, Regency Style

The style adopted after the crowning of Napoleon as Emperor in 1804 until his defeat in 1814 not only roughly coincided with the British Regency (1800–20), but also shared its French origin. Fundamentally an architectural style, it was created by Napoleon's architect and interior designer Charles Percier, whose published designs and friendship with the English architect Thomas Hope helped its spread across the Channel. As applied to ceramics, it involved exclusively the porcelain factories of Sèvres and Paris in France, and especially Derby and Worcester in England. Strong neo-classical forms offered large plain areas for luxurious decoration by the best painters available, while details of shape and painted borders relied heavily on a repertoire of designs borrowed from Greece, Rome and, after Napoleon's successful campaigns, Egypt. In a century in which European politics alternated between the rule of Republic and Emperor, the Empire style remained of use to successive royal houses in France, Germany, Austria and Russia for over 50 years, with Russia as the last serious exponent. Huge porcelain display vases of crater and amphora shape provided grand furnishings for palaces as well as diplomatic gifts for foreign heads of state.

157 (above). The superb decoration of Thomas Baxter Jr came closest to the painting found on Continental porcelains of the early 19th century. In 1797, Thomas Baxter Sr, a decorator at Worcester, set up a decorating studio at Gough Square in London – the subject of this watercolour which his son exhibited at the Royal Academy in 1811.

158 (right). Of the new porcelain factories founded at the beginning of the 19th century, the more progressive firms, such as Spode and Coalport, took up elements of the fashionable Regency style. Moulded forms, copying classical bronzes for example, required minimal painted decoration.

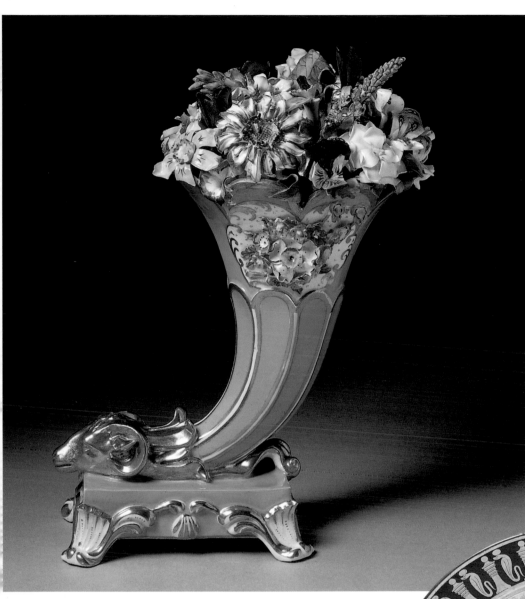

156 (left). At the Derby factory, severe classical forms became tempered by elements of the neo-rococo.

159 (below left). In Italy, the manufacture of fashionable Empire-style ceramics in the early 19th century was limited to the Kingdom of Naples (then under French rule). Using a version of English creamware, Greek forms were adapted and combined with decoration of 'Etruscan' type.

160 (below). The huge Sèvres 'Service Egyptien', with plates painted by Swebach of views of ancient Egypt deriving from Vivant Denon's participation in Napoleon's invasion of Egypt in 1798, is perhaps the ultimate expression of Empire style. Ordered by the Empress Josephine as part of her divorce settlement, it was rejected when completed in 1812, and eventually presented to the Duke of Wellington in 1818.

Minton

The factory founded by Thomas Minton at Stoke-on-Trent in 1793 followed the pattern of Wedgwood in moving rapidly from utilitarian but lucrative products to artistic ceramics designed for an élite market. Once the mass-production of fine blue-printed pottery and conventional bone-china teawares with simple patterns had established Minton's reputation, the meteoric expansion in the 1820s enabled Herbert Minton (1793–1858) to develop sophisticated figures and bone-china versions of eighteenth-century Meissen and Sèvres of the highest quality. His subsequent friendship with Henry Cole and involvement with his Summerly Art Manufacture, the pioneering development of encaustic tiles, the perfection of Parian about 1846, and the invention of *majolica* by Léon Arnoux in 1849 made Minton the leading manufacturer by the middle of the century. The dynasty continued with Colin Minton Campbell (1827–85). With wealth and influence, the factory could draw artists from France, notably M.L. Solon who introduced the *pâte-sur-pâte* technique on his arrival in 1870, and the modellers Carrier de Belleuse and Émile Jeannest. Talented artists, such as Lawton, Kirkby and Lockett, decorated neo-Renaissance wares in styles combining Italian *maiolica* with Limoges enamels, while in the 1870s Toft made reproductions of Saint-Porchaire. The Minton Art Studio in Kensington, in attempting to merge painting with pottery, depended largely on the talent of W.S. Coleman. Always in the forefront of ceramic innovation, Mintons introduced tube-lined art nouveau designs in its Secessionist Ware from 1902.

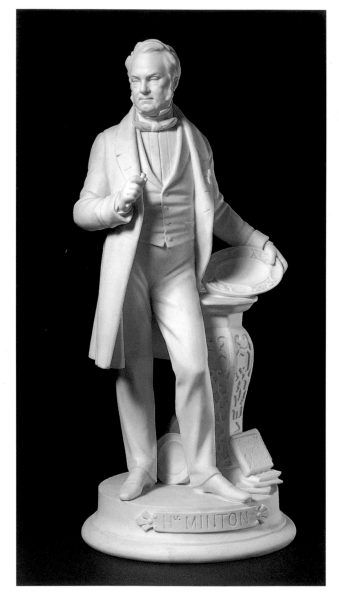

161 (left). Herbert Minton was responsible for the great inventions which made the factory supreme throughout the 19th century. Included as 'attributes' in the manner of classical statuary, many of these new ceramic bodies and forms are displayed at the feet of this Parian figure.

163 (above). Parian or 'Statuary Porcelain', a sugar-white soft-paste porcelain with good moulding properties, was one of the great ceramic innovations of the 19th century. It was developed in the 1840s by Mintons and Copelands simultaneously, with the intention of making figures in the style of Ancient Greece – in ignorance of the fact that Greek marble statues were originally painted in strong earth colours.

162 (left). Minton's early bone-chinas showed an awareness of French porcelains of the 1820s to 1830s, which was later to blossom into a close working relationship with the Sèvres factory. Many versions of the food-warmer (*veilleuse*) were made by the Paris factories.

165 (above). The Refreshment Room at South Kensington Museum was designed by James Gamble in 1866, but inspired by the Dairy at Frogmore. Despite the highly decorative effect of the specially made Minton wall-cladding, the glazed surfaces were actually intended for ease of cleaning, while the columns supported the lecture theatre above, and the enamelled iron ceiling was fireproof.

164 (left). The invention by Léon Arnoux of translucent bright glazes in 1849 led to the first appearance of Minton *majolica* at the Great Exhibition. The new material was applied to old Palissy models as well as to an infinite variety of new forms based on nature. In this unusual design for a chestnut basket of 1855, the spoon is formed as a chestnut branch.

166 (below). In a venture parallel to Henry Doulton's association with the Lambeth School of Art, Mintons set up its Art Studio in Kensington in 1871, using the talents of the Royal School of Art to assist a nucleus of ceramic artists from Stoke in painting tiles and large dishes. The talented manager, W.S. Coleman, left after two years and in 1875 the studio (with its enamelling kiln) burned to the ground. However, the fashion for amateur painters to decorate Staffordshire pottery blanks was firmly established.

The Gothic Revival

The Gothic revival was one of the most important movements of the nineteenth century. It was not a passing whim like the eighteenth-century 'Gothick', but was securely based on the academic study of North European medieval building styles and was inevitably linked to the restoration of old, and the building of new, parish churches. Aside from the much-admired romantic and picturesque qualities of Gothic ruins, the favoured fourteenth-century 'Decorated' style could now be reproduced in cast-iron, and the tracery applied as decoration to a range of brightly coloured objects – notably Minton earthenwares – by the leading neo-Gothic architect A.W.N. Pugin (1812–52), whose greatest works were the

Medieval Court at the Great Exhibition and the new Houses of Parliament. On a smaller scale, the stylised plant and animal forms of medieval tiles were mass-produced for the floors of both church and home from the early 1840s. On the Continent, similar awakenings took place from about 1830, with the architect Viollet-le-Duc prominent in France. In Germany, the Gothic elements of sixteenth-century Raeren stoneware were seized upon and quickly reproduced. Although its heyday was the 1830s and 1840s, traces of Gothic influence are discernible throughout most of the century, kept alive by the medievalism of the Pre-Raphaelites, the writings of William Morris and the strength of the Church itself.

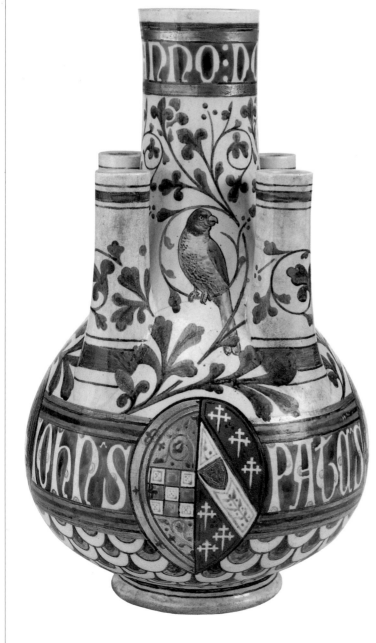

169 (left). With the rise of integrated architectural schemes by influential architects, specially designed ceramics could provide useful furnishings. Although called a 'tulip vase', this pseudo-medieval design of 1874 by the architect William Burges for the smoking room at the Marquis of Bute's Cardiff Castle seems to owe more to the turreted extravagances of fairy-story castles.

167 (above). Pugin's concept of a medieval bread plate with the moral inscription 'Waste Not Want Not' harks back to Rhineland stonewares with a moulded frieze meaning 'Eat and Drink but Do Not Forget thy God'. Applying mechanical moulding techniques and immensely durable materials to such objects was a Victorian ideal.

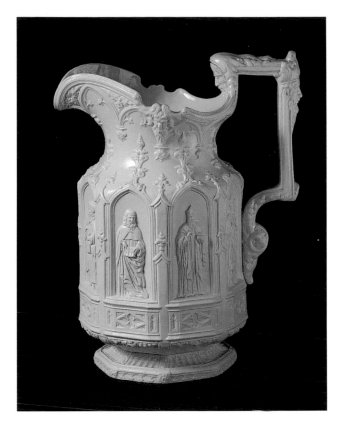

168. Stoneware with 'smeared' glaze became popular in the 1830s for a new class of ceramics, namely jugs, usually in sets of three graduated sizes and made in elaborate plaster moulds. Many colours – from drab to sage to sky blue – were available and, from 1842, the design could be registered and, thus, protected. One of the most successful early designs was undoubtedly Charles Meigh's 'Apostle' jug of 1842 (shown here), which was even used for a tea set.

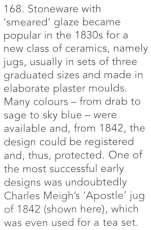

171 (below). Combining neo-Renaissance and Gothic ornament, Rhineland stonewares were highly popular throughout the second half of the 19th century, ultimately inspiring the art stonewares of Henry Doulton. In 1875 the South Kensington Museum purchased 78 of these passable reproductions, made by Merkelbach & Wick of Grenzhausen, as suitable for teaching purposes.

170 (left). Although serious essays in the Gothic taste were produced at Sèvres in the early 19th century, it was not until the 1830s that the 'romantic' Gothic style filtered through to the smaller porcelain factories of Paris.

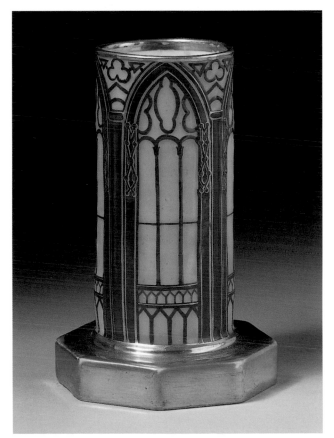

THE TWENTIETH CENTURY: CRAFT OR INDUSTRY?

The term 'art nouveau', deriving from the name of Samuel (or Siegfried) Bing's fashionable Paris shop founded in 1895, covers a wide variety of materials and several different styles, spanning the end of the nine-teenth and the beginning of the twentieth centuries. Considered decadent, and viewed with great suspicion by the art establishment in England, the more extreme, organic and sensual French and Belgian versions of the style – for example the sinuous moulded vases of J. Jurriaan Kok at Rozenburg (fig. 172), the tablewares designed by Maurice Dufrêne (fig. 173) and, of course, the French glass in which art nouveau found its fullest expression – had little to offer Britain. The sinuous tube-lining of William Moorcroft's 1898 'Florian Ware' designs for Macintyre & Co. perhaps represent the most exotic version to be adopted by a British manufacturer. The style, although displayed to great effect at the 1900 Paris Exhibition, notably at Bing's Art Nouveau Pavilion, was already over-ripe and moving towards the decline that was apparent at the Turin Exhibition two years later. This last great struggle of wild nature to assert itself in the arts was shortly to be bridled by the cool hand of the archi-tect and what we now call the modern movement.

Yet art nouveau left a legacy that was to extend into the 1920s, clearly discernible in the early years of the century as the linear, stylised organic surface decoration that represented natural forms tamed by geometry according to the principles of an earlier professional designer, Christopher Dresser. The essentials of this later art nouveau style can be seen in the Vienna Secessionist Movement of 1897, the establishment of the *Wiener Werkstätte* in 1903 under Josef Hoffmann, and the creation of the Wiener Keramik workshop two years later. The interest shown by Finland in art nouveau and traditional textile designs also bore fruit in the striking 'Fennia' range (fig. 174) made at the Arabia Factory from 1902. In Britain, these essentials were epitomised by the designs of the architect Charles Rennie Mackintosh in Glasgow, the somewhat unadventurous tube-lined 'Secessionist Ware' (fig. 175) designed by Leon Solon and J.W. Wadsworth for Mintons about 1902, and the Celtic interlaced ornament of Archibald Knox. The derivation of this style from stone-carving and metalwork made it acceptable as embellishment on the new functional designs of the modern movement, which had found natural champions in Germany with the ceramic designs of the architects Henri van de Velde and Richard Riemerschmid, who later, in a spirit of nationalism, devel-oped modernist versions of their native salt-glazed stoneware.

This particularly fertile period in German design witnessed the opening of the Weimar Art School by the Belgian van de Velde in 1901, the founding by the Grand Duke of Hesse of an experimental artists' colony at Darmstadt (which included the architect Peter Behrens), and in 1908 the establishment of the *Schwarzburger Werkstätte* under Max Adolf Pfeiffer (who was, from 1918, to produce the first important modern figures for Meissen). Besides these independent workshops, this was also a period of increasing nationalism which encouraged artists and designers, including Max Laeuger, to co-found the Deutsche Werkbund in 1907. New factories appeared, notably that of Philipp Rosenthal (whose pioneering 'Donatello Service' dared to appear entirely naked of decoration) and the artist-based factory estab-lished at Karlsruhe about 1900. Old established factories adopted such elements of the new styles as suited their clientele – Josef Wackerle at the privatised Nymphenburg factory created modern figures, while Amberg's 'Wedding Procession' was later produced at Berlin, where the new art director Theo Schmuz-Baudiss was

175 (opposite). *The Minton factory's response to art nouveau was tube-lined decoration – a revival of the old slip-trailing technique.*

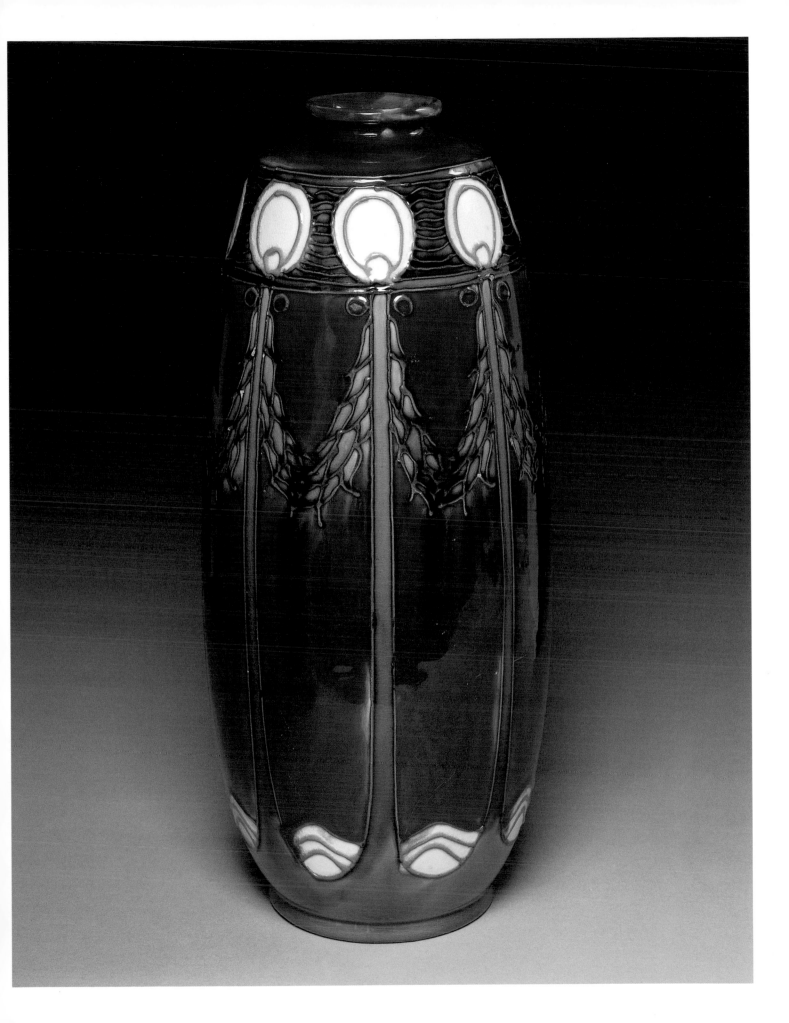

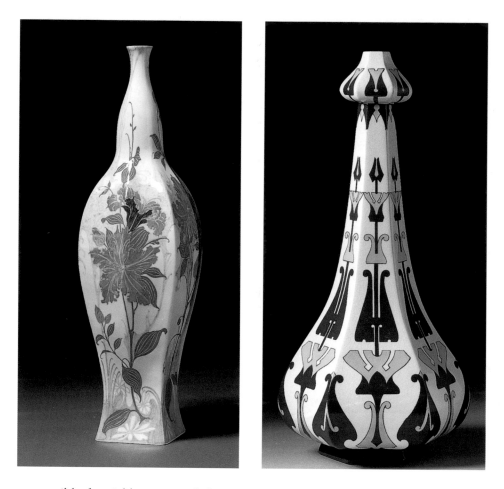

172 (far left). *The art nouveau style was often used purely for surface decoration, but at Rozenburg both form and decoration displayed equally sinuous design.*

174 (near left). *Crisp geometric ornament derived from traditional native weaving patterns was incorporated into the art nouveau style produced by Finnish architects and designers.*

responsible for richly patterned dinner services. Paul Scheurich's Nymphenberg figures (fig. 176) have an idiosyncratic style comparable with the models of his great eighteenth-century predecessor, F.A. Bustelli.

To isolate strands of influence in the applied arts of this period is hazardous. Modernism with its lean design ethic and its socialist principles flourished alongside the rich self-indulgent neo-classicism of the wealthy élite, not to mention the continuing mass-production of cheap transfer-printed tablewares dimly reflecting grand styles of the past. In so far as these conflicting elements affected ceramic design, it might be said that pure architect-based modernism took root in Germany and, combined with luxuriant decoration derived from both neo-classicism and cubism, in Austria with the Wiener Keramik designs of Michael Polwolny (fig. 177) and Berthold Löffler. Meanwhile, in France and Britain avant garde ceramic design was inspired not by architectural design, but by painting and literature. The most élitist manifestation of this link was the painting of pots by prominent artists and

independent decorators, a blurring of conventional boundaries with roots in the painting of Théodore Deck's pots by his artist friends, the long collaboration between Ernest Chaplet and Paul Gauguin, and the later studio work of Jean Dufy, Marcel Goupy and Jean Luce. In England, this direct link between original artist and pottery was virtually unknown until Roger Fry (artist, critic, controversial British champion of the post-impressionists and central figure in the Bloomsbury Group) founded the Omega Workshops in 1913. The tin-glazed surface of these sturdy Omega pots and tiles was freely painted by Duncan Grant (fig. 57) and later by others, including Vanessa Bell, making few concessions to form or material. Although short-lived and appealing to a limited intellectual market, the experiment paved the way for prominent ceramic artists of the 1920s and 1930s to be marketed commercially.

With a conviction that the pot itself should be regarded as art, a later generation of that close-knit band of French ceramists originally inspired by Japonisme of the 1870s

and 1880s continued to seek the spontaneous effects of high-temperature Oriental glazes. These ceramists included Émile Lenoble (son-in-law of Ernest Chaplet), George Hoentschel (pupil of Jean Carriès) and Émile Decoeur (pupil of Edmond Lachenal). Ignoring the prevalent modernism of Germany, Hermann and Richard Mutz and Julius Scharvogel continued to explore high-temperature glazes; and in Scandinavia, without a tradition of independent artist potters, stoneware production was adopted at Rörstrand and Gustavsberg, in about 1900. In 1912, following the pioneering ceramic work of Thorvald Bindesbøll in the 1880s and 1890s, the great ceramist Patrick Nordström introduced stoneware, with the special glazes of Jean Carriès, to the Royal Copenhagen factory.

Art pottery in Britain, however, followed divergent paths. On the one hand, the beginnings of studio pottery were to be seen in the highly individual crackled lustre

173. The extreme French and Belgian forms of art nouveau were unpopular in Britain. The advanced designs of M. Dufrêne show elements that were later to appear in art deco.

pots of Sir Edmund Elton and the austere work of Reginald Wells in Wrotham and Chelsea; while, on the other, the socialist principles of the arts and crafts movement and the obvious commercial possibilities gave rise to experiments in mass-producing art pottery of the type shunned by the major Staffordshire manufacturers. Development and expansion of the hand-decorated art stonewares of the vast Doulton pottery in Lambeth continued, while production of bone-china tablewares, and eventually figures, was added through the acquisition of the Burslem factory of Pinder, Bourne & Co. in 1882. On a small scale, Italian and English *sgraffito* slipware prototypes (rather than German stonewares) were chosen by another venture which relied on the talents of young art students – the Della Robbia Pottery (1894–1906) at Birkenhead (fig. 178). Serious commercial exploitation of the market for exciting glazes, such as those invented by Chaplet in France, followed the experiments of the brilliant ceramic chemist William Howson Taylor at his Ruskin Pottery (1898–1935) at Smethwick (fig. 179). On a smaller scale, the pottery of Bernard Moore at Stoke

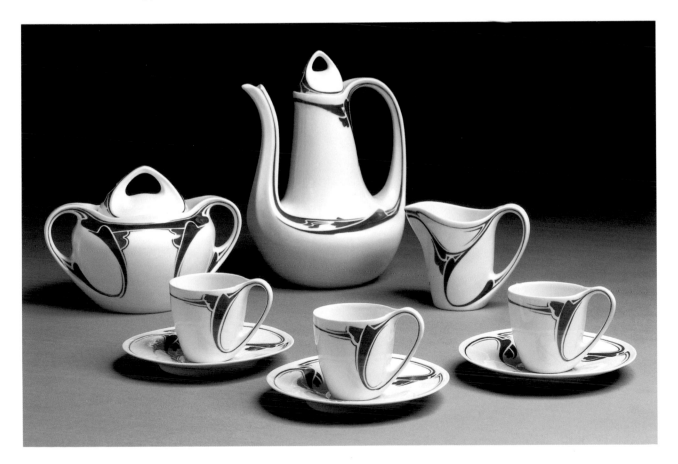

(1905–15) also relied on the effects of special glazes on commercial shapes of both earthenware and bone-china. It may have been the work of Clément Massier at Golfe-Juan that inspired the Pilkington's Tile & Pottery Co. near Manchester (1897–1957) to adopt the lustre painting (fig. 180) which was carried out by talented decorators, notably Gordon Forsyth. The sheer technical and controlled perfection of all these English factory products, although worlds apart from ordinary mass-produced tablewares (fig. 181), inevitably put them in a different category to contemporary French 'artist' pottery.

The International Exhibition planned for Paris in 1914 had to wait until 1925. Its themes were simply specified as 'modern' and 'original'. Meanwhile, the lost years of the First World War and the repercussions of the Russian Revolution of 1917 had led to some major changes in thinking. As pointers for the future, for example, the year 1919 saw the demise of the Omega Workshops, the building of Bernard Leach's second pottery kiln in Japan, and the re-opening of the Weimar Art School as the Bauhaus under the management of the architect Walter Gropius. Although it is possible now to pick out the

names of the future leaders from the stylistic ferment of the early 1920s, in the aftermath of the bloodiest war the world had ever seen, many potential strands of cross-fertilisation were severely curtailed, or even excluded, simply by nationalist considerations. Thus, the Exposition des Art Décoratifs in Paris, which success-fully displayed the pre-eminence of French ceramists, had no representa-tion from the defeated Germany and its new Bauhaus pottery established by the radical designers Otto Lindig and Theodor Bogler (fig. 92) in 1920, or the revolutionary designs of Gerhard Marcks produced at the Karlsruhe factory. On the other hand, Russia was able to offer an astonishing array of Soviet porcelains, notably those with abstract graphic designs by the Suprematist Malevich, which were later to inspire the ceramics of the Italian Futurists made at Albissola Mare (1928–39). Meanwhile, Italy could boast the witty exuberant designs of Gio Ponti (fig. 182) for the Richard-Ginori factory at Doccia.

The opportunity to secure international recognition in 1925 was not lost on the Scandinavian countries, where, uniquely, artist potters and designers worked under the wing of commercial manufacturers. Although long isolated from the influence of ancient Greece and Rome, in the nineteenth century these countries had embraced neo-classicism with such astonishing fervour that any later deviation from it must, in retrospect, be judged in terms of reaction or re-working. Sweden, where the family values espoused by the influential painter Carl Larsson in the 1890s co-existed with the new 'Swedish Grace' style, was well represented by the Rörstrand table-wares in the eighteenth century *faience* tradition, and more ambitiously by the ceramics of Wilhelm Kåge (a former pupil of Henri Matisse) at Gustavsberg, which combined a neo-classical spirit with painterly decoration. A complete contrast was offered by the almost brutal handling of clay by Jean Gauguin of the Bing & Grøndahl factory at Copenhagen.

As regards Britain, the *Pottery Gazette* reported that its display was 'an unaggressive, uncompetitive

176 (opposite below left). *In the early 20th century, stylish porcelain figures made at the leading German factories became vehicles for the mannered poses and calculated distortion of professional sculptors.*

177 (opposite above left). *The rich and self-indulgent luxury of many* Wiener Werkstätte *products directly influenced French art deco of the 1920s.*

178 (opposite below right). *Shapes of renaissance Italian* maiolica *completely covered with carved or* sgraffito *decoration characterised the late art pottery of the Della Robbia factory at Birkenhead.*

179 (opposite above right). *William Howson Taylor's brilliant high-temperature glazes could never disguise the fact that, unlike the French prototypes, his pots were factory-produced.*

180 (above). *Pilkingtons employed exceptional artists to decorate its commercially made pots with lustre. The lustre technique, whether on Spanish pottery, Italian* maiolica *or English art pottery, was always highly regarded.*

181. *Throughout the period of art nouveau and art deco, smaller Staffordshire firms continued making old-fashioned printed earthenwares for everyday use which they sold directly to the public.*

presentation', without explaining that, after the exhaustive efforts applied to the huge captive markets at the 1924 British Empire Exhibition at Wembley, the lure and glamour of Paris was outweighed by its exclusivity and the enormous additional expense. Taking little notice of the 'modern' theme of the exhibition, and deviating little from their Wembley displays, large firms such as Wedgwood and the Cauldon Potteries (formerly the major nineteenth-century manufacturer, Brown-Westhead, Moore & Co.) showed practical tablewares of the type epitomised by Wedgwood's pattern names 'Celtic' and 'Bewick'. The need to relive past successes was everywhere apparent, most especially in the Derby factory's 'Japan' patterns, which were no less persistent

than they had been in 1810 and which remain so today. Factory-made art wares included W. Howson Taylor, Pilkingtons, Moorcroft (described as an ideal blend of 'art and handicraft'), the 'Old Sung' and 'Rouge Flambé' of Doultons, and the progressive style leader, the Poole Pottery of Carter, Stabler & Adams with its semi-matt glaze and minimalist decoration (fig. 183). The early studio wares of Bernard Leach were quite overshadowed by the painted and titled pots of William Staite Murray, who in that year was appointed head of ceramics at the Royal College of Art. Also under the category of studio ceramics – and much admired at the time – came the hand-modelled picturesque figures of flower-sellers and gypsies by Chelsea artists such as Gwendolen Parnell.

The enormous influence on the rest of the twentieth century that history has attributed to the 1925 Paris Exhibition (which received 28 million visitors) resulted in the merging of a number of apparently incompatible styles. At one end of the spectrum, prevalent socialist principles had given rise to Wilhelm Kåge's 'Workers Service' at Gustavsberg in 1917 and to the severe modernist 'Form without Ornament' designs for mass-production at the Bauhaus. Although neither of these critically acclaimed designs was greeted with enthusiasm by their intended users, the worthy arts and crafts ideal of making good design available to a wider public persisted. At the other end of the spectrum, love of extravagant style, lavish materials and superb craftsmanship, deriving from the decadent tail-end of art nouveau and the self-indulgent products of the Wiener Keramik, attempted to dazzle rather than serve the public. It was this style which, as late as the 1960s, became generally known as 'art deco'.

In Britain, where the apparently improvised and ephemeral nature of this style was reflected in the disparaging term 'Jazz Modern', certain modernistic elements were seized on by the Staffordshire manufacturers in the late 1920s and used on cheap tablewares. The painter and designer Clarice Cliff (fig. 202), whose many designs for A.J. Wilkinson Ltd. incorporated a superficial modernity of shape and decoration, achieved great popularity for her modestly priced tablewares, such as the 'Bizarre' pattern (produced in 1929–41). Other major Staffordshire factories produced modernistic useful and ornamental wares for a similar market in the late 1920s and 1930s, including Carlton Ware of Wiltshaw & Robinson, Shelley Potteries, and the Foley china of E. Brain Ltd. More serious original designs were produced over a longer period by Susie Cooper (fig. 203), whose

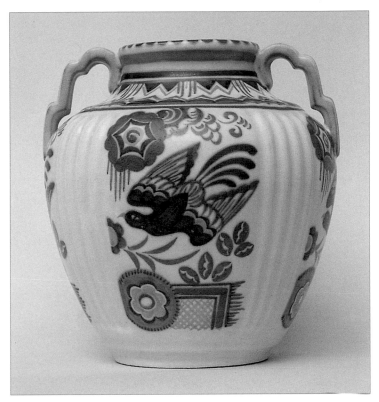

182 (above). *After its 19th century role feeding the taste of the renaissance revival, from the 1920s Italy launched itself as the source of exuberant, even outrageous, design.*

183 (above right). *After 1921, when the Poole Pottery of Charles Carter was re-formed in partnership with Harold (and Phoebe) Stabler and John Adams, inspired modernist forms and decoration rapidly took the firm into a dominant position.*

184 (right). *With the architectural forms and cool matt pastel glazes of Keith Murray, Wedgwood was able to compete with modernist design from Germany and Scandinavia.*

185. *The brown stoneware of Doulton's gin flasks and drainpipes was first adapted to art wares, and finally to* flambé *glazes and experimental functional wares.*

elegant shapes reflected the modernist interest in aerodynamics and whose minimalist patterns were well-suited to mass-production for a middle-class market. In contrast to these progressive designs, the popularity of ceramics decorated with cosy images of thatched cottages, stage coaches and other symbols of a vanished 'Merrie Englande' testified to the conservative nature of the British pottery trade and its customers. Re-worked Regency-style designs abounded, of which the cheap but effective lustred jugs were typical. At Wedgwoods, Millicent Taplin devised a range of quiet floral patterns which never strayed too far from the eighteenth century, while the eccentric 'Fairyland Lustre' designs of Daisy Makeig-Jones showed familiarity with the illustrations of Edmund Dulac appealing to a more specialised market.

The 1920s also saw the last flowering of the ceramic decorator working in the arts and crafts tradition (for example, Alfred and Louise Powell and Thérèse Lessore for Wedgwoods, and Charlotte Rhead for H.J. Wood Ltd.) and the beginnings of fresh attempts to graft the creativity of mainstream artists onto a rather conservative pottery trade. These comprised bold but commercially unsuccessful exhibitions in London ('British Industrial Art in Relation to the Home' in 1933, 'Modern Art for the Table' at Harrods in 1934 and 'British Art in Industry' in 1935), which included work by artists as

diverse as Duncan Grant, Vanessa Bell, Gordon Forsyth, Clarice Cliff, Paul Nash, Frank Brangwyn, Ben Nicholson, Graham Sutherland and Laura Knight. The re-founding of the British Institute for Industrial Art in 1934 as the Council for Art and Design was a serious attempt to promote good design on a popular level. It continued later with the creation of the Council of Industrial Design in 1944 and the Design Centre in 1956. In the 1930s, the most successful use of pure modernist design was to be seen in the architect Keith Murray's crisp designs for Wedgwood. His strong forms were either stepped or broken by incised grooves and covered with matt pastel-coloured glazes (fig. 184). Contemporary critics admired the fact that this popular 'banding' exhibited 'truth to materials', for not only was it formed naturally during the pottery-making process, but it also emphasised the rotundity of hand-thrown pottery. Similar functional designs were produced experimentally at Doultons (fig. 185), using an ideal material – brown stoneware. Echoes of this may be seen in the 'Ruska' range made at Arabia from 1960 and later in the revival of Denby.

The return of Bernard Leach from Japan in 1920 is now seen as the birth of a new approach to the making of 'artist' pottery, whereby a single artist is responsible for the whole designing and making process. At this time, interest in the consummate craftsmanship of early Chinese monochrome stonewares, which had spread from the early connoisseurs to a wider public, not only inspired stoneware potters such as Charles Vyse in Chelsea to seek the ultimate perfection in his 'Sung wares', but was also taken up commercially by major firms such as Doultons. At the same time, William Staite Murray saw pottery as a bridge between sculpture and painting, and exhibited his titled pots in London galleries alongside paintings by artists of the calibre of Ben Nicholson. Meanwhile Leach (fig. 186), pursuing a solitary and impoverished path in St Ives, not only built his own kilns and successfully combined the forms and design ethics of Oriental pottery and English slipware, but also imparted to his pupils – Michael Cardew, Norah Braden and Katherine Pleydell-Bouverie (fig. 187) – by his single-minded dedication, a philosophy of pot-making which almost amounted to a religion, and which exerted on the craft world an influence much greater than that of the teachings of Staite Murray at the Royal College of Art. After the publication of *A Potter's Book* in 1940 and the unplanned emigration of Murray to Rhodesia, the triumph of Leach's beliefs in

186 (left). *Bernard Leach's training as an artist and etcher under Frank Brangwyn is apparent in his spirited brushwork. The Museum paid 20 guineas (£21) for this 'Leaping Salmon' vase from one of the most famous kiln-firings at St Ives.*

187 (below). *Of Leach's dedicated pupils, only his son David was a close follower of his style. Katherine Pleydell-Bouverie worked with Nora Braden, pursuing the ultimate subtlety obtainable from wood-ash glazing.*

the teaching of a new generation of post-war potters was assured.

Although Leach's hand may be seen in the modern work of Ray Finch, Richard Batterham, Jim Malone and a large band of makers of domestic stoneware, his death in 1979 was followed by a further reaction, prompted in part by the abstract tendencies of American studio pottery. A fusion of painting, drawing, graphic art and sculpture is evident in the work of Liz Fritsch and Alison Britton, while the abstract sculptural forms of Gordon Baldwin, Gillian Lowndes and Ewen Henderson (fig. 195) never lack invention. The richly coloured organic modernism of Richard Slee defies exact definition. At the other end of the spectrum, salt-glazed stoneware continues to explore the subtle relationship between glaze, form and function, in the hands of Mick Casson, Jane Hamlyn and Wally Keeler.

188. *Picasso designed pots, decorated them, or both. Here the early Peruvian stirrup-vase shape (a favourite form for Christopher Dresser's art pottery) provides a vehicle for a painted monochrome self-portrait.*

189. *The architectural functionalism of the Bauhaus has continued to be developed by leading Scandinavian designers and factories, such as Royal Copenhagen, until the present day.*

The years of the Second World War were, in terms of artistic industrial development, almost entirely lost to all countries of Europe. Some countries, notably France where the demand for Sèvres diplomatic gifts and the traditional ranges of Limoges porcelain still continues, have never re-entered the international design arena. The pots designed and decorated by Pablo Picasso at Vallauris (fig. 188) form a fascinating addendum to his painting rather than a vital part of the story of mainstream European ceramics. However, in neutral Sweden, the utilitarian designs developed by Stig Lindberg (fig. 204) and Wilhelm Kåge at Gustavsberg enabled them to score major successes at the 1948 and 1951 Triennale at Milan. That venue was to see the launching of the unified Scandinavian style that became firmly established with the exhibition 'Design in Scandinavia' which travelled to North America and Canada in the mid 1950s. Later Triennales of 1954, 1957, 1960 confirmed that dependable Nordic virtues of craftsmanship, classicism and restraint (together producing what Jennifer Opie has described as a 'comfortable undemanding modernity') continued to be preferred to the exuberance of Italy. The sober functional designs of Kaj Franck at Arabia (such as the 'Kilta' range born of shortage of materials), the exacting standards set by Gertrud Vasegaard at Royal Copenhagen and Bing & Grøndahl, the work of Anne Marie Trolle (fig. 189), the practical designs of Stig Lindberg and his successor Karen Björquist at Gustavsberg, and the products of the Norwegian Porsgrund factory were all admired and honoured by awards. However, the bubble of success eventually burst, when, by the 1970s, the falling price of functional porcelain tableware resulted in factory amalgamations and talented members of the factory design studios were compelled to seek independence in new artists' collectives. In a short time, the great Scandinavian achievement of combining art with industry became unravelled to the point where the two were effectively polarised.

In Germany, apart from the bright colour-sprayed utilitarian pottery of the 1920s Weimar Republic, the inherent dual taste for the severity of Modernism and the luxury of the baroque was perfectly expressed during the 1930s by the varied products of Rosenthal at Selb. In the early 1950s, however, the success of Scandinavian design at the Milan Triennales pointed the way forward. This challenge was taken up at Rosenthals with the creation of their innovative 'Studio-Linie' range in 1961, with the assistance of established designers such as Bjørn Wiinblad from Denmark and Tapio Wirkkala from Finland. In a surprising merger, the style-leading Rosenthal firm is now part of the Wedgwood Group.

When Scandinavian design declined in popularity during the 1970s, the main beneficiary was Italy, which rapidly became the focus for sparkling design in Europe. The playful 1950s designs of Piero Fornasetti in Milan, inspired by ancient Rome and printed on tough German porcelain blanks, had already demonstrated well the quirky inventiveness of Italian style. Also in Milan, a group of progressive young architects set up a design studio under Ettore Sottsass in 1981, known as

190. *Milan, where the success of its Triennale exhibitions made it the focus of avant garde design and the style capital of Europe, also gave birth to the Memphis studio with its unique ceramic post-modernism.*

'Memphis' (fig. 190). Using a limited repertoire of colours and architectural forms, a wide range of anti-functionalist and slightly fragile ceramics and glass were produced in a post-modern idiom.

In Britain, austerity prevailed until the export-only restrictions on the Staffordshire factories were lifted in 1952. Elements of Italian exhibitionism and plain practicality were soon combined to form a recognisable 1950s style, in which miscellaneous scattered prints – molecular structure, or the abstract organic forms devised by the 1951 Festival Pattern Group – comprise the entire decoration. Figures also became increasingly abstract, looking back to ancient civilisations (fig. 191). Shapes, particularly the rounded squares or triangles, were entirely freed from old conventions; and if some of these new forms owed their inspiration to the modernist work of Eva Zeisel, this in itself was entirely a result of Roy Midwinter's 1952 trip to North America. The 'Stylecraft' and 'Fashion' ranges developed by Midwinter and Jessie Tait rapidly launched that firm into a leading position which was continued by collaborative ventures with Terence Conran, Hugh Casson and, in the 1960s, David Queensberry. From the 1960s, the influence of domestic studio pottery infiltrated the industry, for example in the angular 'Stonehenge' range with its mock-rustic speckled glaze (although popular, this pattern heralded Midwinter's

decline until its closure in 1987). Other potteries flourished, but rarely for long. At Portmeirion, Susan Williams-Ellis adopted raised moulded symbols for her 'Totem' range in 1963, followed nine years later by the 'Botanic Garden' pattern. Ridgway's 'Homemaker' (fig. 192), designed by Enid Seeney in 1955, was sold exclusively through Woolworths. The enterprising Hornsea factory, for which Martin Hunt produced award-winning designs, closed in 1987. Denby successfully turned from its nineteenth-century stoneware ginger beer bottles to its popular oven-to-table wares of the 1960s. Today, besides a continuing demand for well-known bland patterns of the conglomerate Staffordshire factories as well as exclusive tablewares, it is salutary to reflect on the fact that all have been outsold by the carefully planned retro style of Royal Albert's 'Old Country Roses'.

As design becomes more international and more closely linked to marketing, so the boundaries between industrial, 'designed' and studio ceramics overlap while the tastes of buyers broaden. Sheer fineness is no longer a measure of quality, when practical hand-thrown plain domestic pottery may cost more than factory-produced delicate gilt and painted porcelain. It is difficult to predict the future development of ceramics; but to think that 'everything has been done' would be to ignore the lessons of history.

191 (right). *In order to create a new idiom in figure-modelling, sculptors of the 1950s looked back to the minimalist and abbreviated forms of the Ancient World.*

192 (below). *Contemporary living was unashamedly celebrated in the Ridgway 'Homemaker' pattern, sold exclusively through Woolworths from 1955 to 1967.*

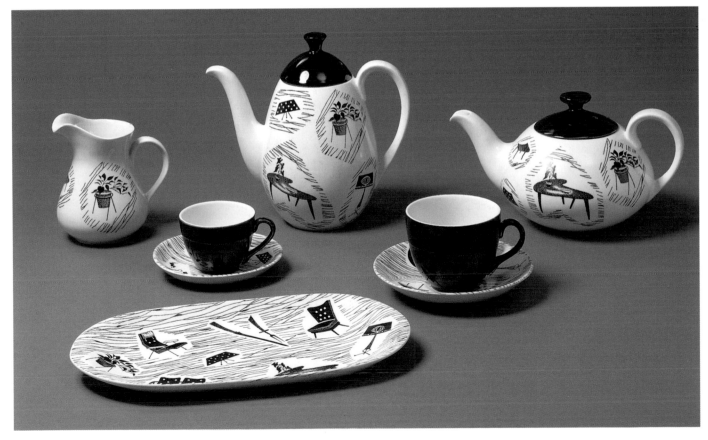

Studio Pottery

To be a Master Potter in eighteenth-century Staffordshire indicated ownership of a factory and probably wealth. To Bernard Leach, who had absorbed the Japanese Mingei philosophy deriving from the teachings of William Morris, and to whom was given the mantle of the potter Kenzan, it meant something quite different, namely the exact opposite of the specialisation of labour in factories which made mass-production so profitable. It is Leach's approach to potting which defines the studio potter as the person who conceives the object, prepares its materials, makes it and puts it to the ultimate test in the kiln.

The influence of Japanese stonewares inspired the earliest artist potters in France in the 1870s and 1880s. In England, before the First World War, the concept was introduced by pioneer potters such as Reginald Wells, Denise Tuckfield (later Wren) and Sir Edmund Elton, but it only began to be considered in terms of an artist's studio with the establishment of Leach's Japanese-type kiln and small pottery at St Ives in 1920. Thereafter, until the Second World War, the Oriental-style pots of Leach and the more traditional English slipware pots of Michael Cardew (who was trained by a surviving country potter, Fishley Holland of Fremington) competed with the painted and titled works of Staite Murray. In the 1950s, the highly sophisticated products of the partnership between the refugee Austrian potter Lucie Rie and her compatriot, the sculptor Hans Coper, provided an interesting contrast to

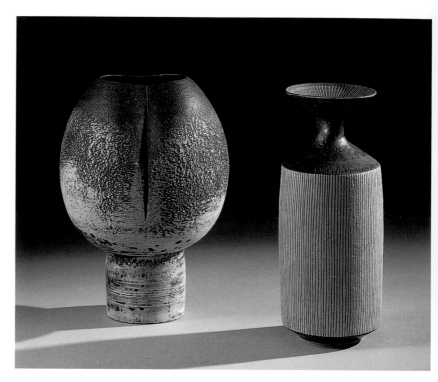

English 'earthy' pots. Both schools have left their descendants. Today, the arts of sculpture and painting are almost inseparable from studio ceramics, and in the work of Ewen Henderson, even the materials of pottery and porcelain are intermingled.

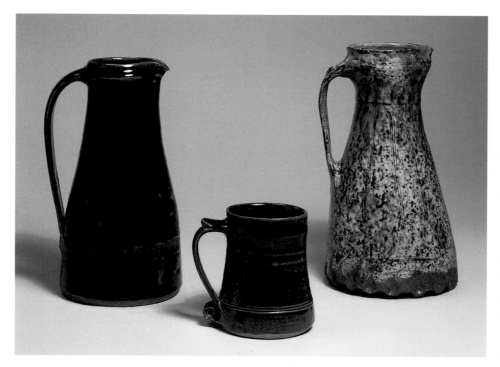

194 (above). Hans Coper's pots inevitably betray his training as a sculptor. His monumental forms, however, which show influence from the enigmatic marble votive heads of the Cycladic islands, benefit immeasurably from the remarkable surface textures learned during his partnership with Lucie Rie. By contrast, her pots exhibit a careful balance between strength of form and delicacy of potting.

193 (left). Leach drew inspiration from Japanese and English pottery at grass-roots level. The simple tapering form and practical strap handles of thirteenth-century English pots, thrown as large beakers with the 'bottom' attached at the top, were easily translated into stoneware for a range of inexpensive tewares.

195 (above left). The many influences on abstract sculpture may often be teased out. Here the title of the series, 'Skull Mountain', explains the elaborate (but apparently casual) mingling of stoneware and bone-china clays, surface staining and texture, and the solid but partially hollow form.

196 (above right). Liz Fritsch developed her coloured slip painting at the Bing & Grøndahl factory in Denmark. The lively visual effect of the optical decoration, which perfectly matches the illusionistic form, belies the slow and painstaking painting technique.

197. Richard Slee's work combines superb technique, highly refined materials and inexhaustible invention. A fascination with, and a satirical commentary on, the history of ceramics is also shown by his widely differing studio pieces, none of which are made for practical use.

Art Deco

199 (left). Stylish banded and colour-sprayed wares were introduced at the Porsgrund factory in Norway by Nora Guldbrandsen after her arrival in 1927. Here architectural form and decoration appear in harmony.

198 (below). The engraver and ceramicist René Buthaud, although working in Bordeaux, was a member of the Jury at the 1925 Paris Exhibition, and exhibited regularly in Paris. This pot successfully combines abstract geometric forms with a passing allusion to the earth-brown painted bands on early Cypriot pottery.

The term 'art deco', although ostensibly derived from the Exposition des Art Decoratifs et Industriels (the Paris Exhibition of 1925) with its obligatory 'modern' theme, actually became current only in the 1960s with the creation of a collectors' market. Its origins are in the aftermath of art nouveau in about 1910, and the luxurious (even decadent) products of the Wiener *Werkstätte.* By 1925, the style was fully developed and incorporated many other elements, including the current interest in the Cubist and Fauvist painting schools, the exoticism and bold colours and forms of Africa, the Aztecs, the ancient Egyptians as revealed by the discovery of Tutankhamun's tomb in 1922 and, later, aerodynamic streamlining and wave-forms. The uneasy blending of this style with the·opposing severe architectural modernism of the 1920s produced an international style known as 'art moderne', the influence of which spread to North America and was still discernible in the 1950s.

In France, the art deco style was associated with artists, exotic materials and consummate craftsmanship. However, when it became established in England by the late 1920s, many of its elements were simplified and exploited for use on cheap earthenware tablewares by new designers such as Clarice Cliff. In that way, it may be compared with the cheap stencilled and spray-glazed pottery produced in Germany during the Weimar Republic.

200. Carlton Ware may claim to be one of the best exponents of the art deco style. Contrasting blocks of colour and geometric patterns added movement to a conventional ginger jar form.

202 (above). Art deco ceramics in England are now usually judged in relation to the popular cheap earthenwares of Clarice Cliff. Here her 'Inspiration' pattern seems tame besides her bolder designs for A.J. Wilkinson Ltd., which started with her 'Bizarre' pattern launched in 1929. For those setting up a new home with cream walls and rounded corners, these tablewares must have provided instant decoration for comparatively little money

201 (left). Paragon China, a progressive factory founded in 1920, took up the art deco style along with many other ambitious Staffordshire potteries. Modernistic shapes and startling bright decoration epitomised a style then known as 'Jazz Modern'.

Designed Ceramics

From early beginnings in the close association of Josiah Wedgwood with his contemporary neo-classical architects, and the neo-Gothic designs of the architect Pugin for Mintons (not to mention those of Schinkel for the Berlin factory), the idea of potters directly employing professional designers has blossomed. After Christopher Dresser's facsimile signature was used as a guarantee of good design, the customary anonymity of designers was replaced by the unashamed exploitation of 'names' as advertising, epitomised in the 1930s by Clarice Cliff's and Keith Murray's printed signatures. If factory decorators' designs were too tame and architects' designs were too functional, an alternative was offered by mainstream painters of the calibre of Ben Nicholson, Frank Brangwyn and Laura Knight, whose interesting painted contributions were lively but not enduring.

In the 1950s, the influence of Scandinavian designers spread throughout Europe. Accustomed to working in many materials, they also introduced the concept of totally designed sets of tableware, cutlery and glass. Today, designers are international. For example, the partnerships of David Queensberry and Martin Hunt (now including Robin Levien) have worked for Rosenthal and Bing & Grøndahl respectively, and it is not unusual for design, manufacture and market to be split between Europe, North America and the Far East. Interest in food consumption and its implements, first seriously expressed by the architect-designer Charles Rennie Mackintosh, now contributes much to tableware design. Designers such as Maryse Boxer and Peter Ting succeed not just because of their innate creativity, but also because of their intimate knowledge of cuisine and table layout.

205. The concept of making dessert services heavily moulded with fruit or leaves originated in the 18th century. In the 1950s, Terence Conran made the link between tableware decoration and food consumption much more explicit through the use of transfer-prints.

203. The designer Susie Cooper was noted for her practical and decorative teawares which – like this 'Cromer' pattern and 'Wren' shape – were much admired at the 1935 British Art in Industry Exhibition.

206. As in 18th-century Staffordshire, designs for moulded pots were conceived in three dimensions. In the hands of modern professional designers, such as Martin Hunt, this process resulted in solid 'models' made for the client's approval. Now this stage of the design process has been largely taken over by computer technology.

204. The range of undecorated modernist shapes developed by Stig Lindberg at Gustavsberg during the Second World War enabled Sweden, and Scandinavia in general, to capture the design market in the 1950s.

207. The Scandinavian tradition of creative 'factory designers' and art studios never fully established itself in Britain. In a reversal of previously accepted roles, the London retailer Thomas Goode not only commissions work from the designer Peter Ting, but also runs its own factory, formerly Caverswall China & Co. Ltd. at Stoke-on-Trent.

NOTES ON ILLUSTRATIONS

1 Coloured lead-glazed earthenware, moulded with Earth and Water from the Elements. French, made by Bernard Palissy, second half of the 16th century. H: 27.5 cm. (C.2306-1910)

2 Lead-glazed earthenware moulded with the arms of France and brushed with coloured oxides. French, made at Saintonge, about 1600. H: 16.5 cm. (1934-1855)

3 German, made at Nuremberg, probably Paul Preuning workshop, mid 16th century. H: 52.8 cm. (C.74-1925)

4 Bottle (*Bartmann*), salt-glazed, made at Frechen in about 1650–80. H: 22.9 cm. (713-1908) Jug with AR for Anna Regina, salt-glazed, made in Westerwald in about 1702–14. H: 17.4 cm. (3751-1901) Mug with funnel neck, unglazed, made at Siegburg, about 1500. H: 15.2 cm. (2018-1901)

5 Salt-glazed stoneware with moulded applied decoration including the arms of Cologne and Spiers and the date 1598. German, made at Raeren in the Jan Baldems Mennicken workshop, about 1598. H: 42.6 cm. (772-1868)

6 Salt-glazed stoneware enamelled with hunting scenes and dated 1653. German, made at Creussen in Saxony. H: 17.8 cm. (811-1868)

7 Lead-glazed red earthenware with trailed white-slip decoration, including the figure of a hare. Said to have been excavated in Colchester. Made in North Holland, first half of the 17th century. Diameter: 13.2 cm. (C.38-1966)

8 Money box, 16th century. (C.229-1939) Jug, early 16th century. (268-1903) Mug, late 16th century. (2028-1901) Max H: 20.3 cm.

9 Candlestick, lead-glazed earthenware with trailed white-slip decoration, inscribed 'EM 1649'. H: 18.4 cm. (4736-1901)

10 Lead-glazed earthenware with slip-trailed decoration. Staffordshire, made by Joshua Heath and dated 1707. H: 12.3 cm. (4719-1901)

11 Red earthenware with trailed white-slip decoration, including the name of 'THOMAS TOFT', and a crowned lion taken from the royal arms. H: 45.8 cm. (2079-1901)

12 Bottle, salt-glazed 'marbled' stoneware with applied white decoration (made in brass sprig moulds), including birds, snails and a bust of William and Mary. Made by John Dwight at Fulham, about 1690. H: 17.2 cm. (C.101-1938)

13 Jar, red earthenware covered in a white slip with green glaze, with carved and incised decoration. Italian, made in Padua in the 16th century. H: 29.2 cm. (4621-1858)

14 Footed bowl, red earthenware, covered with in white slip and elaborately decorated with incised drawing, overall lead glaze with brushed oxide colours. Italian, probably made in Bologna, about 1480–1500. H: 24.8 cm. (187-1866)

15 Dish, red earthenware, partially covered in white slip with incised, carved and trailed decoration including the date 1615. Lead-glazed with brushed oxide colours. German, made at Werra. H: 32.4 cm. (C.302-1919)

16 Red earthenware, covered with a white slip, carved and incised with 'folk' emblems, including a nautical compass with the date 1764 in a heart. Made in Barnstaple or Bideford. H: 35.6 cm (C.140-1977)

17 Vase, brown salt-glazed stoneware, covered in a white slip, with incised decoration by Hannah Barlow. Made by Doultons of Lambeth, dated 1874. H: 22.2 cm. (3786-1901)

18 Salt-glazed stoneware with applied oak-leaf decoration and partially brushed with cobalt blue. German, made in Cologne, about 1550. H. 36.2 cm. (4610-1858)

19 Bust of John Dwight, made at Fulham by an unidentified modeller in about 1675. Part of the 'Dwight Heirlooms' discovered at the factory in about 1860. H: 18.2 cm. (1053-1871)

20 Loving cup, lustrous brown with cut decoration and applied 'breadcrumb' bands. Made about 1750–5. H: 15.6 cm. (C.302-1927)

21 Vase, brown stoneware with overall incised decoration, including grotesque birds, dated 1902. H: 19.8 cm. (C.11-1974)

22 Jug, heavily mottled salt-glazed stoneware, wheel-thrown, cut and re-assembled, made by Wally Keeler in 1992. H: 25.5 cm. (C.104-1992)

23 Engraving attributed to Palissy: 'Grotto with with the Provinces of France in the Guise of Muses', from Jean Dorat's *Magnificentia Spectaculi a regina matre in hortis suburbanis editi Descriptio*, Paris, 1573. Courtesy of New York Public Library.

24 Coloured lead-glazed earthenware moulded with Pomona after an engraving of about 1600 by de Vos. Width: 33.7 cm. (7170-1860)

25 Coloured lead-glazed earthenware with hand-modelled, press-moulded and cast decoration. Diameter: 53.3 cm. (2815-1856)

26 Coloured, lead-glazed earthenware internally moulded with figures of Bacchus and Ceres (perhaps a sauceboat). Probably made in Bernard Palissy's workshop, in the second half of the 16th century. H: 7.6 cm. (C.2311-1910)

27 *Tazza* and cover, white lead-glazed earthenware with impressed decoration inlaid in red-brown clay, including the arms of the Papin family of Poitou. So-called 'Saint-Porchaire Ware', probably made in Paris, perhaps in the workshop of Bernard Palissy, in the third quarter of the 16th century. H: 16.5 cm. (8715-1863)

28 Tin-glazed earthenware, painted in lustre and cobalt blue. Spanish, made at Manises, Valencia, in about 1440–70. H: 52.7 cm. (8968-1863)

29 Dish, tin-glazed earthenware, painted in colours, with the badge of the Monastery of Escorial and the arms and name of its abbot, Juan de Santsteban (abbot 1699–1705). Spanish, made at Talavera, about 1700. Diameter: 39 cm. (C.289-1987)

30 Jug with pewter lid, tin-glazed earthenware, painted in blue with the arms of the city of Hamburg, the initials 'PL', a merchant's mark and the date 1643. Portuguese. H: 34.9 cm. (C.200-1921)

31 Dish, tin-glazed earthenware (*maiolica*), painted in colours with the Marriage of Alexander and Roxana, and the arms of Gonzaga (Duke of Mantua) impaling Paleologo. Signed by the artist Xanto and dated 1533. Diameter: 46.9 cm. (1748–1855)

32 Dish, tin-glazed earthenware (*maiolica*), painted in cobalt blue and yellow lustre with a portrait of lady and 'TIMOR DOMINI SVI E FILIVM SVVM'. Italian, made at Deruta, about 1520. Diameter: 40 cm. (7163-1860)

33 Engraving: 'Prospetto della Bottigleria…' from Carolus Fontana's *Fest des Kardinals Chigi, Rom*, 1668. V&A, National Art-Library.

34 Dish, tin-glazed earthenware (*maiolica*), painted in colours with a striding musketeer. Italian, made at Montelupo, about 1630. Diameter: 31.4 cm. (C.135-1912)

35 Pierced dish, tin-glazed earthenware (*maiolica*), painted in blue. Mark: crowned shield containing the arms of Savona. Italian, made at Savona in about 1650–70. Diameter: 29.2 cm. (C.153-1934)

36 Pair of pot-pourri vases with pierced covers, tin-glazed earthenware (*faience*), painted in blue. French, made at Rouen, about 1700–1720. H: 24.7 cm. (440 & A-1870)

37 Dish, tin-glazed earthenware (*faience*), painted in yellow and green with grotesque figures. Mark: 'OL' and 'G'. French, made at Moustiers by the Olerys factory in the mid 18th century. Length: 42.2 cm. (389-1869)

38 Tin-glazed earthenware, painted in colours, inscribed 'Wer swassers trinckt das Christus gibt, Den wirdt Ewigklich dursten nit. IESAIA. AM.55.CAP, 1640'. Swiss, made at Winterthur and dated 1640. H: 28.5 cm. (1942-1855)

39 Moulded dish, tin-glazed earthenware, painted in blue and yellow. Marked 'B'. Of a type previously attributed to Frankfurt, but probably Dutch, late 17th century. Diameter: 34.3 cm. (C.103-1924)

40 Tankard, tin-glazed earthenware painted in enamel *petit feu* colours, including monochrome black (*Schwarzlot* technique), and

signed by Johann Schaper. German, made and decorated in Nuremberg, about 1660–5. H: 22.2 cm. (9-1867)

41 Fish tureen, tin-glazed earthenware, painted with enamel *petit feu* colours in the Kakiemon style by Carl Heinrich von Löwenfinck. German, made at Fulda, about 1741–3. H: 30.4 cm. (C.133 & A-1951)

42 Tin-glazed earthenware, painted in cobalt blue, from North Mymms Park and probably made for the Third Duke of Portland. Dutch, made at the Greek A factory of Adrianus Koeks at Delft, about 1690. H: 160 cm. (C.96-1981, C.19-1982)

43 Jug, tin-glazed earthenware, painted in polychrome with a lover, hand on heart, and inscribed with triangulated initials 'R.E.C' and 'I AM NO BEGGER I CAN NOT CRAVE BUT YU KNOW THE THING THAT I WOULD HAVE'. Probably made in Southwark, about 1620. H: 32.2 cm. (C.5-1974)

44 Tin-glazed earthenware, painted in colours with an imaginary townscape, the date 1657 and the triangulated initials 'R.E.N.' for Richard Newman, proprietor of the Pickleherring Pottery, and his wife Elizabeth. Made at the Pickleherring Quay factory at Southwark. Diameter: 47 cm. (C.57-1971)

45 Wet drug jar, tin-glazed earthenware, painted in blue, inscribed 'S.CYDONIORV' (syrup of quinces), made in London, about 1660–1700. Dry drug jar or *albarello*, inscribed 'E.CARYOCOST' (a purgative compound), made in London, about 1760–70. Max H: 18.5 cm. (C.187-1991, C.191-1991)

46 Dish, tin-glazed earthenware, painted in manganese purple, and with the numeral 3 on the reverse. Made at the Dublin factory of Henry or Mary Delamain, about 1753–60. Length: 37.9 cm. (C.4-1928)

47 Potters stoking *maiolica* kiln, from Picolpasso, *Li Tre Libri dell Arte del Vasaio*, p. 35.

48 Four *maiolica*-painters at work, from Picolpasso (as fig. 47), p. 58.

49 *Maiolica*, painted in colours with an artist decorating a plate, signed 'Japo' for Jacopo and 'SP' monogram crossed by a paraph. Italian, made at Cafaggiolo about 1510. Diameter: 23.5 cm. (1717-1855)

50 Group of press-moulds for hollow wares, from Picolpasso (as fig. 47), p. 18.

51 Tile panel, tin-glazed earthenware, painted in blue with a cross-section of the Bolsward factory in Friesland, dated 1737. Reproduced by courtesy of the Rijksmuseum, Amsterdam.

52 Lead-glazed earthenware, covered with a white slip, and carved and incised with scenes from the infancy of Christ. Made in the 14th century, from Tring Parish Church. Length: 35.9 cm. (C.470-1927)

53 Stove, lead-glazed earthenware, moulded with scenes from the Lives of the Patriarchs and the Divinities of the Planets, after Sebald Beham, and the Crucifixion after Vergil Solis. Signed and dated by Hans Kraut in the Black Forest. H: 238.7 cm. (498-1868)

54 Panel of 66 tiles, tin-glazed earthenware painted in blue with a whaling scene, after an engraving by Adof van der Laan, signed 'CBM' for the artist Cornelis Boumeester of Rotterdam. Dutch, made in Rotterdam in the mid 17th century. Length: 121.9 cm. (C.744-1925)

55 Screw press for tile making, illustrated in L. Lefevre, *Architectural Pottery*, 1900, p. 297.

56 Panel of 66 tiles, lead-glazed earthenware painted after a design by William Morris of about 1877. Made by William De Morgan at Chelsea, about 1880. H: 160 cm. (C.36-1972)

57 Panel of two tiles, tin-glazed earthenware, painted by Duncan Grant with 'Lytton Strachey in Repose'. Signed 'dG'. The tiles are probably from the Omega Workshop and the decoration is mid 1920s. Length: 30.5 cm. (Misc 2:62 (1-2)-1934)

58 Bottle, painted in cobalt blue and manganese purple. Italian, made in Florence, about 1575–87. H: 17.4 cm. (229-1890)

59 Vase and cover, porcelain with applied moulded decoration. German, made under Böttger at Meissen, about 1715. H: 22.5 cm. (C.833 & A-1920)

60 Vase and cover, porcelain painted in enamels with *indianische Blumen* and *perlmutter* lustre. Marked 'AR' monogram. German, made at Meissen for Augustus the Strong, about 1727–30. H: 39.6 cm. (C.48-1971)

61 Chocolate pot and cover, porcelain painted in colours with *deutsche Blumen*. Marked with crossed swords in blue. German, made at Meissen, about 1745–50. H: 23 cm. (C.999 & A-1919)

62 Ice bucket or flower pot, porcelain painted in underglaze blue. Marked with crossed swords in blue. German, made at Meissen, about 1735. H: 19 cm. (C.229-1921)

63 Tea set, porcelain painted in colours and gilt. Marked with crossed swords and star. German, made at Meissen under the management of Marcolini, about 1780. Max H: 24.1 cm. (C.353 to 365-1914)

64 Pastille-burner in the form of an artichoke, supported by *chinoiserie* figures, porcelain painted in colours. Marked with a lion rampant in blue. German, made at Frankenthal from a model by J.F. Luck, about 1758–62. H: 24.8 cm. (C.216-1913)

65 Figure group of Paris and Helen, biscuit-porcelain. Marked with a sceptre in blue and impressed 'B'. German, made in Berlin, probably from a model by J.G. Müller, about 1790. H: 26 cm. (C.87-1922)

66 Teapot, porcelain, painted in colours with masquerading ladies. Marked 'Ven:a' (for Venezia) in red. Italian, made in Venice by Francesco Vezzi, about 1725. H: 15.2 cm. (C.130-1940)

67 Figure of a Circassian woman, porcelain, painted in colours and gilt. Mark, 6 in red. Italian, made at Doccia, about 1770. H: 15.2 cm. (378-1902)

68 Vase and cover, porcelain painted in colours with Silenus and Bacchantes. Mark, a *fleur-de-lis* in blue. Italian, made at Capodimonte, about 1750. H: 26.7 cm. (C.33-1932)

69 Teapot and cover, porcelain painted in cobalt blue. Mark, a sun-face in blue. French, made at Saint-Cloud in the early 18th century. H: 12.1 cm. (30 & A-1874)

70 Ewer and basin, porcelain with yellow enamel ground and painting in blue. Mark: crossed Ls enclosing the letter 'K' for 1763. French, made at Sèvres in 1763, painted by Catrice. H of jug: 16.2 cm. (753-1882)

71 Vase and cover, porcelain in *gros bleu* with *oeil-de-perdrix* ground, painted in colours. Mark: crossed Ls. French, made at Sèvres, about 1760. H: 34 cm. (751-1882)

72 Figures of Cupid and Psyche, biscuit porcelain on glazed and enamelled bases. French, made at Sèvres, about 1765, the figures modelled by Falconet in 1758 and 1761. H: 30.5 cm. (804 &A-1882)

73 Dish, porcelain, painted in colours with the Fox, the Dog and the Cock from Aesop's Fables. The dish probably modelled by Nicholas Sprimont, the painting by J.H. O'Neale. Made at Chelsea, about 1754. Length: 22.9 cm. (Sch.I 170/414:352-1885)

74 Melon tureen and ladle, porcelain, painted in colours. Staffordshire, Longton Hall factory, about 1755–7. Bought by Lady Charlotte Schreiber in Utrecht. H: 12.1 cm. (Sch.I 144/414:332-1885)

75 Miniature toy tea and coffee set, porcelain painted in blue. Mark: S on some pieces. Made at Caughley, about 1780. Max H: 7.6 cm. (C.197-1921 etc.)

76 Teapot, hard-paste porcelain painted in enamels and inscribed 'Sophia Sayer 1803'. Mark: pattern number 354 in pink. Made at New Hall, dated 1803. (C.969 & A-1924)

77 Milk pan, tin-glazed earthenware, painted in blue. From the dairy at Hampton Court. Mark: 'AK' in blue. Dutch, made by Adrianus Kocks of the Greek A factory at Delft, in the early 1690s. Diameter: 47.4 cm. (C.384-1926)

78 'China Closet' from Daniel Marot's *Nouveaux Livres de Partements*, 1702.

79 'Porcelain Room at Orianienburg', from *Vues de Palais et Maisons*. Augsburg, 1733, engraved by I.G. Merz.

80 Figure of a goat, white porcelain. Marked with a '2' incised, and probably one of the four recorded in factory archives. German, modelled by J.J. Kaendler, made at Meissen, about 1732. Length: 66 cm. (C.111-1932)

81 Plate, tin-glazed earthenware painted with a garniture of vases on a yellow ground. Dutch, made at Delft, about 1760. Diameter: 25.4 cm. (C.60-1966)

82 Figures of Harlequin, porcelain painted in colours and gilt. German, modelled by J.J. Kaendler, made at Meissen, about 1745. Max H: 18.4 cm. (C.9. 10, 11, 13, 15-1984)

83 Figures of a lion and lioness, porcelain painted in colours. The *ormolu* mounts French mid 18th century. German, the model by J.J. Kaendler about 1740–4, made at Meissen about 1745–50. Max H: 19.7 cm. (835,836-1882)

84 Centrepiece, porcelain, marked with the shield of Bavaria impressed. German, modelled by F.A. Bustelli, made at Nymphenburg, about 1759–60. H: 27.3 cm. (C.21-1946)

85 Three 'Masquerade figures', porcelain, painted in colours and gilt. Made at Chelsea, about 1760–70. Max H: 21.9 cm. (C.32,33-1973, C.184-1977)

86 Erato and Polyhymnia from a set of the Muses, porcelain, painted in colours. The figures are inscribed 'Eraton for the Love' and 'Polimnie'. Made at Bow, about 1750. Max H: 17.1 cm. (C.1348-1924, C.63-1927)

87 Globular with applied prunus and gilt metal mounts, the mark translated as 'Hall of the Friendly and Virtuous, made by Meng-ch'en. 1627'. Chinese, made at Yixing, dated 1627, but perhaps late 17th century. H: 17.4 cm. (C.16-1968) Cylindrical with applied sprigs of the crowned George III and his Queen. Made in Staffordshire, about 1761. H: 8 cm. (3865-1853) Hexagonal, moulded and partly polished on the wheel. German, made at Meissen, about 1715. H: 9.4 cm. (C.108-1940)

88 *A Family at Tea*, oil on canvas, artist unknown, about 1725. Courtesy of the Goldsmiths Company, London.

89 Tea tray, tin-glazed earthenware, painted in blue with a tea party, inscribed 'E + A' and dated 1743. Probably London. Width: 35.2 cm. (3864-1901)

90 Porcelain, with *Rose Pompadour* ground, painted in colours and gilt, including the owner's monogram 'PN'. Mark: interlaced Ls and a tree in blue. French, made at Sèvres, about 1765, painted by Bouchet. Length: 35 cm. (C.440-446-1921)

91 Part tea set, bone-china, painted in colours and gilt. Some pieces marked 'Spode Felspar Porcelain' and pattern no. 4896. Made by Spode, about 1825. Max H: 18.4 cm. (553-558-1902)

92 Teapot (*Kombinationssteekanne* or *Tee-Extraktkanne*), tin-glazed earthenware. Marked with TB monogram. German, designed by Theodor Bogler, made at Dornburger *Töpfer Werkstatt*, about 1923. H: 7.3 cm. (C.90-1994)

93 Lead-glazed earthenware with impressed, incised and applied decoration, including the inscription 'MT 1702', probably made in Wiltshire. H: 32.4 cm. (C.35-1987)

94 Teapot, thrown salt-glazed stoneware with cut, rouletted and sprigged decoration, the top dipped in red-brown slip. Made in Staffordshire (probably Burslem), about 1725–30. H: 15.6 cm. (C.145-1991) Tea bottle, moulded salt-glazed stoneware, the top dipped in red-brown slip. Staffordshire. H: 10 cm. (C.2-1994)

95 Teapot, lead-glazed red earthenware with white sprigged decoration and metal fittings. Made in Staffordshire, about 1735–40. H: 13.4 cm. (Sch.II 244 & A/414: 1032-1885)

96 Milk jug, black lead-glazed earthenware (so-called 'Jackfield Ware'), with gilt cartouche enclosing the date 1754. Probably Staffordshire. H: 13.4 cm. (C.357-1923)

97 Mug, thrown and turned salt-glazed stoneware, rouletted and sprigged decoration, inscribed 'THE BRITISH GLORY: REVIV:D BY ADMIRAL VERNON. HE TOOK PORTO BEL WITH SIX: SHIPS ONLY NOV.YE:22 1739'. H: 17.6 (Sch.II 71/414:942-1885) Teapot, slip-cast salt-glazed stoneware, inscribed 'PORTOBELLO TAKEN BY ADMIRAL VERNON FORT CHAGRE'. H: 14 cm. (Sch.II 99/414:984-1885)

98 Coffee pot and cover, hexagonal moulded lead-glazed 'agate' ware. Made in Staffordshire, mid 18th century. H: 25.4 cm. (C.72-1948)

99 Tureen and stand, press-moulded salt-glazed stoneware. Inscribed with the initials of the maker, 'JB 1766'. Made in Staffordshire, 1766. H: 23.5 cm. (2169-1901)

100 Milk jug and cover, salt-glazed stoneware dipped in 'Littler's Blue', perhaps originally with gilt decoration. Made in Staffordshire, mid 18th century. H: 8.9 cm. (Sch.II 235/414:1011-1885)

101 Punch pot, salt-glazed stoneware painted in enamel colours. Made in Staffordshire, about 1755–60. H: 19 cm. (C.42-1938)

102 Teapot and cover, lead-glazed creamware with underglaze blue decoration, blue ground and white reserve panels. Staffordshire, made by Enoch Booth of Tunstall, about 1745. H: 10.5 cm. (C.66-1989)

103 Figure of a boy on buffalo, after a Chinese porcelain model, lead-glazed earthenware, stained with oxides. Staffordshire, possibly made by Thomas Whieldon, in about 1760. H: 19.7 cm. (C.65-1958)

104 Mug, salt-glazed stoneware with incised blue decoration, including the inscription: 'This is Thomas Coxe's Cup: Come my Friend and Drink it Up: Good News is come'n the Bells do Ring: & here's a Health to Prusia's King February 16th 1758'. Staffordshire, dated 1758. H: 14.4 cm. (Sch.II 83/414:941-1885)

105 Teacaddy and cover, moulded creamware ('Pineapple Ware') with stained lead glaze. Moulded from a block by William Greatbatch. Made by either Josiah Wedgwood or Thomas Whieldon, in the early 1760s. H: 11.5 cm. (Sch.II 295/414:10691885)

106 Portrait medallions of Josiah Wedgwood and Thomas Bentley, white and black stoneware.Marked Wedgwood impressed. Made by Wedgwood in the 19th century. H: 12.7 cm. (453, 454-1890)

107 Vase, white terracotta stoneware with applied reliefs and porphyry glaze. Marked 'WEDGWOOD & BENTLEY: ETRURIA'. Made by Wedgwood, about 1773–5. H: 31.7 cm. (2386 &A-1901)

108 Dish, creamware painted in enamels with a green frog crest and brown monochrome view of West Wycombe Park. Inscribed with the view number '285'. Made by Wedgwood in 1773–4. Length: 38.5 cm. (C.74-1931)

109 Black basalt with encaustic decoration, copied from a 4th-century BC Apulian vase in Sir William Hamilton's collection. Made by Wedgwood about 1785. H: 87.4 cm. (2419-1901)

110 Pew Group, salt-glazed stoneware with applied brown details. Staffordshire, mid 18th century. H: 16.3 cm. (C.6-1975)

111 Figure of a recumbent deer, earthenware with stained lead glazes. Staffordshire, made by Ralph and Enoch Wood of Burslem or John Wood of Brownhills. H: 11.8 cm. (C.18-1930)

112 Moulded earthenware painted with high-temperature colours. Staffordshire, made by William Pratt of Lane Delph, about 1790–1800. H: 12.7 cm. (C.45-1940)

113 Flower vase and cover, blue Jasper with white sprigs emblematic of Art & Industry, Commerce, Liberty, and the 1786 Trade Treaty with France. Marked 'Neale & Co.'. Staffordshire, made by Neale & Co. of Hanley, about 1786. H: 15.3 cm. (2496 & A-1901)

114 Pot pourri, 'Bow Handled Bucket', white stoneware with brown ground and white sprigged decoration. Staffordshire, made by Spode of Stoke-on-Trent, about 1810–20. H: 6.4 cm. (2603-1901)

115 Plate, tin-glazed earthenware, painted in blue. Made in Bristol, about 1760. Diameter: 24.8 cm. (C.81-1965) Plate with shell-edge, lead-glazed earthenware ('pearlware'), painted in blue. Staffordshire, late 18th century. Diameter: 24.8 cm. (2263-1901) Plate, lead-glazed earthenware with underglaze blue printed 'Willow Pattern' decoration, inscribed 'Thomasine Willey 1818' (for a Cornish family, perhaps involved in the supply of cobalt to Staffordshire). Staffordshire, perhaps Spode, dated 1818. H: 22.5 cm. (C.231-1934)

116 Plate, creamware, painted in enamels, after an illustration in William Curtis, *Botanical Magazine*, 1787. Inscribed on the back 'Round leav'd cyclamen' in red, and marked with 'S' impressed. Made in Swansea, probably painted by Thomas Pardoe, about 1800. Diameter 22.5 cm. (3699-1901)

117 Chestnut basket and stand, creamware with pierced decoration. Leeds, late 18th century. Length: 28 cm. (C.51 & A-1947)

118 P. 34 of the 1794 Leeds Pottery pattern book, showing baskets, catalogue numbers 132–7. National Art-Library.

119 Jug, creamware with overglaze crimson transfer-print of the Death of Wolfe, from the engraving after the painting by Benjamin West. Staffordshire, late 18th century. H: 15.3 cm. (3630-1901)

120 Plate, creamware with transfer-printed decoration, including the crest of Baron d'Arnauld for whom the service was made, and a view of 'SOUTHILL Comte de Bedford Angleterre'. Marked 'CREIL' impressed and 'STONE, COQUEREL & LE GROS. PARIS. PAR BREVET D'INVENTION'. French, made at Creil, printed by Stone Coquerel & Le Gros, about 1815–20. Diameter: 23.5 cm. (C.735-1921)

121 *View of Etruria Works*, from Eliza Meteyard, *The Life of Josiah Wedgwood*, 1866, vol. II, p. 234.

122 'Glazing or dipping the ware in a prepared liquid', from *A Representation of the Manufactory of Earthenware, etc.* (Enoch Wood's factory) (1827).

123 Detail of bowl, creamware with red enamel decoration, depicting a pottery factory throwing room. Leeds, about 1770. Full diameter: 22 cm. (C.22-1978)
124 Creamware profiling tool, incised '12R'. Leeds, late 18th century. Length: 12.1 cm. (C.78-1932) Salt-glazed block-mould for cream jug, incised 'RW 1749' for Ralph Wood. H: 8.9 cm. (3097-1852). Sprig-mould, fired clay, impressed 'WOOD & CALDWELL 1818', for Wood & Caldwell of Burslem. Length: 9.8 cm. (C.158-1937)
125 Vase, one of a pair, bone-china, painted in enamels with a view of the Mount, Penkhull. Made by Spode of Stoke-on-Trent, about 1825. H: 25.4 cm. (372-1899)
126 Teapot, soft-paste porcelain with underglaze transfer-printed decoration. Italian, made at Doccia, about 1750–5. H: 16.2 cm. (C.407-1928)
127 Jug, porcelain with underglaze blue transfer-printed decoration. Marked with hatched crescent. Made at Worcester, about 1770. H: 23.2 cm. (C.59-1921)
128 Plate and sugar basin with cover, bone-china with bat-printed decoration. Pattern number '558' on base in gilt. Made by Spode of Stoke-on-Trent, about 1805–10. Diameter of plate: 22 cm. (18, 19-1904)
129 Plate, bone-china with enamelled outline-printed decoration. Marked 'H&S' within a wreath. Made by Hilditch & Son of Longton, about 1825. Diameter: 19.8 cm. (C.23-1966)
130 Earthenware with underglaze blue transfer-printing. Staffordshire, made by Bourne, Baker & Bourne, about 1830. H: 71 cm. (53-1870)

131 Tea service (*Cabaret*), hard-paste porcelain painted in enamels. Mark: printed interlaced Ls and 'Sèvres', the painting signed 'Charles Develly 1814'. French, made at Sèvres. Length of tray: 50.6 cm. (3579-1856)
132 Milk jug, porcelain with 'LP' monogram for Louis-Philippe, marked 'S 1846' and 'Chateau de Compiegne'. (C.718 1921) Coffee pot with 'LP' monogram, marked 'S 47'. (C.72-1973) Sugar basin, with 'LP' monogram, marked 'Sèvres 1845' and 'Chateau d'Eu'. (C.508-1920) All made at Sèvres, dated 1845–7. Max H: 16.2 cm.
133 Garniture of three porcelain vases, mounted in *ormolu* (probably French), encrusted with flowers and painted with Watteau-esque scenes on gilt reserves. German, made at Meissen, about 1830. H: 30.5 cm. (832 to B-1882)
134 Tea set, porcelain, painted in colours and gilt. Marked with 'A' over 'I' in blue, for the Tsar Alexander I of Russia (1801–25). Russian, made at the St Petersburg factory, early 19th century. Tray diameter: 32 cm. (C.47-52-1933)
135 Pair of figures of Russian peasants, porcelain, painted in colours. Marked 'G'. Russian, made at the Gardner factory, Moscow, early 19th century. H: 22.2 cm. (C.77, 78-1973)
136 Porringer and stand, soft-paste porcelain, painted in colours and gilt. Marked with a

crowned 'N'. Italian, made at the Real Fabbrica Ferdinandea, Naples, about 1800. H: 15.2 cm. (12 to B-1869)
137 Jug, lead-glazed earthenware with applied decoration in coloured clays. (C.410-1922) Jug, as above. (C.227-1926) Jug and lid, as above. (C.101 & A-1924) German, made at Marburg, about 1830–40. Max H: 24.8 cm.
138 Teapot and cream jug, porcelain, painted in colours and gilt. Unmarked. French, Paris, perhaps Jacob Petit factory, about 1840. Max H: 17.8 cm. (C.772, 773-1935)
139 Vase, porcelain, enamelled in colours and gilt. Marked 'Flight Barr and Barr Royal Porcelain Works Worcester. London House No.1 Coventry Street' in black, and inscribed 'CYMBELINE Posthumus… For my sake wear this. It is a manacle of love. Act I, Sc.1'. Made at Worcester and painted by Thomas Baxter, about 1815. H: 16.1 cm. (C.239-1919)
140 Sugar basin, cover and stand, porcelain, enamelled and gilt. Marked 'SWANSEA' in red. Made at Swansea, about 1815–22. H: 14 cm. (C.47 to B-1950)
141 Vase, bone-china with applied flowers and enamelled in colours. Unmarked. Probably Coalport, about 1830. H: 35.6 cm. (C.28-1964)
142 Vase and cover, Ironstone china, outline-printed and painted in colours and gilt. Marked 'MASON'S PATENT IRONSTONE CHINA' and 'EXHIBITION 1851'. Made by C.J. Mason of Longton, about 1851. H: 36.2 cm. (C.87:1-2-1992)
143 Figures of Venus and Neptune, lead-glazed earthenware, painted in overglaze enamels. Staffordshire, about 1820. H: 24.1 cm. (115, 116-1874)
144 Vase (one of a pair), stoneware, painted in enamels with Queen Victoria, Prince Albert and views of the Crystal Palace, and gilt. Made by Charles Meigh of Hanley, 1851. H: 101.6 cm. (C.481-1963)
145 Vase, bone-china, with transfer-printed decoration. Marked 'FAC-SIMILE OF A VASE Representing THE BATTLE BETWEEN THE GREEKS and the AMAZONS, FOUND AT CUMAE towards the latter end of the year 1855', and 'S.A.& Co.'. Made by Samuel Alcock of Burslem, about 1856–60. H: 21.6 cm. (C.43-1969)
146 Teapot (*Cafétière Eléphant*), moulded porcelain with *pâte-sur-pâte* decoration. French, made at Sevres, designed and decorated by M.L. Solon, about 1862. H: 19.7 cm. (8055-1862)
147 *Tazza* and cover, porcelain painted in the *pâte-sur-pâte* technique. French, made by M.L. Solon, about 1864, for the designer/retailer F. E. Rousseau. H: 24.8 cm. (759-1864)
148 Pilgrim bottle, lead-glazed earthenware, painted in colours after designs by H. Stacy Marks. Marked with impressed date-symbol for 1877. Made by Minton and decorated in the Kensington Art Pottery Studio, about 1877. H: 35.8 cm. (C.54-1915)
149 Wedgwood toilet wares, from the catalogue of the retailer Silber & Fleming, about 1882.

National Art-Library. (A.20.16)
150 Vase, lead-glazed earthenware, painted in lustre colours. Marked with impressed circle enclosing 'W. DE MORGAN & CO. SANDS END POTTERY'. Made by William De Morgan, about 1889–98. H: 30.4 cm. (C.414-1919)
151 Vase, moulded lead-glazed earthenware, painted in red lustre after designs by Walter Crane and signed in monogram. Made by Maw & Co. of Broseley, designed in 1889 and made about 1901. H: 23 cm. (C.313-1953)
152 Vase, moulded earthenware, with streaked lead glazes. Mark: a facsimile signature for Dr Christopher Dresser. Made by William Ault at Swadlincote, designed by Christopher Dresser, about 1892–6. H: 26.7 cm. (C.316-1953)
153 Ewer and dish, earthenware with raised slip and enamel decoration. Mark: 'L.Parvillée 158' on both. French, made by Léon Parvillée in Paris, about 1870. H: 39.3 cm. (C.18-1981)
154 Vase, stoneware, with high-temperature *flambé* glaze. French, made by August Delaherche in Paris, about 1889–90. H: 66.5 cm. (1613-1892)
155 Ice bucket, porcelain, painted in colours and gilt. Marked fully, including 'B & G KJOBENHAVN DANMARK'. Danish, made by Bing & Grøndahl of Copenhagen, about 1915, from the 1886–8 designs of Pietro Krohn. H: 12.5 cm. (C.236-1986)
156 Vase in the form of a horn on plinth, porcelain, painted in colours and gilt. Marked with printed Gothic 'D' and crown. Made at Derby, about 1830. H: 22.9 cm. (2988-1901)
157 Watercolour depicting Thomas Baxter's London decorating studios, about 1800. Painted by T. Baxter Jr. (782-1894)
158 Vase (one of a pair) in the form of a lamp, bone-china, painted in colours and gilt. Made by Spode of Stoke-on-Trent, early 19th century. H: 20.8 cm. (378-1899)
159 Cup and stand, earthenware, painted in red and black. Italian, probably Naples, Giustiniani factory, early 19th century. H: 9.5 cm. (4767 & A-1859)
160 Plate, porcelain, painted in brown monochrome with a blue ground border, and gilt. Painted with a view of 'Le Sphynx prés de les Pyramides'. French, made at Sèvres, painted by Swebach after engravings by Denon. Diameter: 24 cm. (C.124/16-1979)
161 Figure of Herbert Minton, Parian porcelain. Signed 'Hughes Prôtat, April 24 1860'. Perhaps a one-off or strictly limited edition. Made by Minton, Stoke-on-Trent, modelled by H. Prôtat, in 1860. H: 17.1 cm. (7126-1860)
162 Bone-china painted in colours and gilt. Unmarked, but matches the 'Night Lamp' in the Minton pattern book. Made by Minton at Stoke-on-Trent, about 1820. H: 22.5 cm. (C.601-1935)
163 Una and the Lion (from the Fairy Queen), Parian porcelain. Model by John Bell made by Minton of Stoke-on-Trent for Summerly Art Manufactures in 1847. H: 37 cm. (46-1865)
164 Lead-glazed earthenware (*majolica*). Made by Minton of Stoke-on-Trent in 1855.

H: 12.1 cm. (3568-1857)

165 View of the 'Gamble Room' at the V&A Museum, clad in Minton *majolica* tiles.

166 Plaque, lead-glazed earthenware painted in overglaze enamels. Signed by W.S. Coleman. The blank made by Minton in 1850, the decoration executed at the Kensington Art Studio, about 1870–5. Diameter: 42.2 cm. (C.207-1965)

167 Encaustic stoneware. Designed by A.W.N. Pugin, made by Minton of Stoke-on-Trent, about 1850. Diameter: 33.2 cm. (C.46-1972)

168 Moulded stoneware. Marked in relief with 'REGISTERED March 17th 1842 By CHARLES MEIGH. HANLEY'. Made by Charles Meigh of Hanley, about 1842. H: 25.8 cm. (C.11-1958)

169 Lead-glazed earthenware, painted in colours, inscribed 'ANNO DOMIN 1874 IOMNS PATCS.MARQU.DE BUTE'. ENGLISH, factory unknown. H: 36 cm. (C.40-1972)

170 Spill vase, porcelain, painted in colours. French, Paris, about 1830. H: 13.1 cm. (C.13-1915)

171 Jug, salt-glazed stoneware with moulded decoration and cobalt blue painting. German, made by Merkelbach & Wick of Grenzhausen, in 1875. H: 61 cm. (941-1875)

172 Vase, moulded porcelain painted in colours. Dutch, Rozenburg factory in The Hague, designed by J. Juriaan Kok in 1904. H: 32 cm. (C.41-1972)

173 Coffee service, porcelain cast and painted and stencilled. Marked 'LE PARTHENON' and signed 'M.Dufrêne'. French, factory unknown, designed by Maurice Dufrêne, about 1900, originally for La Maison Moderne in Paris. Max H: 22.5 cm. (C.69 to P-1989)

174 Vase, earthenware with printed and painted decoration. Marked 'MADE IN FINLAND ARABIA'. Finnish, made at the Arabia factory, by an unknown designer in about 1900–02. H: 35 cm. (C.30-1990)

175 Vase, lead-glazed earthenware slip-trailed and painted in colours. Marked 'MINTON LTD' and 'No.1', also '0707' incised. Made by Mintons of Stoke-on-Trent, designed by L.V. Solon and J.W. Wadsworth, about 1902. H: 32 cm. (C.364-1976)

176 Figure of a woman, porcelain. Signed 'Scheurich'. German, made at Nymphenburg, modelled by Paul Scheurich, about 1920–5. H: 22 cm. (C.21-1955)

177 Centrepiece in the form of a *tazza*, earthenware with moulded, painted and gilt decoration. Marked with geometric printed monogram. Austrian, made at the Wiener *Kunstkeramischer Werkstätte*, designed by Michael Powolny, about 1908. H: 19.1. (C.8-1982)

178 Handled vase, earthenware, carved and incised *sgraffito* decoration, painted in colours. Made by the Della Robbia factory at Birkenhead, 1894–1906. H: 30.4 cm. (C.201-1961)

179 Bowl on stand, stoneware with high-temperature *flambé* glaze. Marked, impressed 'RUSKIN ENGLAND 1927'. Made at W. Howson

Taylor's Ruskin Pottery, Smethwick, probably in the 1920s. H: 11 cm. (C.86-1981)

180 Vase, earthenware, painted in lustre. Marked with 'RJ' monogram. Made by Pilkingtons, Clifton Junction, Manchester, and decorated by Richard Joyce, about 1910–20. H: 22.9 cm. (C.51-1971)

181 Page from the catalogue of 'Fenton China' (E. Hughes & Co.), about 1905, showing inexpensive bone-china tablewares. V&A Museum, Dept. of Ceramics & Glass.

182 Vase, porcelain with transfer-printed decoration. Marked 'Richard Ginori (twice) PITTORIA DI DOCCIA 1927', and signed 'Gio Ponti'. Italian, made by Richard-Ginori at Doccia, designed by Gio Ponti and dated 1927. H: 19.2 cm. (C.51-1976)

183 Vase, lead-glazed earthenware, painted decoration, decorators' marks and 'CARTER STABLER ADAMS POOLE ENGLAND'. Poole Pottery, about 1935. H: 22 cm. (C.356-1976)

184 Breakfast set, earthenware, 'Moonstone' glaze. Marked with Keith Murray's printed facsimile signature or 'KM', and 'Wedgwood Made in England'. Made by Wedgwood and designed by Keith Murray, about 1935. Max H: 20.5 cm. (C.540 to 542-1974)

185 Lidded pot, brown stoneware. Made by Doulton & Co. of Lambeth, designed by Reco Capey, about 1935. H: 16.5 cm. (C.368 & A-1935)

186 Stoneware, painted in brown. Marked, impressed 'BL' and 'SI'. Made by Bernard Leach at St Ives in 1931. H: 34.3 cm. (C.144-1931)

187 Vase, 'Roc's Egg', stoneware with ash glaze. Marked, 'KPB' impressed. Made by Katherine Pleydell-Bouverie, about 1929–30. H: 25.4 cm. (C.236-1930)

188 Earthenware painted in monochrome with an artist at his easel. French, made at Vallauris, painted by Pablo Picasso (probably a self-portrait). Dated 1954. H: 58 cm. (C.109-1994)

189 Part of tableware range, 'Domino', porcelain with printed decoration. Marked, 'ROYAL COPENHAGEN DENMARK' with crown, 'DOMINO' and three wavy lines. Danish, made at Royal Copenhagen, designed by Anne Marie Trolle in 1970. Max H: 18 cm. (C.127 & A to 129 &A-1986)

190 Teapot, 'Colorado', earthenware. Italian, made by Ceramiche Flavia, Montelupo Fiorentino, designed by Marco Zanini in 1983. H: 21 cm. (C.207-1985)

191 Figure of a bull, earthenware with printed decoration. ENGLISH, made by Wedgwood, designed by Arnold Machin in 1950. H: 16.5 cm. (C.276-1951)

192 Made for Woolworths by Ridgway of Stoke-on-Trent, the shape designed by Tom Arnold, the decoration by Enid Seeney. H. of coffee pot: 18.3 cm. (C.48-51-1991 etc.)

193 Tankard and jug, stoneware, *tenmoku* glaze. Made at Bernard Leach's St Ives Pottery in 1949. Max H: 26.4 cm. (C.172, 176-1950) Tall jug, earthenware, partial copper-green lead glaze. 14th century. H: 28.5 cm. (C.184-1926)

194 Pot, stoneware with white and black glazes. Marked, 'HC' impressed. Made by Hans Coper in 1968. H: 12.8 cm. (C.767-1969) Pot, porcelain with white and blue glazes and incised decoration. Marked, 'LR' monogram impressed. Made by Lucie Rie in 1959. H: 17.8 cm. (C.127-1959)

195 Bone-china and porcelain intermixed, hand-built. Made by Ewen Henderson in 1988. H: 35.8 cm. (C.39-1989)

196 Vase, 'Optical Pot', stoneware with coloured matt glazes. Made by Liz Fritsch in 1980. H: 31.1 cm. (C.13-1981)

197 'Landscape with a Hippo', earthenware, with coloured glazes. Made by Richard Slee in 1997. H: 23.5 cm. (C.90-1997)

198 Vase, stoneware with cream glaze painted in brown. Marked, 'RB' monogram in brown. French, made at Bordeaux by René Buthaud, about 1928–30. H: 23.5 cm. (C.292-1987)

199 Tablewares, porcelain with sprayed decoration. Marked, 'PORSGRUNN NORGE'. NORWEGIAN, made at Porsgrund, designed by Nora Gulbrandsen in about 1929–31. Max H: 21 cm. (C.144 to D-1987)

200 Jar and cover, bone-china decorated in 'Jazz' pattern. Marked, 'Carlton Ware. Made in England. Trade Mark', printed. 'Carlton Ware' made by Wiltshaw & Robinson of Stoke-on-Trent, the pattern designed by Enoch Boulton, about 1928–30. H: 26 cm. (C.526-1974)

201 Tableware, bone-china, printed and painted with 'Tulip' pattern. Made by Paragon China Ltd. of Longton, the pattern registered 1931. Max H: 7.6 cm. (C.251, 252, 255-1970)

202 Cup, saucer and dish, earthenware, painted in colours with 'Inspiration' pattern. Mark: 'HAND PAINTED. Bizarre by Clarice Cliff. Wilkinson Ltd England'. Made by A.J. Wilkinson Ltd. of Burslem, pattern designed by Clarice Cliff, about 1930. Diameter of dish: 22.8 cm. (C.71-1976, C.13 & A-1977)

203 Part tea set, earthenware. Made by Wood & Sons Ltd, designed by Susie Cooper, about 1935. Max H: 11.5 cm. (C.112 to C-1986)

204 Tablewares, bone-china. Mark: 'GUSTAVSBERG SWEDEN BEN PORSLIN SA' and anchor. Swedish, made at Gustavsberg, designed by Stig Lindberg in 1949. Max H: 20.3 cm (C.34 to 37-1961)

205 Salad bowl set, earthenware with transfer-printed decoration. Made by Midwinter, designed by Terence Conran in 1955. Max H: 10.5 cm. (C.34 to B-1987, C.212-1991)

206 Coffee pot and cover, stoneware, 'Concept' range, shown with original resin model. Mark: 'Hornsea 1977, Concept, Made in England'. Made by Hornsea Pottery, designed by Martin Hunt and Colin Rawson, in 1977. H: 15.2 cm. (C.207-1977, C.9 & A-1990)

207 Coffee set, bone-china, with printed decoration. Marked 'TG in monogram, Thomas Goode since 1827, Fine Bone China Made in England'. Made at T. Goode's factory at Stoke-on-Trent. From the 'Domino' range designed by Peter Ting, 1998. Max H: 27 cm.

SELECTED FURTHER READING

General
Atterbury, P., *The History of Porcelain*, London, 1982.
Charleston, R.J. (ed.), *World Ceramics. An Illustrated History*, London, 1968.
Clark, G., *The Potter's Art. A Complete History of Pottery in Britain*, London, 1995.
Godden, G.A., *British Pottery. An Illustrated Guide*, London, 1974.
Hillier, B., *The Social History of the Decorative Arts: Pottery and Porcelain 1700–1914*, London, 1968.
Honey, W.B., *European Ceramic Art from the End of the Middle Ages to about 1815*, London, 1952.
Morris, B., *Inspiration for Design. The Influence of the Victoria & Albert Museum*, London, 1986.
Röntgen, R.E., *Marks of German, Bohemian and Austrian Porcelain 1710 to the Present*, Exton, USA, 1981.

Chapter 1: From Earthenware to Stoneware
Amico, L., *Bernard Palissy*, Paris/New York, 1996.
Freestone, I. and Gaimster, D. (ed.), *Pottery in the Making. World Ceramic Traditions*, exh. cat. British Museum, London, 1997.
Gaimster, D., *German Stoneware 1200–1900. Archaeology and Cultural History*, London, 1997.
Grigsby, L., *English Slip-Decorated Earthenware at Williamsburg*, Williamsburg, USA, 1993.
Hurst, J.G., Neal, D.S. and van Beuningen, H.J.E., *Pottery Produced and Traded in North-West Europe 1350–1650*, Rotterdam Papers VI, Rotterdam, 1986.
Jennings, S., *Medieval Pottery in the Yorkshire Museum*, York, 1992.
Katz, M.P. and Lehr, R., *Palissy Ware*, London, 1996.
Lewis, E. (ed.), *Custom and Ceramics. Essays Presented to Kenneth Barton*, Wickham, 1991.
Mellor, M., *Pots and People that Have Shaped the Heritage of Medieval and Later England*, Oxford, 1997.
Pearce, J., *Post-Medieval Pottery in London 1500–1700: Border Wares*, London, 1992.

Chapter 2: Tin-glaze
Archer, D.M., *Delftware. A Catalogue of the Collection of the Victoria & Albert Museum*, London, 1997.
Austin, J.C., *British Delft at Williamsburg*, Williamsburg, USA, 1994.
Bondhus, S.V., *Quimper Pottery: A French Folk Art Faïence*, USA, 1981.
Britton, F., *English Delftware: The Bristol Collection*, London, 1982.
Britton, F., *London Delftware*, London, 1986.
Caiger-Smith, A., *Tin-glaze Pottery in Europe and the Islamic World: The Tradition of 1,000 years in Maiolica, Faience and Delfware*, London, 1973.
Carnegy, D., *Tin-glazed Earthenware. From Maiolica, Faience and Delftware to Contemporary*, London, 1993.
de Jonge, C.H., *Dutch Tiles*, London, 1971.
Drey, R.E.A., *Apothecary Jars*, London, 1978.
Fourest, H.-P., *Delftware. Faience Produced at Delft*, Fribourg, 1980.
Frégnac, C., *La Faïence Européenne, Le Guide du Connaisseur*, Fribourg, 1976.
Horne, J., *English Tin-glazed Tiles*, London, 1989.
Lipsky, Louis L. and Archer, M., *Dated English Delftware*, London, 1984.
Marseille, Centre de la Vielle Charité, *La Faience de Marseille au XVIIIe Siècle. La Manufacture de la Veuve Perrin*, exh. cat. Marseille, 1990.
Marseille, Musée Grobet-Labadié, *Faience de Marseille. Saint-Jean-du-Désert*, exh. cat. Marseille, 1985.
Paris, Grand Palais, *Faïences Francaises*, exh. cat., Paris, 1980.
Piccolpasso, C. (in Lightbown, R. and Caiger-Smith, A. eds.), *The Three Books of the Potter's Art*, 2 vols., facsimile manuscript, London, 1980.
Poole, J., *Italian Maiolica and Incised Slipware in the Fitzwilliam Museum, Cambridge*, Cambridge, 1995.
Rackham, B., *Catalogue of Italian Maiolica in the Victoria & Albert Museum*, 2 vols., London, 1940, reprinted 1977.
Ray, A., *English Delftware Tiles*, London, 1973.

Chapter 3: The Invention of Porcelain
Adams, E., *Chelsea Porcelain*, London, 1987.
Adams, E. and Redstone, D., *Bow Porcelain*, London, 1991.
Ayers, J., Impey, O. and Mallet, J.V.G., *Porcelain for Palaces. The Fashion for Japan in Europe 1650–1750*, exh. cat. British Museum, London, 1990.
Bosch, A., *Die Nürnberger Hausmaler, Emailfarbendekor auf Gläsern und Fayencen der Barockzeit*, Munich, 1984.
Bradshaw, P., *English Porcelain Figures 1745–1795*, London, 1981.
Dawson, A., *French Porcelain. A Catalogue of the British Museum Collection*, London, 1994.
de Plinval de Guillebon, R., *Paris Porcelain 1770–1850*, London, 1972.
Godden, G.A., *Eighteenth-century English Porcelain. A Selection from the Godden Reference Collection*, London, 1985.
Godden, G.A., *Encyclopedia of British Porcelain Manufacturers*, London, 1988.
Godden, G.A., *English China*, London, 1985.
Honey, W.B., *French Porcelain of the 18th Century*, London, 1950, reprinted 1972.
Köllman, E. and Jarchow, M., *Berliner Porzellan*, 2 vols., Munich, 1987.
Pauls-Eisenbeiss, Dr E., *German Porcelain of the 18th Century*, 2 vols., London, 1972.
Sassoon, A., *Vincennes and Sèvres Porcelain. Catalogue of the Collections*, J.Paul Getty Museum, Malibu, 1991.
Savill, R., *The Wallace Collection, Catalogue of Sèvres Porcelain*, 3 vols., London, 1988.
Spero, S. and Sandon, J., *Worcester Porcelain 1751–1790. The Zorensky Collection*, Woodbridge, 1996.
Sterba, G., *Meissen Domestic Porcelain*, London, 1988.
Syz, H., Jefferson Miller, J. and Rückert, R., *Catalogue of the Hans Syz Collection. Vol. I, Meissen Porcelain and Hausmaler*, Washington, 1979.
Twitchett, J., *Derby Porcelain*, London, 1980.

Chapter 4: Pottery: From Craft to Industry
Barker, D., *William Greatbatch, a Staffordshire Potter*, London, 1990.
Drakard, D., *Printed English Pottery. History and Humour in the Reign of George III 1760–1820*, London, 1992.
Emmerson, R., *British Teapots and Tea Drinking 1700–1850, Illustrated from the Twining Tea Gallery at Norwich Castle Museum*, London, 1992.
Grigsby, L., *English Pottery 1650–1800, from*

the Henry H. Weldon Collection, London, 1990.

Halfpenny, P., English Earthenware Figures 1740–1840, Woodbridge, 1991.

Kybalová, European Creamware, Prague, 1989.

Lewis, J. and Lewis, G., Pratt Ware, English and Scottish Relief Decorated and Underglaze Coloured Earthenware 1780–1840, Woodbridge, 1984.

McKendrick, N., Brewer, J. and Plumb, J.H., The Birth of a Consumer Society. The Commercialisation of Eighteenth-century England, London, 1981.

Meteyard, E., The Life of Josiah Wedgwood, 2 vols., London, 1865.

Mountford, A.R., The Illustrated Guide to Staffordshire Salt-Glazed Stoneware, London, 1971.

Oswald, A., Hughes, R.G. and Hildyard, R.J.C., English Brown Stoneware, London, 1982.

Rackham, B., The Glaisher Collection of Pottery and Porcelain in the Fitzwilliam Museum, Cambridge, 2 vols., Cambridge, 1935, reprinted Woodbridge, 1987.

Reilly, R., Wedgwood, 2 vols., London, 1989.

Shaw, S., History of the Staffordshire Potteries, Hanley, 1929, reprinted Newton Abbot, 1970.

Thomas, J., The Rise of the Staffordshire Potteries, New York, 1971.

Towner, D., Creamware, London, 1978.

Weatherill, L., The Pottery Trade and North Staffordshire, Manchester, 1971.

Williams-Wood, C., English Transfer-Printed Pottery and Porcelain. A History of Over-Glaze Printing, London, 1981.

Young, H (ed.), The Genius of Wedgwood, exh. cat. V&A, London, 1995.

Chapter 5: Liberty, Imperialism and Mass-production

Art & Design in Europe and America 1800–1900, V&A, London, 1987.

Atterbury, P. (ed.), The Parian Phenomenon, Shepton Beauchamp, 1989.

Atterbury, P. and Batkin, M., The Dictionary of Minton, Woodbridge, 1990.

Bergesen, V., Encyclopedia of British Art Pottery, London, 1991.

Bergesen, V., Majolica, London, 1989.

Bumpus, B., Pâte-sur-Pâte, the Art of Ceramic Relief Decoration 1849–1992, London, 1992.

Cameron, E., Encyclopedia of Pottery and Porcelain. The Nineteenth and Twentieth Centuries, London, 1986.

Coysh, A.W. and Henrywood, R.K., The Dictionary of Blue & White Printed Pottery 1780–1880, Woodbridge, vol. 1, 1982, vol. 2, 1989.

d'Albis, J. and Romanet, C., La Porcelaine de Limoges, Paris, 1980.

Fay-Hallé, A. and Mundt, B., Nineteenth-Century European Porcelain, London, 1983.

Godden, G.A., Godden's Guide to Mason's China and the Ironstone Wares, London, 1980.

Greenwood, M., The Designs of William De Morgan, Shepton Beauchamp, 1989.

Jones, J., Minton, The First Two Hundred Years of Design and Production, Shrewsbury, 1993.

Halén, W., Christopher Dresser, Oxford, 1990.

Henrywood, R.K., An Illustrated Guide to British Jugs, Shrewsbury, 1997.

Henrywood, R.K., Relief-Moulded Jugs 1820–1900, Woodbridge, 1984.

Lockett, T., Godden, G.A., Davenport. China, Earthenware, Glass 1794–1887, London, 1989.

McVeigh, P., Scottish East Coast Potteries 1758–1840, Edinburgh, 1979.

Messenger, M., Coalport 1795–1926, Woodbridge, 1995.

Minton 1798–1910, exh. cat. V&A, London, 1976.

Parry, L. (ed.), William Morris, exh. cat. V&A, London, 1996.

Pélichet, E. and Duperrex, M., La Céramique Art Nouveau, Lausanne (no date).

Préaud, T. et al., The Sèvres Porcelain Manufactory. Alexandre Brogniart and the Triumph of Art and Industry 1801–1847, New York, 1997.

Ross, M., Russian Porcelains, Oklahoma, 1968.

Sandon, H., Royal Worcester Porcelain, from 1862 to the Present Day, London, 1973.

Thomas, T., Villeroy & Boch 1748–1930, exh. cat. Rijksmuseum, Amsterdam, 1977.

Truman, C., The Sèvres Egyptian Service 1810–12, V&A, London, 1982.

Walcha, O., Meissen Porcelain, Dresden, 1981.

Chapter 6: The Twentieth Century: Craft or Industry?

Anscombe, I., Omega and After, 1919–1928, London, 1981.

Arwas, V., Art Deco, London, 1980.

Aveline, M. (ed.), Memphis: Céramique, Argent, Verre, 1981–1987, Marseille, 1991.

Batkin, M., Wedgwood Ceramics 1846–1959, London, 1982.

Beyer, H. and Gropius, W. (ed.), Bauhaus, New York, 1938, reprinted, 1986.

Bischofberger, B., Ettore Sottsass. Ceramics, London, 1995.

Clark, G., Michael Cardew, London, 1978.

Dormer, P., The New Ceramics, Trends and Traditions, London, 1986.

Eatwell, A., Susie Cooper Productions, exh. cat. V&A, London, 1987.

Forsyth, G., 20th Century Ceramics, London, 1936.

Hayward, L., Poole Pottery. Carter & Company and their Succesors 1873–1995, Shepton Beauchamp, 1995.

Jackson, L., The New Look. Design in the Fifties, Manchester, 1992.

Lesieutre, A., The Spirit and Splendour of Art Deco, New York, 1974.

Lewenstein, E. and Cooper, E., New Ceramics, London, 1974.

Lobanov-Rostovsky, N., Revolutionary Ceramics. Soviet Porcelain 1917–1927, London, 1990.

MacCarthy, F., British Design since 1880. A Visual History, London, 1982.

McCready, K., Art Deco and Modernist Ceramics, London, 1995.

McFadden, D.R. (ed.), Scandinavian Modern Design 1880–1980, exh. cat. Cooper-Hewitt Museum, New York, 1982.

Nyström, B., Rörstrand Porcelain. Art Nouveau Masterpieces, The Robert Schreiber Collection, New York, 1996.

Opie, J., Scandinavian Ceramics and Glass in the Twentieth Century, exh. cat. V&A, London, 1989.

Préaud, T. and Gautier, S., Ceramics of the 20th Century, Basle, 1982.

Reports on the Present Position and Tendencies of the INDUSTRIAL ARTS as indicated at the International Exhibition of Modern Decorative and Industrial Arts, Paris 1925, London, 1927.

Rice, P. and Gowing, C., British Studio Ceramics in the 20th Century, London, 1989.

Rosenthal: Hundert Jahre Porzellan, exh. cat. Kestner-Museum, Hannover, 1982.

Rudoe, J., Decorative Arts 1850–1950, A Catalogue of the British Museum Collection, London, 1991.

Spours, J., Art Deco Tableware, London, 1988.

Watson, O., British Studio Pottery. The Victoria & Albert Museum Collection, London, 1990.

Whybrow, M., The Leach Legacy, St. Ives Pottery and its Influence, Bristol, 1996.

INDEX